CANALETTO *in Venice*

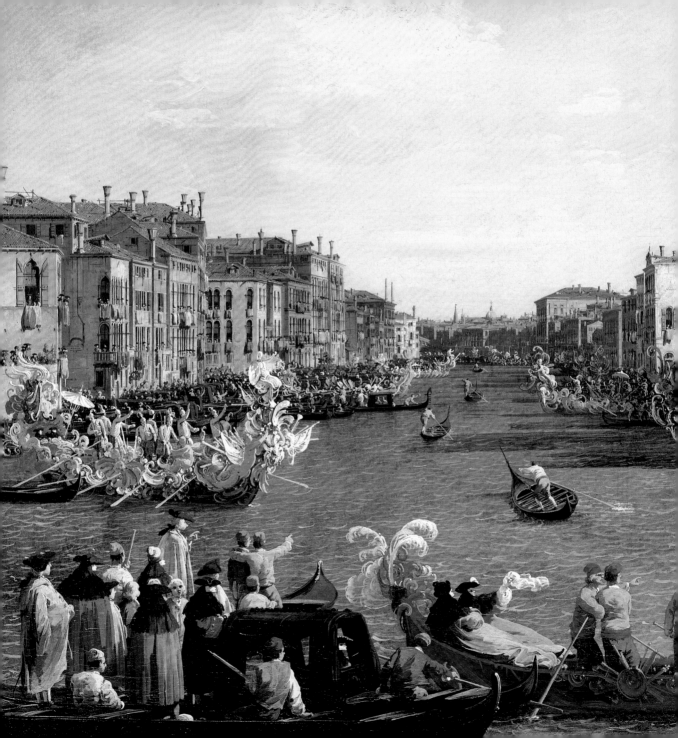

CANALETTO *in Venice*

MARTIN CLAYTON

ROYAL COLLECTION PUBLICATIONS

This publication has been generously
supported by KPMG.

Published by Royal Collection Enterprises Ltd
St James's Palace, London SW1A 1JR

For a complete catalogue of current publications,
please write to the address above, or visit our website on
www.royalcollection.org.uk

ISBN 1 902163 81 8
978 1 902163 81 9

British Library Cataloguing in Publication Data:
A catalogue record for this book is available from
the British Library

Designed by Mick Keates
Production by Debbie Wayment
Printed and bound by Conti Tipocolor, Italy

The author wishes to thank Lucy Whitaker and Viola Pemberton
Pigott for their help and advice.

Frontispiece: Detail of no. 13
Page 6: Detail of no. 61

Contents

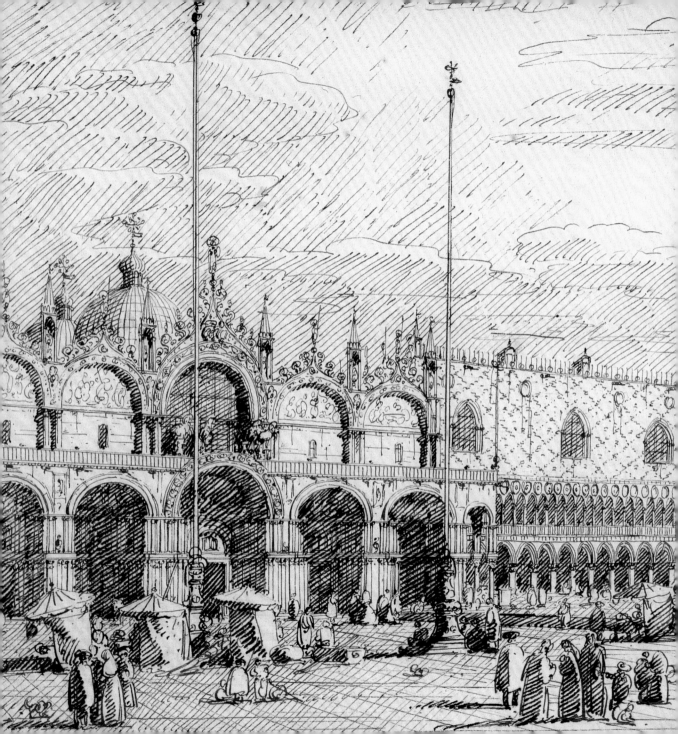

The formation of Canaletto's Venice

The urban structure of Venice, rising out of the waters of a lagoon, is unlike that of any other city in the world. Its wealth over many centuries allowed the construction of a mass of buildings in the styles found all over Italy – Romanesque, Gothic, Renaissance and Baroque; but as the principal point of contact between western Europe and the East, these styles were combined with Byzantine and Moorish influences that make the architecture of Venice unique. In the eighteenth century, as now, Venice was a major tourist destination, but the visitors from across Europe were primarily attracted not by ancient ruins, as in Rome, or by the paintings and sculptures to be found there, as in Florence, but by the city itself, and the career of Canaletto (1697–1768) served those who wished to own a pictorial record of the city. This introduction will briefly trace the development of Venice, charting the growth of the city to the peak of its fortunes around 1500, and the slow decline that has preserved its centuries-old aspect to a remarkable degree.

The islands of the Venetian lagoon were settled around the sixth and seventh centuries by people displaced by the Lombard migrations into northern Italy. At that time Venice consisted of a group of small islands in the lagoon, and was a member of a confederation of similar settlements strung along the north-west Adriatic coast. These were part of the Byzantine Empire centred in Constantinople (today Istanbul), but as Byzantine power waned in western Europe, Venice emerged as an independent city-state.

The two principal settlements of the city's early life were the Rialto ('high bank') at the centre of the archipelago, and what is now San Marco, adjacent to one of the few areas of relatively deep water in the lagoon, the Bacino (dock), scoured out by the confluence of the broad Canale della Giudecca and the Grand Canal. Other parishes grew up on the adjacent islets to accommodate a population that had reached 100,000 as early as 1200. Each parish was centred on a church by an open space (a *campo*, literally a field), with a well-head serving a rainwater cistern, and this original urban structure remains recognisable to this day. Canaletto's drawings of Sant'Elena (nos. 57–8) give an idea of the original appearance of the islets, separated by broad marshy channels. Gradually, the marshland was reclaimed from the lagoon, and the islets coalesced to leave only a network of narrow channels (the *rii*) with solid wharfs, straightened and supplemented by others dug into the dry land.

There was a paucity of natural building materials in the lagoon, and the earliest buildings were constructed from imported wood floated into the city

as rafts, and thatched with reeds from the marshes. Later, brick and stone were shipped to the city, initially from Roman ruins on the mainland. In time, white Istrian limestone and, to a lesser extent, pink Verona marble became the preferred material for architectural details and for the whole of the most important buildings. These heavier buildings needed strong foundations, and piles of pine were sunk to the firm (but not solid) bed of clay below the mud and sand of the lagoon.

With few resources on land, Venice was from the outset a maritime trading state. The sandbanks of the Lido made the lagoon a safe natural harbour, even if its shallow channels caused problems of navigation and mooring. The shipyards of the Arsenale (no. 63) were taken under governmental control as early as the twelfth century, and expanded over the next four hundred years to occupy a large part of the east of the island. This long-term investment in construction and maintenance, and the convoys escorted by the Venetian navy to protect against piracy, gave the merchants of Venice a crucial advantage over the independent merchants of Italy's other maritime city-states. Early military support for the Byzantine Empire gave Venice trading privileges across the eastern Mediterranean, and a chain of fortified trading posts was established down the eastern coast of the Adriatic and throughout the islands of modern-day Greece, Turkey and Cyprus. The position of Venice close to the Brenner Pass through the Alps made it the principal Mediterranean port for northern Europe, especially Germany, and for centuries the city was a cosmopolitan mix of traders from across Europe and the East.

As well as a trade in luxury consumer goods,

contact (and conflict) with the eastern Mediterranean brought both sacred and artistic riches to Venice. In AD 828 Venetian merchants brought from Alexandria the supposed body of St Mark, which was placed in a chapel built on the site of the present basilica of San Marco, and the Evangelist's apocalyptic symbol of the winged lion was from then on the emblem of the city. The basilica in its present form dates from the rebuilding of c.1063–94, and San Marco (and Venice in general) continued to be embellished with treasures from the East. Many of these were

looted from Constantinople in 1204, during the Fourth Crusade, and from Acre (in modern-day Israel) in 1256 when Venice seized the city from the Genoese, including gold and jewels that enriched the Treasury, rare marbles, and sculptures, most notably the winged lion of St Mark and the four horses that were placed on the western façade of the basilica.

During the twelfth century the area around San Marco assumed essentially the layout that it has to this day. A canal running in front of the basilica was filled in, and the church of San Geminiano was rebuilt to form the western boundary of Piazza San Marco – the only space in Venice to be called a *piazza* (square). The Palazzo Ducale, the seat of government established in the ninth century to the south of San Marco, was rebuilt (not for the last time), and the inlet immediately before it was filled in to form the Piazzetta ('Little Piazza', to distinguish it from Piazza San Marco). Two huge granite columns were erected at the end of the Piazzetta as a form of monumental 'gate', one surmounted by the winged lion, the other by a statue of the first patron saint of the city,

San Todaro (or Teodoro; the sculpture is actually an amalgam of various Roman and Hellenistic works).

In 1277 the Zecca (mint) was moved from the Rialto to stand opposite the Palazzo Ducale, and soon after the Granai (state granaries) were built along the waterfront to the west of the Zecca, reinforcing the division between the centres of commerce around the Rialto and the buildings of state around San Marco. By around 1300 the system of government that was to persist until 1797 had also been established. The city was governed by a large nobility who each served short terms in the many offices and councils of state, headed by the Doge (Chief Magistrate), who in time became a powerless figurehead. Canaletto himself claimed descent from the noble family Da Canal, and used a coat of arms charged with a chevron as an occasional signature (nos. 73, 77, 84–5). Below the nobility was a citizen class who were eligible for membership of the *scuole*, the charitable confraternities that were an important feature of civic life. The lesser merchants and tradesmen were represented by autonomous guilds. Though the system was far from perfect (and certainly not a democracy), it gave many people a say in the running of the city. The wealth and power of the nobility were tied to trade and dependent on a flourishing economy, and despotism was in no one's best interest.

The large number of wealthy families explains one of the most striking features of Venice: its proliferation of *palazzi*, the palaces found throughout the city, especially lining the Grand Canal – these are sometimes called instead *Ca'* (for *Casa*, 'house') though there is little difference in meaning. The earliest surviving palaces, such as the thirteenth-century Palazzo Donà and Ca' da Mosto, show the basic structure that was to persist for five hundred years: a ground floor with a central chamber usually giving onto a canal, running the full depth of the building and originally functioning as a warehouse or storeroom, flanked by offices; a principal floor with a *portego* (large central hall) echoing the layout below; and smaller chambers on the upper floors. A small courtyard with a well usually lay behind the house. By the fifteenth century almost all *palazzi* (and the great brick churches of the city, such as the Frari and Santi Giovanni e Paolo, no. 38) were built in a characteristic style that fused a European gothic vocabulary with Eastern elements. It was only with the introduction of Renaissance modes by Pietro Lombardo (*c*.1435–1515) and Mauro Codussi (*c*.1440–1504) (e.g. Palazzi Vendramin-Calergi, seen in no. 4, and Corner-Spinelli, no. 32) in the late fifteenth century that Venetian buildings began to resemble, superficially at least, those in the rest of Italy.

Venice was then at the height of its power, with a population approaching a quarter of a million, though the high urban density made the city particularly susceptible to the plague, and epidemics in 1527, 1575 and 1630 carried off large proportions of the population. The sixteenth century saw the last great wave of civic building. The area around the Rialto was redeveloped following a fire in 1514, and almost all the buildings visible in no. 6, including the bridge, were constructed in the following decades. Piazza San Marco was transformed by the erection of the massive Campanile (belltower) in its present form, the building of the Procuratie Vecchie and Torre dell'Orologio (clocktower) on the north side, the beginning of the Procuratie Nuove on the south (completed 1660), and the rebuilding of San

Detail of no. 66

Geminiano by Jacopo Sansovino in the centre of the west range.

Sansovino (1486–1570) was Florentine by birth and moved to Venice after the sack of Rome in 1527. His experience as a sculptor and architect in central Italy brought the true language of the High Renaissance to Venice, seen in his designs for a succession of secular buildings: Palazzo Corner della Ca' Grande (nos. 10, 29), the Loggetta at the base of the Campanile, the Zecca, and perhaps most notably the Libreria (library), which completed the present aspect of the Piazzetta (nos. 48, 67 etc.). Sansovino was succeeded in importance late in life by another non-Venetian, Andrea Palladio of Vicenza (1508–1580), who in the two decades after 1560 designed a great sequence of churches in Venice – San Giorgio Maggiore, the Redentore, the façade of San Francesco della Vigna, and San Pietro di Castello, carried out posthumously (nos. 39–42). Palladio's rigorous approach was codified in his hugely influential treatise *Quattro libri dell'architettura*, published in 1570, which carried the style that characterised the Venetian late Renaissance all over Europe.

The stability and prosperity of Venice were partly attributable to its relative isolation from the warfare of much of Italy's history, and only three times in a thousand years was the city seriously threatened. Even though its position in the lagoon provided a natural fastness against any land army, the state realised that it could not turn its back on the mainland. Venice acquired Treviso in 1339, and from 1404 mercenary forces conducted a series of campaigns that established a *stato da terra* ('land state', as opposed to the *stato da mare*) stretching as far west as Bergamo. After the fifteenth century Venetian territory on the mainland was gradually eroded by repeated foreign invasions, and to the east its colonies fell one by one to the expanding Ottoman Empire. The most serious blow to Venice was the simultaneous development of trade routes to Asia around the coast of Africa and to the newly discovered Americas. The Mediterranean was no longer the 'centre of the world', and those countries with Atlantic ports – Spain, France, Portugal, and eventually Holland and England – grew while the states of Italy declined as world powers.

But this change in fortunes was slow, and throughout the sixteenth and seventeenth centuries Venice remained a major centre of European commerce. The noble families had built up reserves of wealth that cushioned the civic structure of Venice against this waning influence. While building on the scale of the sixteenth century was no longer possible – or even necessary, given the range of buildings then available to the state – the career of Baldassare Longhena (1596–1682) encompassed many projects that embody a distinctively Venetian version of the Baroque, such as Ca' Pesaro (no. 5) and Ca' Rezzonico (no. 31), the church of the Scalzi (no. 2), and most spectacularly the development of the eastern tip of Dorsoduro, with the new Dogana and the construction of Venice's greatest church of the seventeenth century, Santa Maria della Salute (nos. 11–12).

By Canaletto's day, however, the decline of Venice was becoming obvious. A few new churches and palaces were built, such as the neoclassical San Simeon Piccolo (no. 43) and Palazzo Grassi by Giorgio Massari, but the city seemed trapped in an outdated vision of itself. The aristocratic constitution was an anachronism, and the great

annual ceremonies of the Republic, such as the *Sposalizio del Mar* (see no. 14), were now spectacles that had lost their vital meaning. The *coup de grâce* was delivered in 1797, when the troops of Napoleon laid siege to Venice from the mainland. The impotent city succumbed without a fight, and the *Serenissima* of a thousand years was humiliated by its conquerors. The monasteries and *scuole* were suppressed and many pulled down, such as Santa Croce (no. 33) and La Certosa (no. 57). The west range of the Piazza and the Granai were demolished to make way for a palace and gardens for Napoleon. The ship of state, the Bucintoro (no. 14), was burned to recover the gold from its carvings, and much of the treasury of San Marco was melted down. The ancient symbols of the city, the bronze lion and horses of San Marco, were taken to Paris, and many paintings looted from Venice at this time, such as Paolo Veronese's great *Wedding at Cana* from San Giorgio Maggiore, remain in the Louvre to this day.

Napoleon ceded Venice and its few remaining territories to Austria, and the city remained under Habsburg rule until 1866 when Venice joined the Kingdom of Italy. Economic stagnation was relieved only by the tourist trade, boosted by the construction of a railway bridge to the mainland in 1846, followed by the road bridge in 1933. The area around Santa Lucia (no. 2) was destroyed around 1860 to enlarge the railway station, but few other major demolitions followed the Napoleonic period. The modern suburbs and industrial complexes were built on the mainland at Mestre, where transport and construction were easier. With the notable exception of the Fondaco dei Turchi (no. 4), Venice also largely escaped the nineteenth-century tendency to over-restore, and the city thus preserves essentially the appearance painted and drawn by Canaletto almost three hundred years ago.

Tourism has been both the saviour and the curse of Venice, for the economy of the city is now entirely dependent on visitors. The permanent population of Venice is barely a third of its sixteenth-century peak; it has halved even in the last fifty years, and this depopulation has had inevitable consequences for the urban fabric. But the greatest threat to the city is, ironically, the sea. The inexorable sinking of the buildings into the clay of the lagoon and rising sea levels have led to the *acqua alta* (the flooding of areas of the city at particularly high tides) becoming increasingly frequent. There is, of course, no simple solution, and it remains to be seen whether the political will exists to implement the massive engineering projects required, or whether the living city will gradually become an enormous archaeological theme park.

Canaletto's life and works

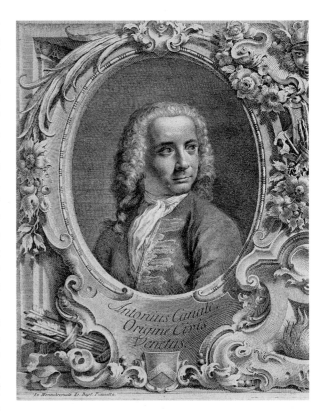

Fig. 1 Antonio Visentini, *A portrait of Canaletto*, 1735, after Giovanni Battista Piazzetta (detail). Engraving. RCIN 809031.d

Giovanni Antonio Canal was born in 1697 near the Rialto in Venice, the son of Bernardo Canal (1674–1744), a successful painter of theatrical scenery, and his nickname Canaletto, 'little Canal', was used to distinguish him from his father. As a youth Canaletto must have trained with his father, and around 1719–20 the pair were in Rome. This training would have taught Canaletto the principles of perspective and the convincing representation of architecture, though his earliest identifiable paintings – probably executed back in Venice in the early 1720s, after he had decided not to pursue his father's trade – are not the crisp works familiar from his maturity, but romantic scenes with churches and ruins lit by stormy skies, which may reflect the dramatic nature of his youthful work for the stage.

The inspiration for Canaletto's early view-paintings came from established Venetian artists such as Marco Ricci (1676–1730), who specialised in imaginary landscapes but was also a stage designer, and Luca Carlevarijs (1663–1730), who developed the idiom of the Venetian cityscape that Canaletto was soon to make his own. Carlevarijs was ailing, and from the first half of the 1720s Canaletto rapidly cornered the market in paintings of Venice for northern European tourists visiting the city. Canaletto's first contact with British patrons may have been his contribution to the

series of paintings of allegorical tombs commissioned from Venetian artists by the impresario Owen McSwiney for the 2nd Duke of Richmond; and as early as 1727 McSwiney wrote to the Duke that Canaletto 'has more work than he can do, in any reasonable time, and well'.

Around this time Canaletto was taken under the wing of Joseph Smith (c.1674–1770), who had lived in Venice as a merchant banker since around 1700. Smith also traded as a book dealer and established the Pasquali publishing house in the 1730s, and was appointed British Consul in 1744 (for Smith, see Frankfurt etc. 1989–90). He was a friend and patron of many leading artists in the city and formed an extensive collection of their works, and his *palazzo* on the Grand Canal (see no. 5) was a regular meeting point for the British nobility passing through the city. Smith's contacts and talents as a businessman thus made him the ideal agent for a young artist, and by the end of the 1720s most of Canaletto's paintings were commissioned through Smith.

Joseph Smith also collected Canaletto's works for himself. The two most important groups of paintings commissioned from the young artist for Smith's *palazzo* were six large views around San Marco and the Piazzetta (see nos. 15–20), painted in the mid-1720s, and a series of twelve smaller views on the Grand Canal (nos. 1–12), executed over several years throughout the second half of the 1720s. The association between Smith and Canaletto continued almost to the end of their lives, and by the time of the sale of Smith's collection to George III in 1762 (see below) he owned over 50 paintings and 140 drawings by the artist. The Royal Collection thus holds the finest extant group of works by Canaletto.

Canaletto's career continued to prosper during the 1730s, but the spread of the War of the Austrian Succession (1740–48) increasingly disrupted travel in Europe, and Canaletto's business suffered along with the rest of the tourist trade in Venice. Smith continued to support him, and a sequence of five large paintings of Rome, all dated 1742, and thirteen overdoor paintings, some dated 1743 or 1744, may all have been commissioned in response to Canaletto's faltering fortunes. But Canaletto eventually decided that, if his former patrons were no longer travelling to Venice, he would have to go to them. He journeyed to London, arriving in May 1746 and staying in England until at least 1755 (with a short return home in 1750–51, and perhaps another in 1753), painting the Thames and the country seats of the nobility bathed as if in the limpid sunlight of Venice.

Canaletto's last decade back in Venice may not have been as productive as his early years, and the outbreak of the Seven Years War (1756–63) must have dealt another blow to Canaletto's market. He may now have felt too old to consider leaving Venice again, but he remained active almost to the end of his life, and at the age of 68 signed and dated a lively drawing of choristers in San Marco with the proud boast that it was made 'without spectacles' (fig. 30). Canaletto died after a short illness in 1768 and was buried in the parish in which he had been baptised, San Lio.

By the time of Canaletto's death, the great collection of his works formed by Joseph Smith had already been sold. Smith's finances, like Canaletto's, suffered during the conflict of the 1740s with the collapse of banks in Germany and the Netherlands, and he was forced to consider selling some of his collection.

He first intended to dispose only of his magnificent library (including volumes of drawings), and to that end a catalogue, *Bibliotheca Smithiana*, was published in 1755. An initial approach by James Stuart Mackenzie, the younger brother of the Earl of Bute, no doubt acting on behalf of George, Prince of Wales, came to nothing. Negotiations were reopened around the time that George III ascended the throne in 1760, and in May 1762 Smith submitted a list of works to be sold, now including paintings, gems and coins. By July the King had agreed a sum of £20,000, and the following winter his librarian, Richard Dalton, travelled to Venice to oversee the packing and transport of the collection. Many of Smith's paintings were used to furnish the newly purchased Buckingham House (later Palace); his volumes of drawings and prints were placed in the Royal Library at Buckingham House, and in the 1830s were moved to Windsor Castle, where they have remained ever since.

From the start of his career Canaletto was attracted to the serial work of art. To a degree the series was necessitated by the nature of his paintings, which would have been hung by his patrons as decorative ensembles, and while some of Canaletto's large paintings were individual pieces, most of his works were produced in sets. The six paintings around San Marco, for example (see nos. 15–20), may well have been conceived to furnish a specific interior in Smith's residence, and the Grand Canal paintings (nos. 1–12) may have begun as a single work but grew to a uniform set of twelve canvases covering almost the entire canal. In 1725–6 Canaletto painted four canvases for Stefano Conti, the crucial documented works of his early career; towards the end of the 1720s, he executed at least nine small paintings on copper, commissioned through McSwiney; from the early 1730s, he produced a set of twenty-one canvases known as the 'Harvey group' (from an earlier owner); between 1731 and 1736 he painted twenty-two small and two large canvases for the Duke of Bedford, still at Woburn Abbey; and so on.

Paintings produced in series lent themselves to reproduction in engravings more readily than singletons, as in this form they were more appealing to the well-established collectors' market, both at home and abroad. A connoisseur of even the most modest means could afford to assemble a sizeable collection of prints, housed in portfolios, on the pages of albums, or bound together in slim volumes. Many later engravers produced sets of prints after Canaletto's works, and it is likely that even before Canaletto had finished his series of twelve Grand Canal canvases, Smith had engaged his artistic factotum Antonio Visentini to reproduce them in a set of engravings. These were followed a few years later by a pair of prints after Smith's two 'festival' paintings of *c*.1733–4 (nos. 13–14), and the fourteen prints were published as a set in 1735. Seven years later the engravings were reissued, with an additional twenty-four prints by Visentini after Canaletto. And in the early 1740s Canaletto produced a sequence of his own etchings which fall into two groups, thirteen large plates (two of which were divided by the artist) measuring around 30 × 43cm (12 × 17"), and seventeen smaller plates (one divided) each around 14.5 × 21cm (5¾ × 8¼"), and thus close to a quarter of a large plate.

Whereas one engraved or etched plate could

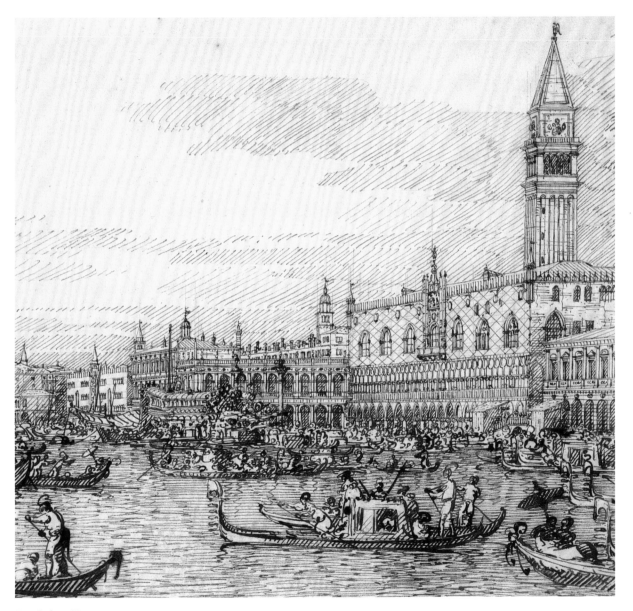

Detail of no. 28

produce hundreds of impressions, a drawing was of course unique, and the time taken to produce a drawing finished to the level of a print could rarely be justified by the price that such a drawing commanded. But the majority of Canaletto's surviving drawings are independent finished works, and not studies for his paintings. His first known drawings are a set of twenty-three small, highly finished views of Rome which may have been conceived as possible models for engraving (C/L 713; Venice 2001, nos. 1–13; though their authorship is still controversial, they must be faithful copies if not actually by the hand of the young artist).

The earliest drawings in this exhibition (nos. 15–25) form two groups that date from the mid- to late 1720s, each group characterised by a deliberate consistency of style and size. Those drawings were carried out in preparation for paintings (whether executed or not), and it seems that Canaletto began to produce finished drawings only in the first half of the 1730s. It is probable that most, if not all, of these early finished drawings were produced for (and presumably commissioned by) Joseph Smith. It has occasionally been suggested that the drawings may have been records of the paintings that passed through Smith's hands in his capacity as Canaletto's agent; but while the drawings are often related, in varying ways, to the compositions of paintings, they rarely correspond exactly, and indeed they go well beyond what would be necessary for a functional record. Moreover, Canaletto adapted the compositions of many of his drawings from a range of earlier paintings, harmonising the pictorial effects to make each set of drawings uniform, and thus emphasising their independence from those paintings.

Canaletto produced the majority of the finished sheets catalogued here in a few bursts of activity, concentrated in the years between 1734 and his departure for England in 1746. The reasons for this are hard to elucidate, and may involve a combination of personal, financial and artistic factors. He was busier in the later 1720s and early 1730s than during any other period of his life, and he may have wished to 'wind down' a little by trying his hand at some activity other than the industrial-scale production of canvases. Smith may have wanted to investigate the commercial potential of such sheets. Crucially, the first wave of finished drawings, in the mid-1730s, probably coincided with the arrival in Canaletto's studio of his nephew Bernardo Bellotto (c.1720–1780), and the drawings may have been conceived as drawing exercises for his young pupil, for many of them were meticulously copied by Bellotto in a series of sheets (now mostly at Darmstadt) that came from Bellotto's studio at the end of his life. A second wave in the 1740s – also the probable date of the etchings – may be attributable to a slackening of Canaletto's workload with the outbreak of war in Europe.

Canaletto's finished drawings are often close to one of two standard sizes, 27 × 38cm (10½ × 15″) and 19 × 27cm (7½ × 10½″), the latter simply half the former. Many of these bear a fragment of a 'Strassburg Lily' watermark, falling at the centre of a long edge of the larger drawings or a corner of the smaller. Watermarks were usually placed by the paper manufacturer in the centre of one half of the sheet; these sizes thus represent a quarter and an eighth (quarto and octavo) of a sheet of paper measuring 54 × 76cm (21 × 30″) which, allowing for a little

Detail of no. 18

trimming to tidy up the deckle edges, was the standard size of paper still known as Imperial. Strassburg Lily paper was primarily produced in the Low Countries and was of high quality, and while the mark was copied all over Europe by paper manufacturers attempting to take advantage of this reputation, it does seem that Canaletto had access to a reliable supply of imported Dutch paper even during his Venetian years.

By the time Canaletto began his career there was an established tradition of view-painting in Venice, and a few of his compositions (e.g. no. 13) derived from the canvases of his great forerunner Luca Carlevarijs. Canaletto presumably owned a 'picture library' of prints of Venice, the two most notable earlier volumes of which were the 103 plates of *Le fabriche e vedute di Venezia* by Carlevarijs himself, published in 1703, and the larger-format collection of engravings by Domenico Lovisa, *Il gran teatro delle più insigni prospettive di Venetia*, published around 1720. Both of these are surprisingly naïve in concept and inaccurate in detail, and the contrast between these engravings and the sophistication of Canaletto's drawings and paintings demonstrates that, while he may have been inspired by some of those images, most of his visual material must have been studied in great detail 'from the life'.

We are fortunate that one of Canaletto's sketchbooks survives, now in the Accademia in Venice, without which our understanding of his working methods would be immeasurably poorer (Nepi Scirè 1997; referred to simply as the 'Sketchbook' throughout this catalogue). This sketchbook contains 74 leaves measuring 17 × 23cm (6¾ × 9″), nearly every one of which bears a compositional study or an outline drawing of the buildings of Venice. Many comprise panoramic sequences of studies from a single viewpoint, covering up to six consecutive openings, sketched in pencil and reinforced in pen. These must have been done on the spot, to be assembled by Canaletto in his studio into a complete composition (see nos. 26, 29–34, 36, 43, 63). It remains questionable whether these outline studies contain enough detail to have allowed Canaletto to produce his perspectivelly and architecturally accurate paintings, or whether there existed another type of architectural survey drawing that has disappeared without trace. It is likely that Canaletto possessed detailed studies of the handful of buildings that appear endlessly in his compositions, such as San Marco or the Libreria; but the *palazzi* on the Grand Canal, less well known to the tourist (and indeed to the average Venetian), allowed a degree of improvisation around an outline study that captured the basic structure of each façade.

A continual point of debate has been the role in Canaletto's practice of the *camera obscura*, a portable light-box that projected an image of the scene at the back of a darkened chamber. While it does seem probable that Canaletto at least experimented with a *camera obscura*, the many outline studies that give the impression of having been traced around a projected image may simply be explained by Canaletto's lack of concern for shading in these studies. The scale of the drawing on each opening of the Sketchbook is consistent, but the scale usually varied on successive openings to make the most

Detail of no. 85

efficient use of the space available. For example, in a study of San Simeon Piccolo (see no. 43), a portion of the dome that would not fit on the page as part of the principal drawing was drawn elsewhere on the page on exactly the same scale; this was adduced by Bomford and Finaldi (1998, p. 25) as evidence that a *camera* had been used. But the façade of the church was divided between that opening of the Sketchbook and the next, and those two studies are *not* on the same scale. A *camera* was an inflexible instrument, and such changes in scale were very difficult to effect. Canaletto was plainly capable of making an accurate and informative study from the life with no aid from optical instruments. It may be observed that ff. 10v–34r of the Sketchbook, used to construct the Grand Canal series of drawings (nos. 29–34), must have been made from a boat, and an image projected in a *camera obscura* would have been continually moving around and impossible to trace.

Any optical system of projection of a three-dimensional subject onto a two-dimensional surface – including an eye and a modern photographic camera – entails distortion, and thus there is no 'correct' mode of depiction in a drawing or painting. That is not to say, of course, that all pictorial representations are equally true (or untrue) to life, and Canaletto's works do fall into two general categories: those views that largely reflect reality, and the *capricci* (nos. 67–85) that display overt distortions of space or setting. Within the former category, however, Canaletto manipulated his subject matter with varying degrees of subtlety to 'improve' the composition. The liberties that Canaletto took are not inaccuracies in the sense of errors. For example, the inconsistent levels of the principal windows on the south front of the Palazzo Ducale (the two to the right lower than the four to the left) are often regularised in his works. The columns in the Piazzetta were moved around at will to satisfy the requirements of a composition. The Campanile, San Marco and the Palazzo Ducale were more often than not depicted with their proportions significantly altered. Canaletto moved buildings around with respect to each other, he opened out and condensed perspectives, and he eliminated uninteresting groups of buildings. The following catalogue often notes these alterations, not from a spirit of pedantry, but because it is there that Canaletto reveals himself as an idealising artist, and not simply a painter of the most beautiful city in the world.

Catalogue

In measurements, height precedes width. All drawings are on white paper.

Canaletto's sketchbook in the Accademia, Venice, is referred to simply as the Sketchbook (see Nepi Scirè 1997). In general, the nomenclature of the Touring Club Italiano's guide to Venice (3rd edn, Milan, 1985) has been followed, usually avoiding Venetian dialect and using the modern names of the *palazzi*, many of which have changed repeatedly over the centuries and are now unwieldy concatenations of the names of noble families.

The following abbreviations are used throughout for the standard catalogues of Canaletto's and Bellotto's works:

C/L
W.G. Constable and J.G. Links, *Canaletto. Giovanni Antonio Canal, 1697–1768*, 2nd edn, Oxford, 1989

K.
S. Kozakiewicz, *Bernardo Bellotto*, 2 vols, London, 1972

P.
K.T. Parker, *The Drawings of Antonio Canaletto in the Collection of His Majesty The King at Windsor Castle*, Oxford and London, 1948 (reprinted with an appendix by C. Crawley, Bologna, 1990)

Levey
M. Levey, *The Pictures in the Collection of Her Majesty The Queen. The Later Italian Pictures*, 2nd edn, Cambridge, 1991

The Grand Canal paintings

On 17 July 1730, Joseph Smith wrote to a collector, Samuel Hill, in England, to tell him: 'The prints of the views and pictures of Venice will now soon be finish'd. I've told you there is only a limited number to be drawn off, so if you want any for friends, speak in time.' Smith must have been referring to the set of engravings by Antonio Visentini that was published by Smith's Pasquali Press in 1735 with the title *Prospectus Magni Canalis Venetiarum, addito Certamine Nautico et Nundinis Venetis*, 'The Prospect of the Grand Canal of Venice, with the addition of the Nautical Contest and Venetian Market'. The title page was followed by an engraving with the portraits of Canaletto (see p. 14) and Visentini, then fourteen engravings after nos. 1–14 here. The engravings were subsequently reissued in 1742, with an additional twenty-four plates, and again in editions of 1751 and 1833.

The paintings by Canaletto engraved by Visentini comprise a set of twelve views on the Grand Canal (nos. 1–12), each measuring about 47 × 78cm (18½ × 31″) together with two larger paintings of festivals (nos. 13–14), each 77 × 125cm (30 × 50″). The twelve smaller paintings take in almost the whole of the Grand Canal, omitting only a small stretch between the Scalzi and San Geremia. Most of the views encompass a wide angle of around 90°, and Canaletto manipulated these spaces to improve the compositions. Some broad stretches of canal were narrowed (nos. 2, 7), and conversely the areas around the bends of the canal were opened out (nos. 5, 8). Inconsequential buildings in the middle distance could be eliminated to bring more interesting churches and palaces beyond closer to the viewer (nos. 2, 11), and curves of the bank were straightened to allow more buildings to be seen (nos. 4, 8). Canaletto routinely shaded the sides of sunlit façades, or conversely lit the sides of shaded façades, to break up the visual effect of chains of palaces proceeding in monotonous foreshortening into the distance. Unlike the Grand Canal drawings (nos. 29–34), none of Smith's Grand Canal paintings is dependent on the studies in Canaletto's Sketchbook in the Accademia (probably begun around 1730), and in fact no preparatory drawings are known for the smaller paintings (nos. 1–12). We therefore have few insights into the way in which Canaletto created these compositions.

Background detail taken from *The Canale di Santa Chiara looking north towards the lagoon* (no. 1)

Though vague in its details, Smith's letter of 1730 makes clear that the project was then well under way, and most of the paintings must have been finished (and impressions of the engravings probably available) several years before the formal publication of the prints in 1735. Canaletto may have taken some time over the production of the paintings, for this was the busiest period of his whole career, and he had many canvases in production concurrently. There is general agreement that the Grand Canal paintings date from the mid-1720s to around 1730, but dating the individual paintings precisely is difficult. Nevertheless the rough order in which the paintings were executed may be established, showing a continual exploration of new ways, both technical and stylistic, to record the substance and light of Venice.

The earliest painting of the series must be the view towards Santa Chiara of the early to mid-1720s (no. 1). At this date Canaletto used an underpaint of different colours to block out the sky, water and buildings, over the red-brown priming. During the 1720s he gradually simplified this technique; by the end of the decade he was using an underpaint of a single light shade of grey or buff, and the tonality of the paintings thus became increasingly pale. Canaletto also modified his technique of adding small accents in black at the last stage of the painting; in nos. 11–12, especially, he used instead a range of grey tones, enhancing the atmospheric recession from the foreground to the slightly hazy horizon. A comparison of the style of the paintings is complicated by the probability that Canaletto completely repainted the sky and possibly the water in a few cases, presumably to harmonise the effects of the group when seen as a whole (see Venice 2001, p. 179). The two larger festival paintings (nos. 13–14) date from around 1733–4, several years after the probable completion of the first twelve views, and they may have been considered part of the series only for the purposes of Visentini's engravings.

It is doubtful that when the first canvas was painted Canaletto envisaged a set of twelve paintings. Perhaps Smith commissioned the continuing series of views around 1725 (having first purchased that one canvas) and then engaged Visentini to produce engravings after them, no doubt with Canaletto's agreement. The order of the engravings as published is puzzling, starting at the Rialto and heading downstream to Santa Maria della Salute, then returning to the Rialto to travel upstream to Santa Chiara. It is very doubtful that this reflects the order in which the paintings were conceived or executed; the order of the later Grand Canal series of drawings (nos. 29–34), as revealed by their preparatory studies in the Sketchbook, is sequential along the canal. The present catalogue simply follows the Grand Canal from its upper reaches at Santa Chiara down to the Salute, before finishing, like Visentini, with the two festival pieces.

1 The Canale di Santa
Chiara looking
north towards the
lagoon, *c*.1723–4

1 The Canale di Santa Chiara looking north towards the lagoon

c.1723–4

At its far north-west, the Grand Canal makes a final sharp turn to pass the island of Santa Chiara before opening onto the lagoon. The view is taken looking north-west from the Fondamenta della Croce; two drawings (nos. 34, 46) show the same stretch of canal from the opposite end. To the left are the shadowed façades of the buildings lining the Fondamenta di Santa Chiara, leading to the convent of the same name across its side canal. At the right is the wall of the convent of Corpus Domini, with houses at the far west of Cannaregio beyond, the island of San Secondo in the distance, and the hills of the mainland suggested along the horizon.

The three buildings at far left survive, but a low nineteenth-century office building now occupies the rest of the Fondamenta, and one of the *vaporetto* (water bus) stops serving the Piazzale Roma car park stands in the left foreground. Both Santa Chiara and Corpus Domini were suppressed in the Napoleonic period. Santa Chiara is now a military hospital, and Corpus Domini was one of the many buildings demolished around 1860 to make way for the railway station, whose sidings sit on reclaimed land (incorporating San Secondo) across the right of the view.

On grounds of style and technique, the painting must be the earliest of Smith's Grand Canal views. Canaletto prepared his canvas with a reddish-brown ground, over which he laid an underpaint of a range of colours for different areas of the painting: a graduated grey for the sky, dark grey for the water, and orange-brown for the buildings, which can clearly be seen in places. This technical feature, which is not found in the other Grand Canal paintings, is shared with the sequence of large paintings around San Marco (see nos. 15–20), along with the dramatic quality of light, the bold handling of paint, and the relatively large size of the foreground figures. Recently Kowalczyk (see Venice 2001) argued for a still earlier date, *c.*1722–3, partly in consequence of a general redating of Canaletto's first paintings.

The painting is unique in the Grand Canal series in the interest accorded to the foreground figures. The building second from the left, marked by a round sign on its balcony (also visible in no. 34), was the residence of the British Secretary-Resident, and the man gesturing prominently at lower left, who from his dress cannot be Venetian, has been cautiously identified as Colonel Elizaeus Burges, the Secretary from 1719 to 1722 and from 1728 until his death in 1736 (and thus not the Secretary at the time that this painting was probably executed). A version of the painting with the Fondamenta in bright sunlight (private collection; C/L 269) shows an important personage being received from a gondola outside that building.

Oil on canvas, 46.7 × 77.9cm (18⅜ × 30¹¹⁄₁₆″)
RCIN 401403. Levey 395; C/L 270; Visentini 1735, no. XII; Toronto etc. 1964–5, no. 13; London 1980–81, no. 18; Corboz 1985, no. P196; Venice 2001, no. 66

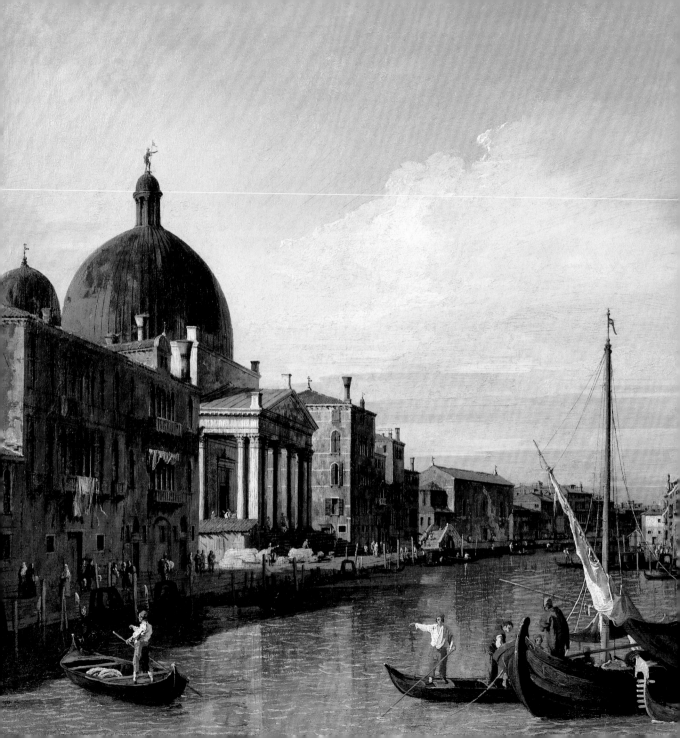

2 The Grand Canal
looking west
with the Scalzi
and San Simeon
Piccolo, *c*.1726–7

2 The Grand Canal looking west with the Scalzi and San Simeon Piccolo

c.1726–7

The view is now interrupted by the bridge before the railway station, the Ponte degli Scalzi, first built in 1858, which would span the immediate foreground of the painting. To the right is the church of Santa Maria di Nazareth, always known as the Scalzi (literally 'shoeless'), as it was the church of the barefoot Carmelites, built after 1654 to the plans of Longhena, with a baroque façade added by Giuseppe Sardi after 1672. Canaletto has captured the general layout of the façade but many of the details are inaccurate, especially the gesturing statues that bear no resemblance to those on the church. The buildings beyond, including the church of Santa Lucia, were demolished in 1861 to make way for the railway station.

In the left distance is the pitched-roof church of Santa Croce, whose façade is seen in no. 33. To the left is San Simeon Piccolo (see no. 43), and at far left are Palazzo Foscari-Contarini and Casa Adoldo, the latter with a gothic façade (the correct Renaissance windows are seen in no. 43). Blocks of stone still lie before San Simeon, under construction from 1718 and consecrated in 1738.

A painting of the later 1730s in the National Gallery (C/L 259) of the same view from a little further back shows the church fully finished, with the stones cleared away and steps cut in the quay.

Canaletto has condensed the composition by halving the number of buildings between San Simeon and Santa Croce to bring the distant buildings closer to the viewer, and by narrowing the Grand Canal. It is clear that the two sides of the composition were studied separately, and in fact they seem mismatched, with the right half sitting at a lower level than the left half. The sky was apparently repainted by Canaletto at a later date, presumably towards the end of his work on the series of Grand Canal paintings. X-rays have revealed that the sky originally had the more dramatic cloud formations seen in the corresponding Visentini engraving.

Oil on canvas, 47.3 × 79.4cm (18⅝ × 31¼")
RCIN 407267. Levey 394; C/L 258; Visentini 1735, no. XI;
London 1980–81, no. 17; Corboz 1985, no. P91;
Bomford and Finaldi 1998, pp. 20–23

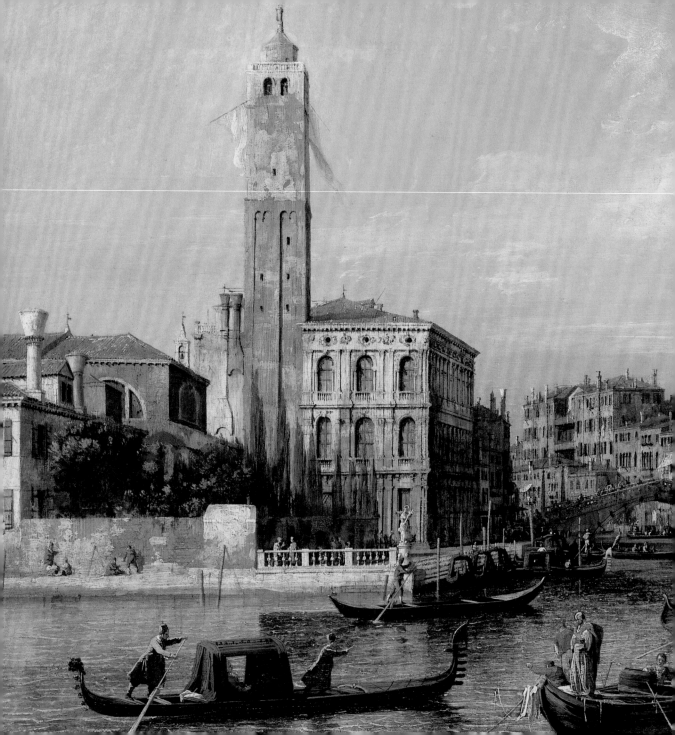

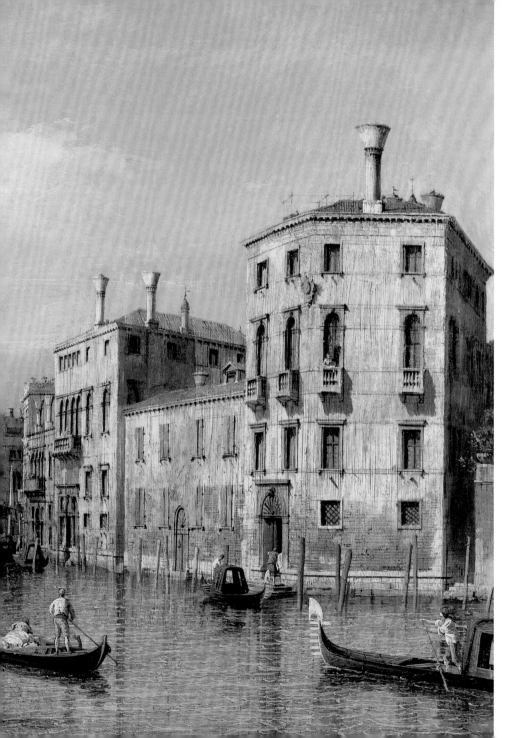

3 San Geremia and
the entrance to
the Cannaregio
*c.*1726–7

3 San Geremia and the entrance to the Cannaregio
c.1726–7

At the centre of the composition is the mouth of the canal of Cannaregio, heading north-west from the Grand Canal towards the lagoon, and at that time the principal route from central Venice to the mainland. The canal is spanned by the sixteenth-century Ponte delle Guglie ('of the obelisks'), painted excessively large to hold the centre of the composition. To the left is the rear of the church of San Geremia with its thirteenth-century belltower, more slender than in reality. The belltower survives, but the church was rebuilt in 1753–60 by Carlo Corbellini and its clumsy mass now dominates the waterfront. Abutting the belltower is Palazzo Labia, built over several decades from the mid-seventeenth century. The buildings on the right are 'opened out', as if from a point on the Riva di Biasio to the left of the principal view (fig. 2).

The composition corresponds in most details with the drawing below (no. 45), dated 16 July 1734, which is however not a study for this painting but a later derivation. The most significant difference is the building second from the right: here it is a humble two-storey brick building; in the drawing it has been transformed into the modern three-storey, five-bay Palazzo Emo.

The painting was altered in later years by Canaletto, who added the balustrade on the waterfront, with a statue of St John of Nepomuk by Giovanni Marchiori (1696–1778) at the corner. According to an inscription on the base of the extant statue, it was erected in 1742; Visentini's engraving was similarly reworked for the second edition of the *Prospectus*, published in the same year, and it is thus likely that Canaletto's alteration to the painting was carried out almost as soon as the balustrade and statue were erected. Why he or Smith should have been so keen to make this alteration is unknown, as they evidently felt no need to 'update' Palazzo Emo. The only comparable instance is the transformation of the façade of Smith's own *palazzo*, reworked in no. 5, and perhaps Smith had some involvement in the commissioning of Marchiori's statue.

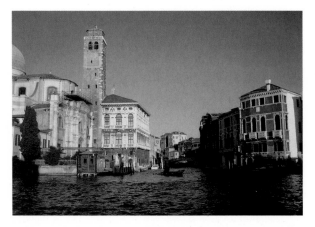

Fig. 2 *San Geremia and the entrance to the Cannaregio*, 2005

Oil on canvas, 47.0 × 78.7cm (18½ × 31˝)
RCIN 400532. Levey 393; C/L 251; Visentini 1735, no. X;
Potterton 1978; London 1980–81, no. 16; Corboz 1985, no. P198

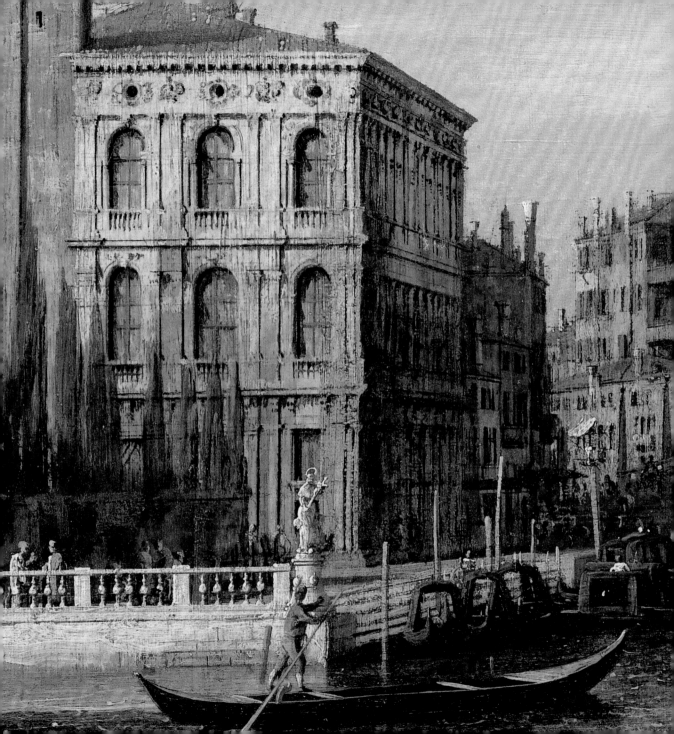

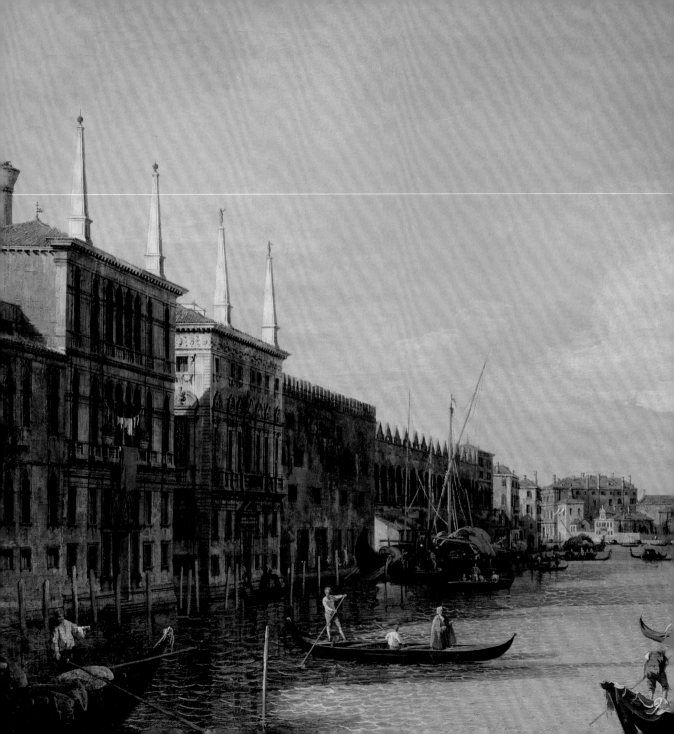

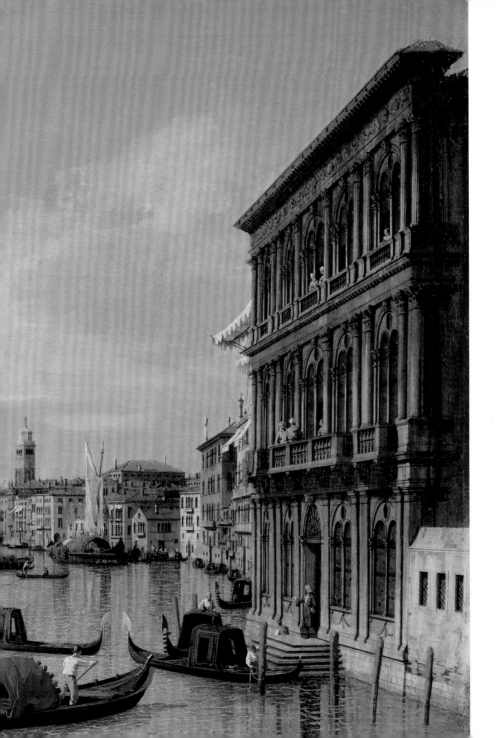

4 The Grand Canal
looking west from
Palazzo Vendramin-
Calergi towards
San Geremia
*c.*1727–8

4 The Grand Canal looking west from Palazzo Vendramin-Calergi towards San Geremia

c.1727–8

To the right is the imposing Renaissance façade of Palazzo Vendramin-Calergi, commissioned in 1481 from Mauro Codussi. Canaletto erroneously added a balustrade to the second floor, and depicted two arched windows either side of the door opening onto the canal – there should be just one either side, flanked by a rectangular window (Canaletto drew the palace correctly in the Sketchbook, f. 48r). In the distance is the tower of San Geremia, correctly proportioned but with three rather than two openings on each side of the bell-storey, and without its flags. Canaletto rendered the pitched-roof church itself very inaccurately – whether deliberately or not – with the windows completely at odds with those shown in the previous painting. Visentini corrected these inaccuracies,

and those in the façade of Palazzo Vendramin-Calergi, in his engraving after the painting.

From the left, in shadow, are Ca' Tron and Palazzo Belloni-Battagia; only the latter, by Longhena, retains the obelisks on its roof. Beyond is the brick façade of the fifteenth-century granaries, the Deposito del Megio (i.e. *miglio*, millet), followed by the Fondaco dei Turchi, built in the twelfth or thirteenth century, the offices and warehouse of the Turkish traders between 1621 and 1838, and one of the finest Byzantine buildings in Venice. In 1858 it was acquired by the state and essentially destroyed in a complete 'restoration'; it is now the Natural History Museum. The Deposito should be significantly stepped back from Palazzo Belloni-Battagia, and the canal should curve gently to the left here. Canaletto has therefore flattened and straightened the left bank to show the Deposito and Fondaco, which would otherwise be half-hidden and extremely foreshortened, and the two sunlit buildings beyond would not be visible at all (fig. 3).

Oil on canvas, 47.3 × 79.4cm (18⅝ × 31¼")
RCIN 406982. Levey 392; C/L 250; Visentini 1735, no. IX;
London 1980–81, no. 15; Corboz 1985, no. P90;
New York 1989–90, no. 42

Fig. 3 *The Grand Canal looking west from Palazzo Vendramin-Calergi*, 2005

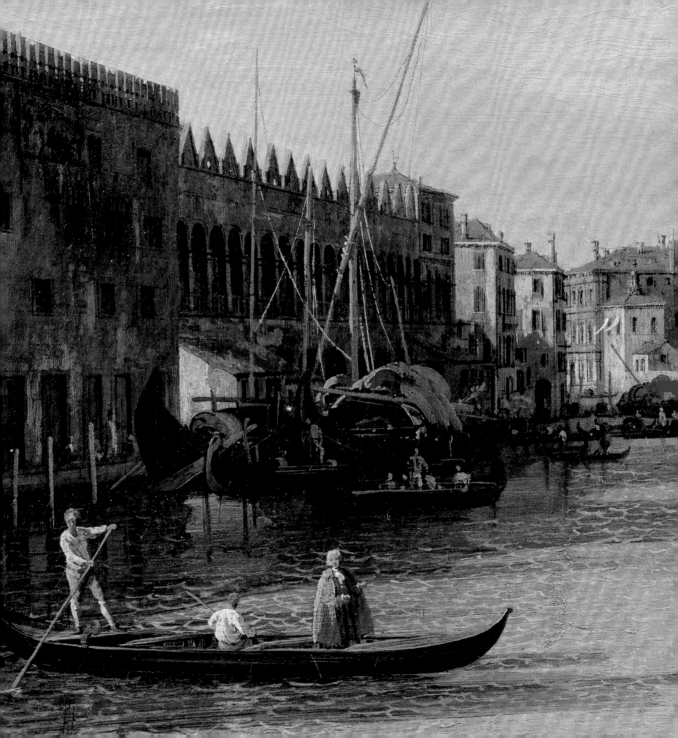

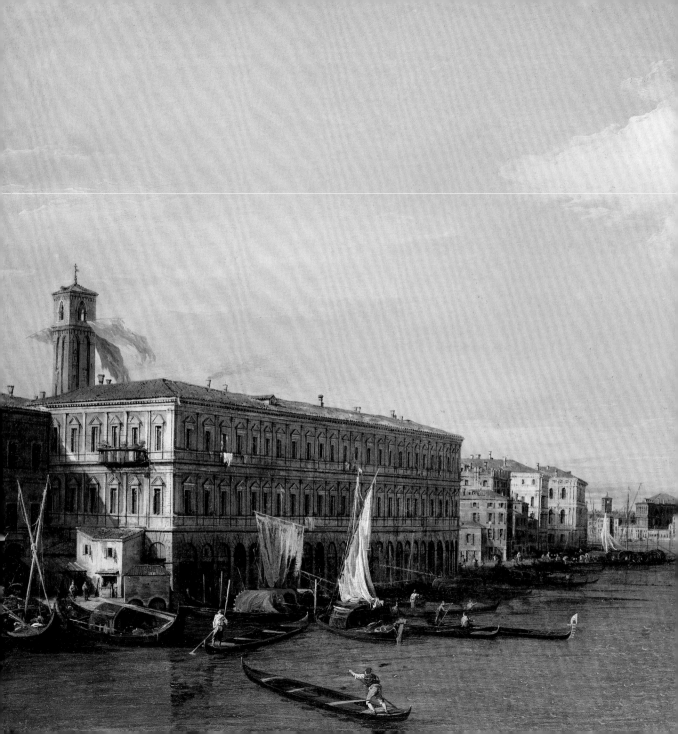

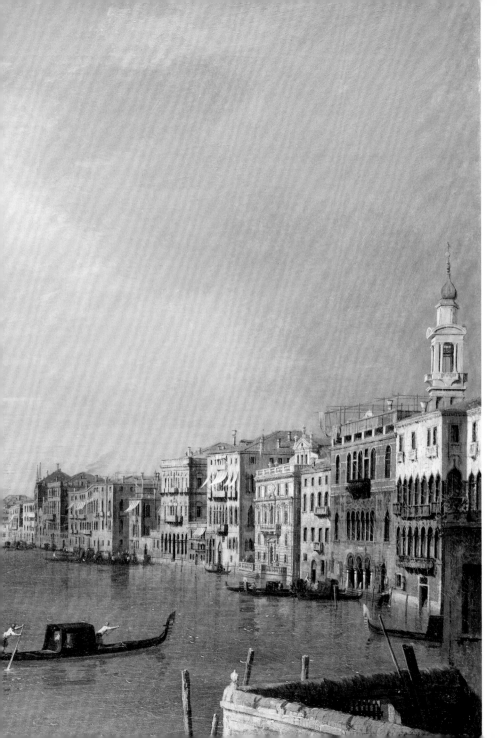

5 The Grand Canal
 looking north-west
 from near the
 Rialto, *c*.1726–7

5 The Grand Canal looking north-west from near the Rialto

*c.*1726–7

The view appears to be taken from somewhere just north of the Rialto bridge, though Canaletto has dramatically widened the vista to include more of both banks of the canal than is visible from a single point. To the left are the extensive Fabbriche Nuove, built to the designs of Sansovino in 1554–6 for the administrators of commerce, as a continuation of the Fabbriche Vecchie of thirty years earlier (see no. 6). Beyond a group of low buildings are the sides of Ca' Corner della Regina, begun in 1724 and here apparently finished (though Canaletto may have 'completed' the building in the painting), and Longhena's Ca' Pesaro.

Along the right bank run a chain of palaces. At far right is the gothic Palazzo Dolfin, followed by the ochre Ca' da Mosto, in Canaletto's day the most famous hotel in Venice (as the Albergo del Leon Bianco). The lower two storeys date from the twelfth or thirteenth century, though the building was remodelled many times, and it appears from the scaffolding on the roof that the fourth floor may have been in the course of construction when Canaletto made his painting.

Two buildings further along is Palazzo Mangilli-Valmarana, the residence of Joseph Smith. After renting the palace for many years, Smith was finally able to purchase it from the Balbi family in 1740, and he commissioned Visentini to renovate and redesign the structure, adding a Palladian façade. After work was completed in 1751, Smith evidently asked Canaletto (presumably on his return from London in 1755) to repaint this detail of the painting, and the thicker paint with deep incisions is clearly visible. The original form of the palace is seen in Visentini's engraving of the painting (fig. 4), which was not reworked for the 1751 edition of the *Prospectus*.

In the distance is Palazzo Vendramin-Calergi (shown in the previous painting) and the belltower of San Marcuola, demolished in the rebuilding of the ancient church in 1728–36. At far left is the belltower of San Cassiano, and at far right that of Santi Apostoli; in fact neither should be visible, each being further to the left and right respectively. Joseph Smith's only child, his son John (1721–*c*.1727), was buried in Santi Apostoli, where his commemorative tablet may still be seen. (Smith himself was buried in the Protestant cemetery on the Lido, with a commemorative slab in the English church of San Giorgio.)

Fig. 4
Antonio Visentini
The Grand Canal looking north-west from near the Rialto
1735, after Canaletto (detail showing Palazzo Mangilli-Valmarana, third from right, before restructuring).
Engraving.
RCIN 809031.l

Oil on canvas, 47.6 × 80.0cm (18¾ × 31½")
RCIN 406017. Levey 391; C/L 233; Visentini 1735, no. VIII;
London 1980–81, no. 14; Corboz 1985, no. P89;
New York 1989–90, no. 41; Venice 2001, no. 68

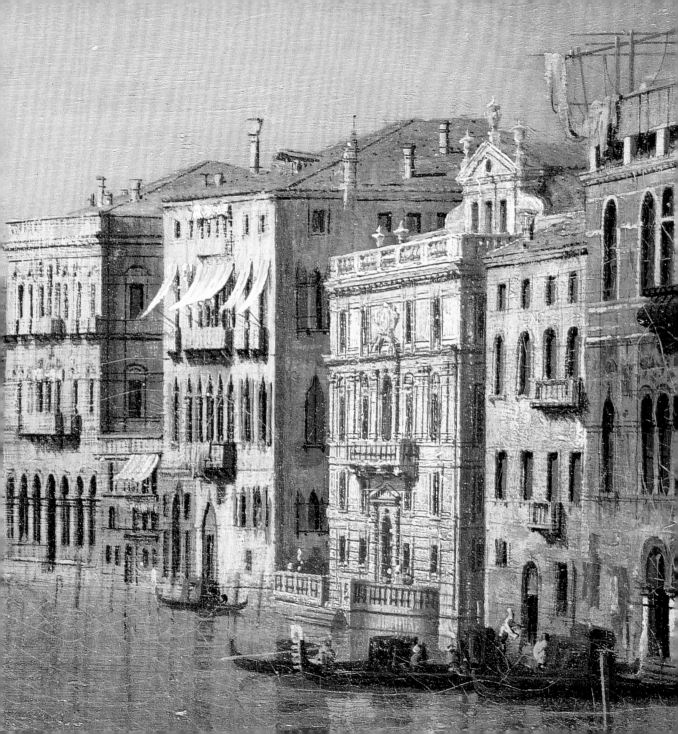

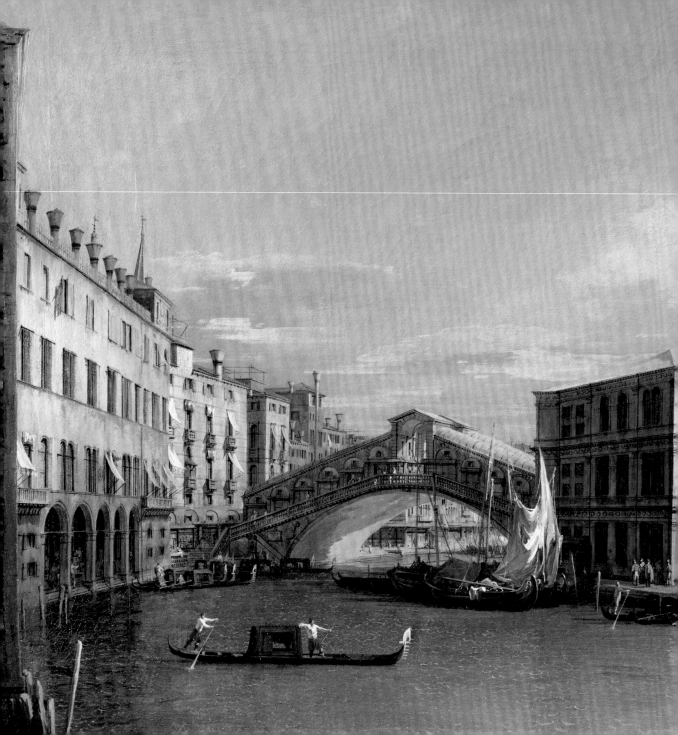

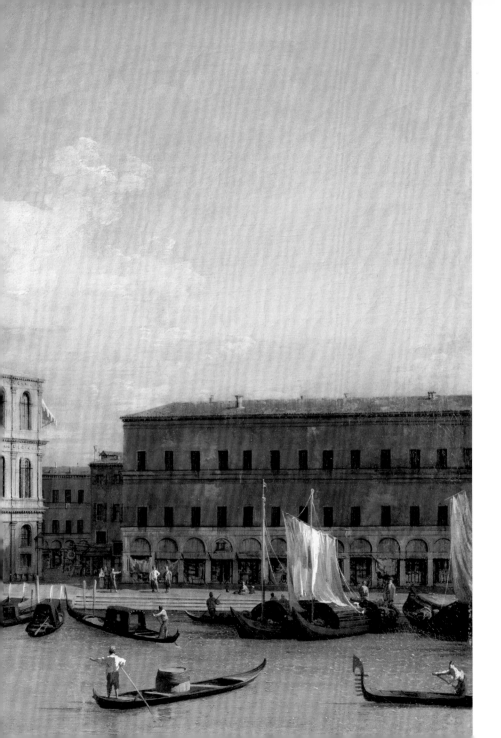

6 The Rialto bridge
 from the north
 c.1726–7

6 The Rialto bridge from the north
c.1726–7

The painting records the view from roughly the same point (or range of points) as no. 5, but looks in the opposite direction to take in an assemblage of sixteenth-century buildings. The Rialto, at the centre of the natural archipelago, was one of the first areas of Venice to be settled, and has always been the commercial centre of the city. The bridge there, first constructed in wood possibly in the twelfth century, was the only crossing of the Grand Canal until the Accademia and Scalzi bridges were built in the 1850s. The present bridge was built around 1590, an impressive stone structure with a single span of 28 metres (92 feet) incorporating two rows of workshops.

The corner of what is probably Palazzo Civran runs down the left edge of the painting. The early sixteenth-century Fondaco dei Tedeschi, the offices and warehouse of the German traders (now the city post office), is seen obliquely, with the belltower spire of San Bartolomeo just poking above the roof-line. The presence of the Fondaco dei Tedeschi at the heart of Venice's commercial district emphasises the importance of the German trading community in the city. To the right of the bridge is the Palazzo dei Camerlenghi, the seat of the financial officers of the Republic, reconstructed in the 1520s in a restrained Renaissance style on an old five-sided plan that Canaletto has disguised here. Further right are the Fabbriche Vecchie, the block of offices and workshops also built in the 1520s; Canaletto misrepresented their proportions, for the ground-floor arcade should occupy half the height of the building.

There is no one viewpoint that encompasses all these crowded buildings, and Canaletto has opened out the topography to give an impression of space (fig. 5). The bridge has been moved to the left to show most of its width; the short, sunlit façade of the Palazzo dei Camerlenghi actually lies almost flush with the front of the Fabbriche, and Canaletto turned the Palazzo through almost 90° to create a square on the bank of the canal. The composition is close to that of one of a pair of canvases painted in 1725 (C/L 234; New York 1989–90, no. 8), and he executed versions of the composition many times over the next two decades (C/L 234–9).

Oil on canvas, 47.6 × 80.0cm (18¾ × 31½")
RCIN 400668. Levey 390; C/L 236; Visentini 1735, no. VII; London 1980–81, no. 13; Corboz 1985, no. P88

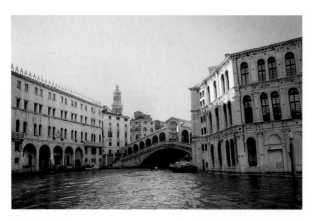

Fig. 5 *The Rialto Bridge from the north*, 2005

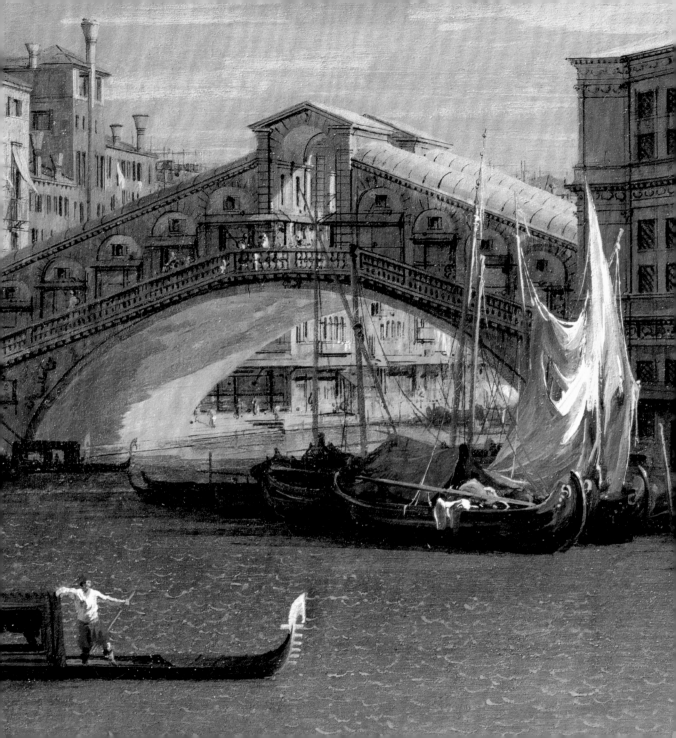

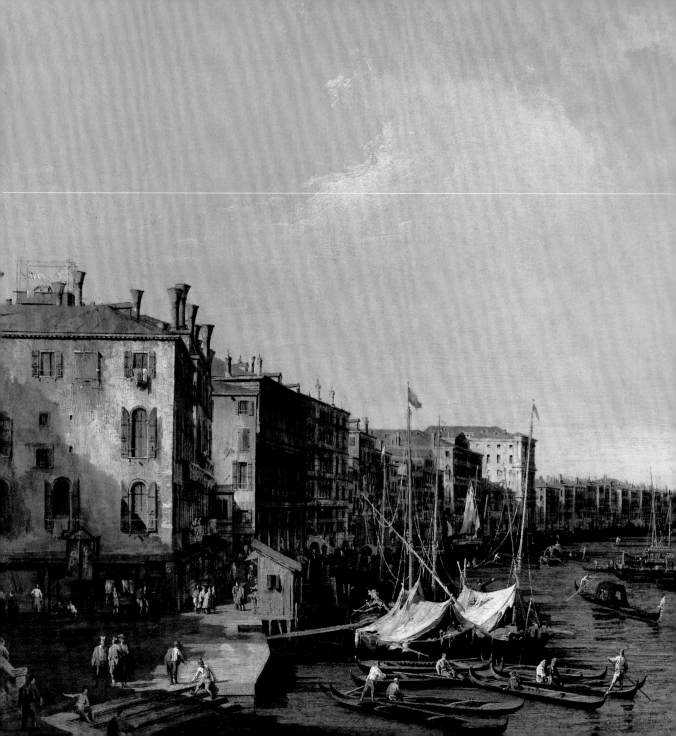

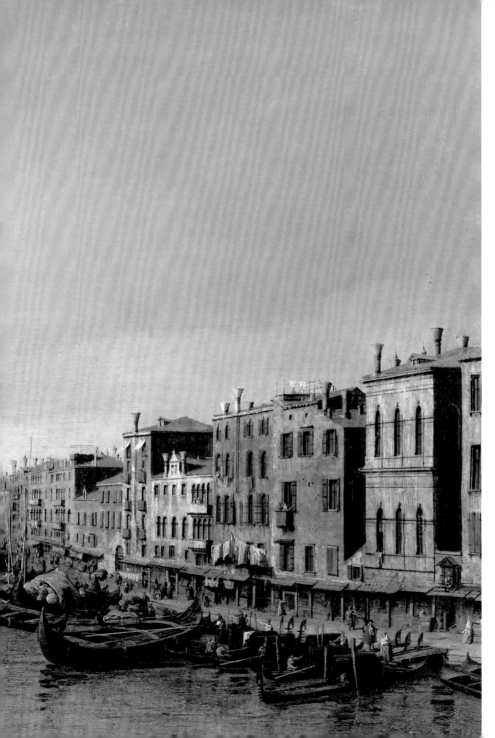

7 The Grand Canal
 looking south-west
 from the Rialto
 to Ca' Foscari
 *c.*1725–6

7 The Grand Canal looking south-west from the Rialto to Ca' Foscari

c.1725–6

The central stretch of the Grand Canal is shown, looking south-west from the left side of the Rialto bridge, about ten steps up from Campo San Bartolomeo – Canaletto painted the lateral steps approaching the bridge at the far bottom left of the composition to indicate the vantage point. After the Campo come the Riva di Ferro, the Ponte della Pescaria and the Riva di Carbon (the area was traditionally the home of the iron workshops and charcoal burners). On the quayside is a wooden hut, possibly for the sale of lottery tickets. The left bank of the canal beyond is dominated by the massive sixteenth-century Palazzo Grimani. In the far distance is the façade of Ca' Foscari, as the canal turns sharply to the left.

Much of the right bank, beyond the shops of the Fondamenta del Vin, is hidden from view by the slight curve of the canal. Whereas in the previous painting Canaletto opened out the spaces, here he has narrowed the canal, leaving only a narrow channel between the many commercial vessels moored either side (fig. 6).

The painting is richer in tone and more dramatic in lighting than most of the Grand Canal series, and is probably one of the earlier paintings in the group. It must have been painted several years before a significantly weaker version now in Houston (C/L 220), which was finished by 22 August 1730 when payment was sent to Canaletto through Smith.

Oil on canvas, 47.0 × 79.1cm (18½ × 31⅛")
RCIN 406890. Levey 384; C/L 219; Visentini 1735, no. I;
London 1980–81, no. 7; Corboz 1985, no. P84;
New York 1989–90, no. 39; Venice 2001, no. 67

Fig. 6 *The Grand Canal looking south-west from the Rialto*, 2005

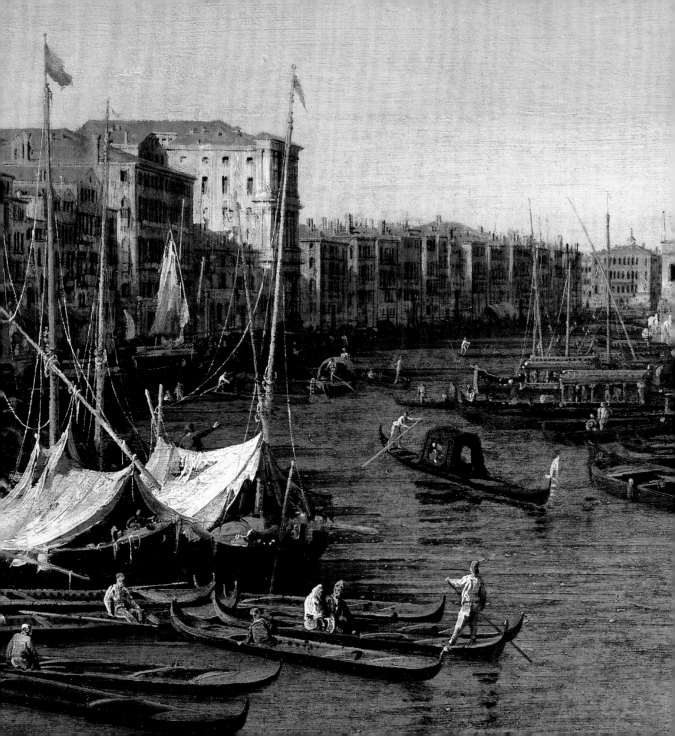

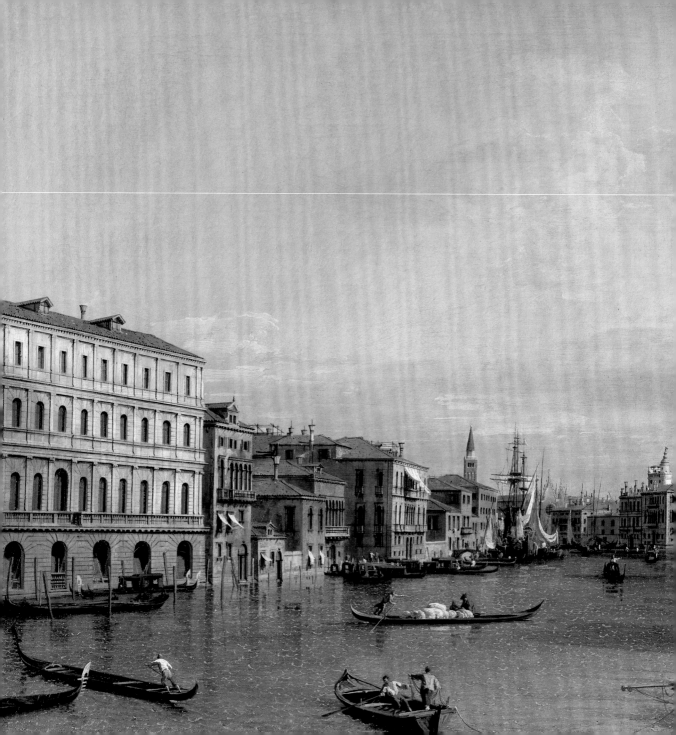

8 The Grand Canal
 looking south from
 Ca' Foscari to the
 Carità, *c*.1726–7

8 The Grand Canal looking south from Ca' Foscari to the Carità

*c.*1726–7

Ca' Foscari, seen in the distance in no. 7, here occupies the right foreground: we are looking south from the Volta del Canal, in front of Palazzo Balbi, thus taking in the same stretch of canal as the drawing, no. 31, from the opposite direction. Beyond Ca' Foscari are Palazzo Giustinian and Palazzo Nani, followed by Ca' Rezzonico with its temporary pitched roof. Then comes the tower of Palazzo Contarini degli Scrigni (also seen in no. 30), and the façade and belltower of Santa Maria della Carità, either side of the rigging of a tall ship.

To the left, brightly lit, is the austere Tuscan-style façade of Palazzo Moro-Lin (of unusual width and known as *dalle tredici finestre*, 'of the thirteen windows'), built in 1671–3 by the Florentine Sebastiano Mazzoni for the painter Pietro Liberi. Next to it are the low buildings of Campo San Samuele (now occupied by Palazzo Grassi), and Palazzo Malipiero with a large white awning.

Canaletto has significantly widened the canal and has straightened the left bank. A corresponding sketch of the buildings from Ca' Rezzonico to the Carità is in a private collection (C/L 587), apparently a sheet from a sketchbook. Levey deduced from the two statues visible on the right-hand pinnacles of the Carità, neither of which is present in the following painting, that this was one of the earliest compositions in the Grand Canal series. Canaletto was often scrupulous in recording changes in the details of a building, but he would also take liberties to create his own compositions, and the evidence of the statues should be treated with caution.

Oil on canvas, 49.9 × 80.3cm (19⅝ × 31⅝")
RCIN 401404. Levey 385; C/L 203; Visentini 1735, no. II;
London 1980–81, no. 8; Corboz 1985, no. P86

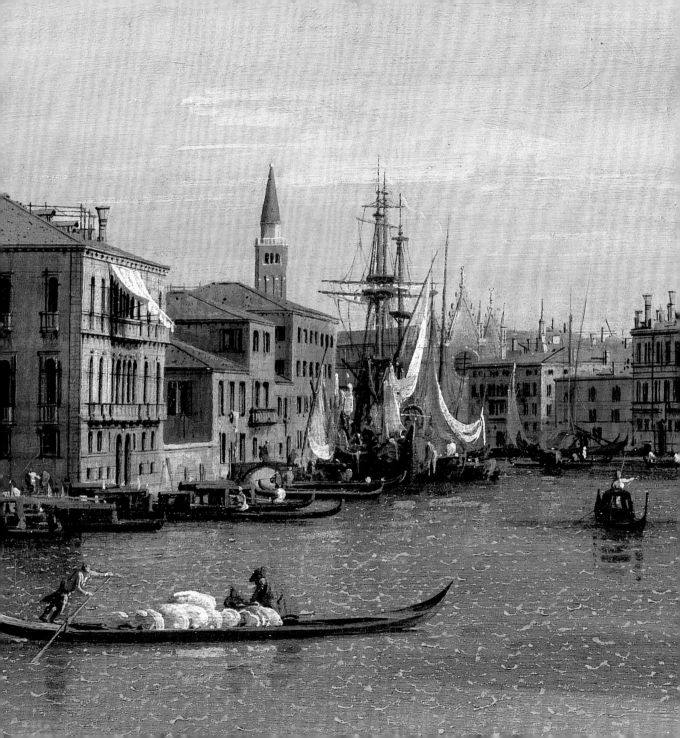

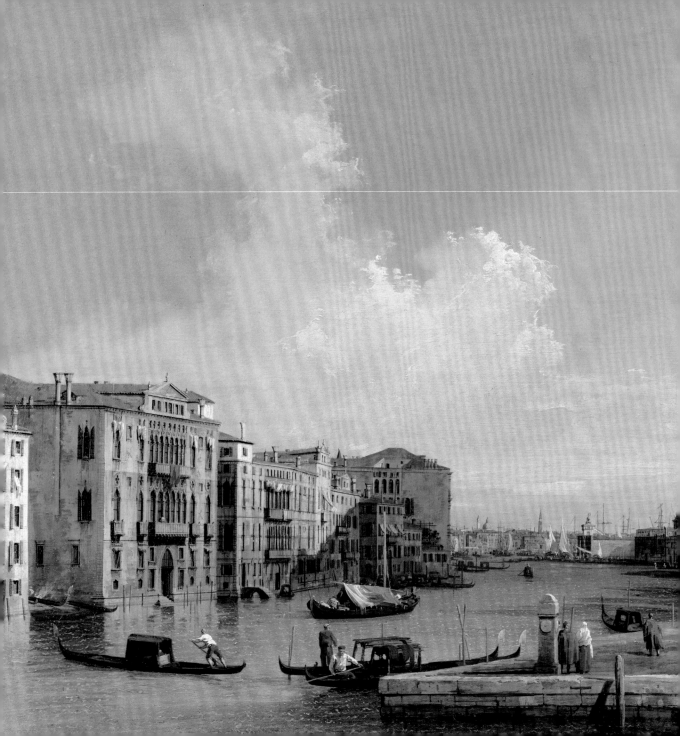

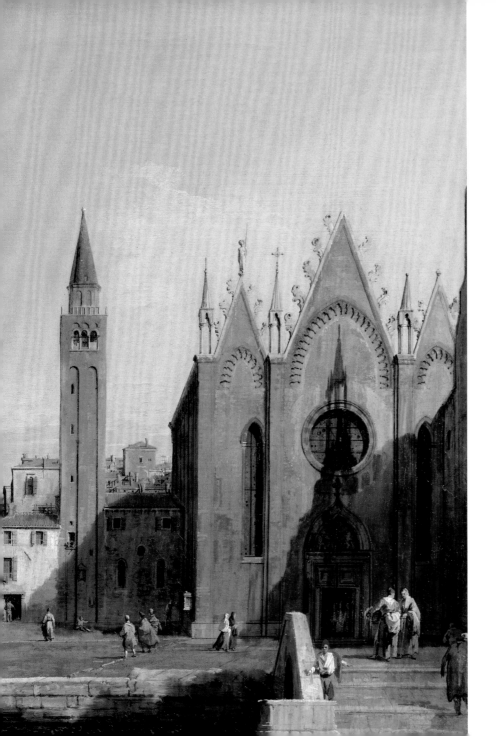

9 The Grand Canal
 looking east from
 the Carità towards
 the Bacino
 *c.*1727–8

9 The Grand Canal looking east from the Carità towards the Bacino

c.1727–8

The painting is dominated by the façade and belltower of Santa Maria della Carità, built in the 1440s. The adjacent Scuola Grande della Carità, just visible at the right edge of the painting, casts its shadow on the façade of the church, providing a delightful foil to the sunlit figures on the foreground bridge. By the eighteenth century the church was in a state of disrepair: of the two statues present on the side pinnacles in two slightly earlier paintings by Canaletto (C/L 194–5), only one remains here, and the belltower collapsed in 1744. The Scuola was suppressed in 1807, and a decision was made to transfer the Accademia di Pittura e Scultura here from the Fontegheto della Farina (nos. 70–73). Ten years later the galleries of the Accademia opened in the former Scuola, where they remain. During the subsequent restoration of the redundant church its façade was much altered: the pinnacles were removed such that the upper profile is now formed by the line of the pointed-arch brick detailing, and the windows and portal were bricked up, to be replaced by four round-headed windows. The Rio della Carità in the foreground was filled in around the same time.

Canaletto eliminated the buildings that would rise from the bottom edge of the composition, to give a view down the Grand Canal to Santa Maria della Salute and the Bacino. The left bank takes in the gothic Palazzo Cavalli Franchetti and Palazzo Barbaro to end with the flank of Palazzo Corner della Ca' Grande (better seen in nos. 10 and 29). The dome and belltower of San Pietro di Castello and the pointed tower of San Biagio (demolished when the church was rebuilt in the middle of the eighteenth century) can be seen on the distant skyline. The Accademia bridge and *vaporetto* stop now disrupt this view down the canal.

Oil on canvas, 47.9 × 80.0cm (18⅞ × 31½")
RCIN 400523. Levey 386; C/L 196; Visentini 1735, no. III;
London 1980–81, no. 9; Corboz 1985, no. P28;
New York 1989–90, no. 40; Bomford and Finaldi 1998, pp. 44–6

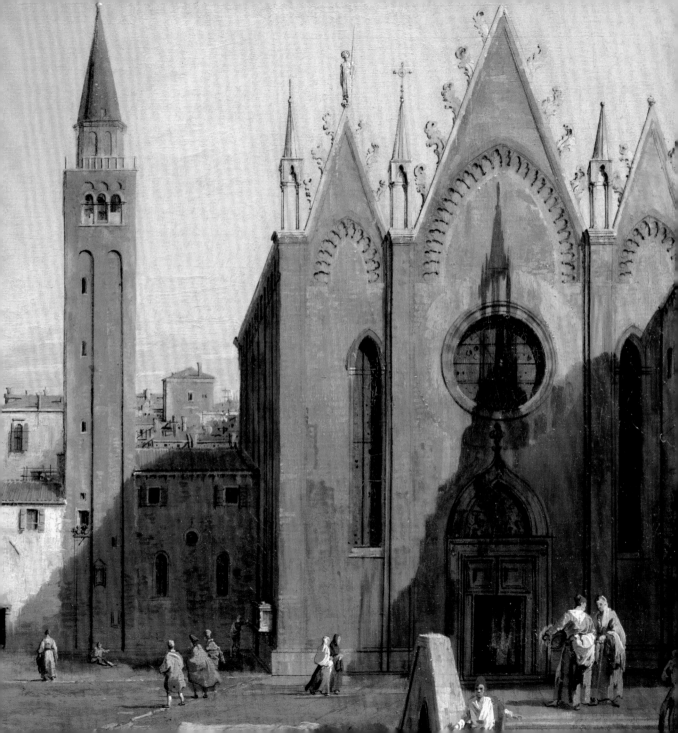

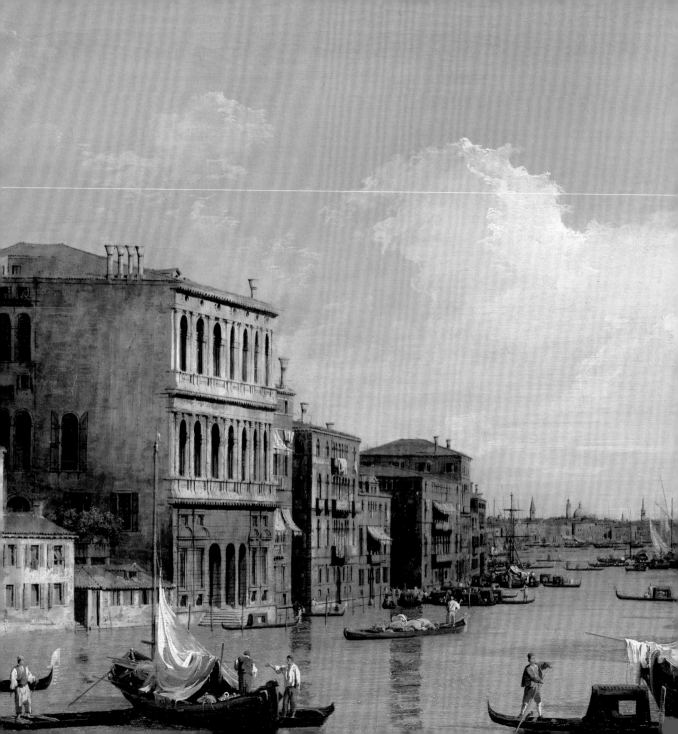

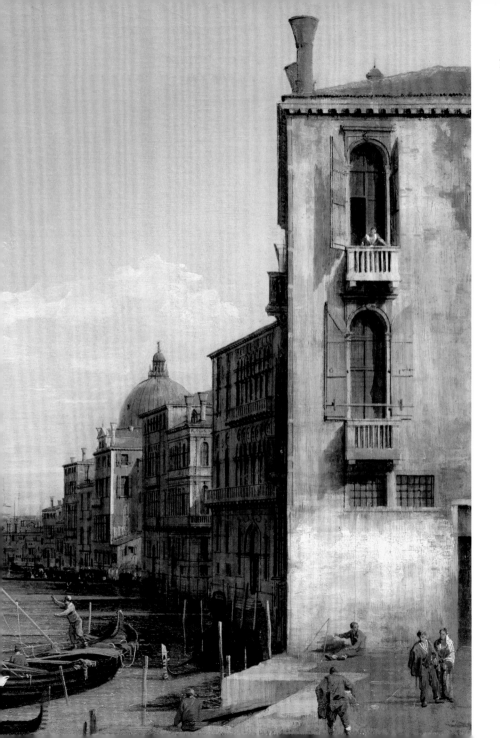

10 The Grand Canal
looking east from
Campo San Vio
towards the
Bacino, *c*.1727–8

10 The Grand Canal looking east from Campo San Vio towards the Bacino

*c.*1727–8

The Campo (or Campiello) San Vio opens onto the Grand Canal at a point a hundred metres east of the Carità, and this view thus repeats some of the buildings shown in the previous painting. The church of San Vio, properly Santi Vito e Modesto, is out of picture to the right of this view, and was demolished in 1813. The right side of the painting is taken up by the flank of Palazzo Barbarigo, with the gothic façade of Palazzo da Mula in sharp foreshortening beyond. The dome of the Salute protrudes above the Palazzi Dario, Barbaro and Benzon. This view is impossible from the narrow *campo*: Canaletto has expanded the foreground and incorporated a view of the right bank taken from a little way into the canal.

The left bank of the canal is dominated by Palazzo Corner della Ca' Grande, built after 1533 to Sansovino's designs, and shown from the other direction in the drawing below, no. 29. Beyond are Palazzi Minotto and Gritti, and finally the tall Palazzo Flanghini Fini. On the horizon are the belltowers of San Martino (left) and San Biagio (right), with the dome and tower of San Pietro di Castello in between. Perhaps surprisingly, given that no celebrated building other than Palazzo Corner is seen well, this was one of the most popular compositions of Canaletto's whole career, and many versions are known (C/L 182–92).

Oil on canvas, 47.0 × 79.1cm (18½ × 31⅛")
RCIN 400518. Levey 387; C/L 184; Visentini 1735, no. IV;
London 1980–81, no. 10; Corboz 1985, no. P55

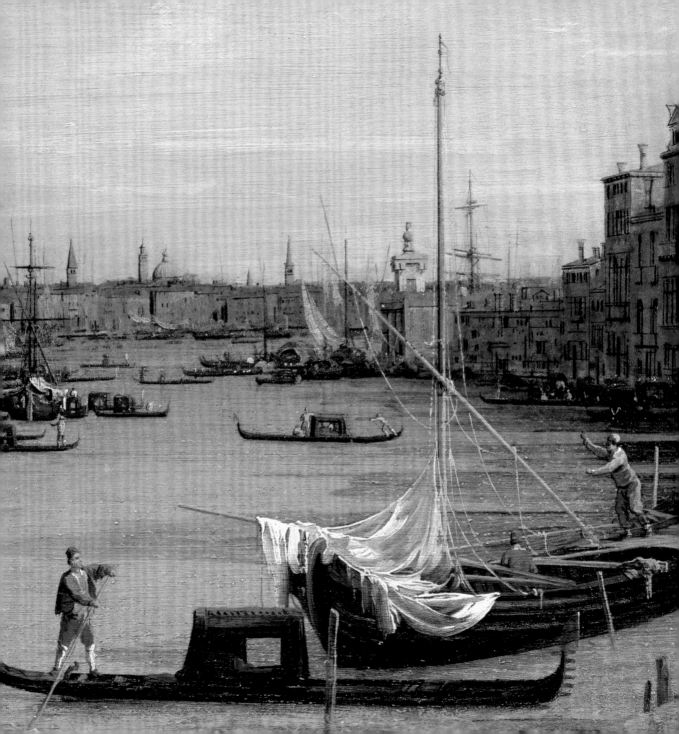

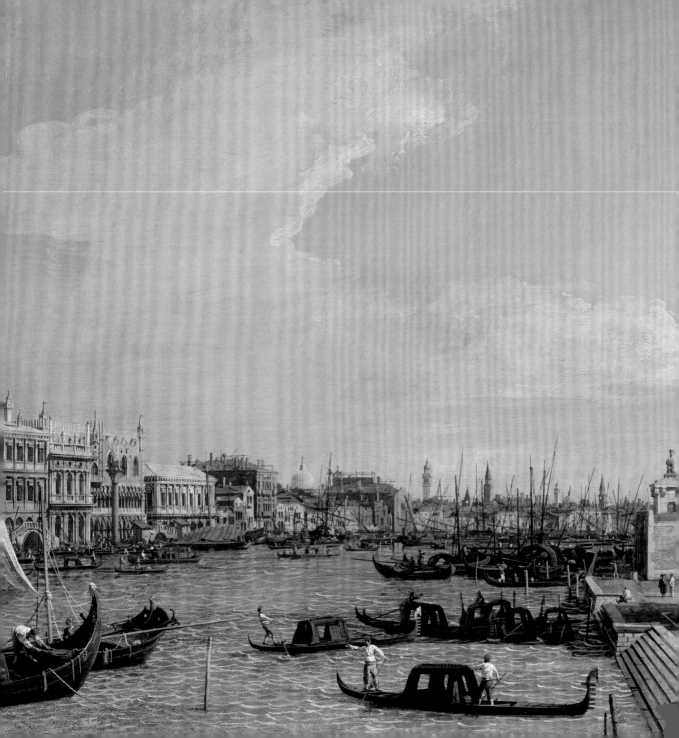

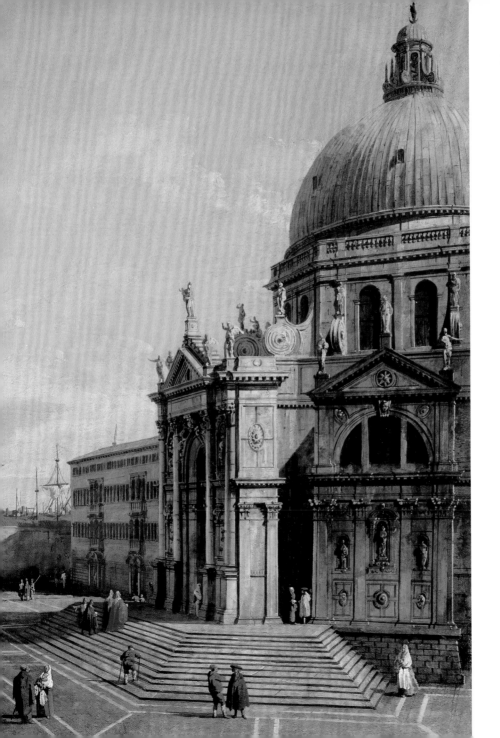

11 The Grand Canal
looking towards
the Riva degli
Schiavoni
*c.*1729–30

11 The Grand Canal looking towards the Riva degli Schiavoni

*c.*1729–30

Santa Maria della Salute ('of health') was built in thanksgiving for the cessation of the plague of 1630–31, which killed almost 50,000 Venetians. As with the Redentore (no. 41), built the previous century following an equally devastating epidemic, the Doge walked to the church across a pontoon bridge to attend an annual commemorative service, in this case held on 21 November. The church was the masterpiece of Baldassare Longhena, built on a central plan with a huge dome over the crossing and a subsidiary dome over the great sanctuary; it was consecrated in 1687, five years after the architect's death. On the far side of the church is the Seminario Patriarcale, also by Longhena, its sober façade standing in contrast to the exuberance of the church.

The view is ostensibly taken from a first-floor window in the corner of the abbey of San Gregorio, overlooking the Rio della Salute, though Canaletto has radically corrected the perspective of the church – the drum and dome should be seen strongly foreshortened from below (as in a dramatic version of the composition in the Louvre, C/L 169,

now generally attributed to Michele Marieschi). Canaletto has also eliminated the buildings immediately across the Grand Canal from the Salute, bringing the complex around San Marco much closer to the viewer and showing the Libreria and the column with the lion, neither of which is visible from this viewpoint.

Unlike the earlier paintings in the series, Canaletto here used a range of tones to pick out the architectural details, from black in the foreground to paler greys in the distance. This gives a degree of atmospheric haze to the skyline, which features (left to right) the dome of San Giorgio dei Greci, the old church of the Pietà with scaffolding on its roof, the towers of San Giovanni in Bragora (demolished) and San Martino, the tower and dome of San Pietro di Castello, and the tower of San Biagio (demolished).

Oil on canvas, 47.6 × 80.0cm (18¾ × 31½")
RCIN 400520. Levey 388; C/L 170; Visentini 1735, no. V;
London 1980–81, no. 11; Corboz 1985, no. P87

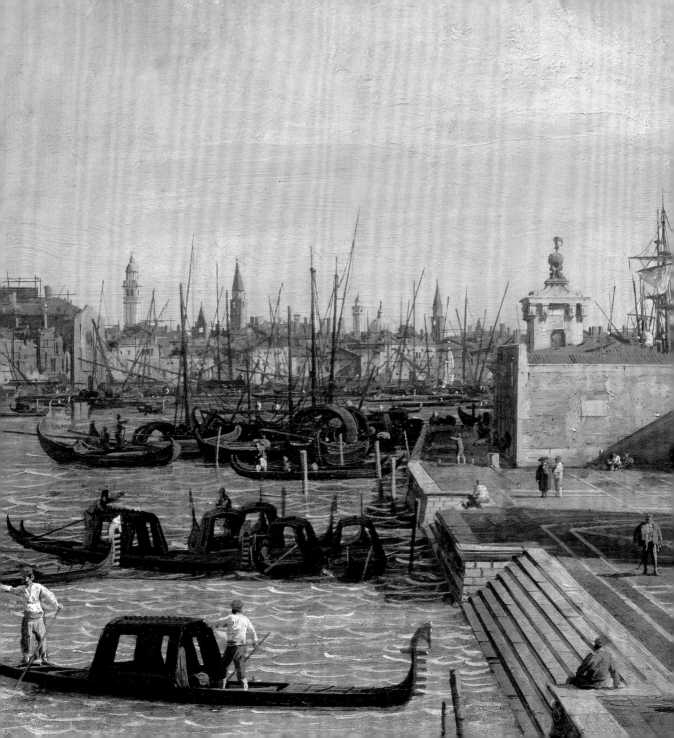

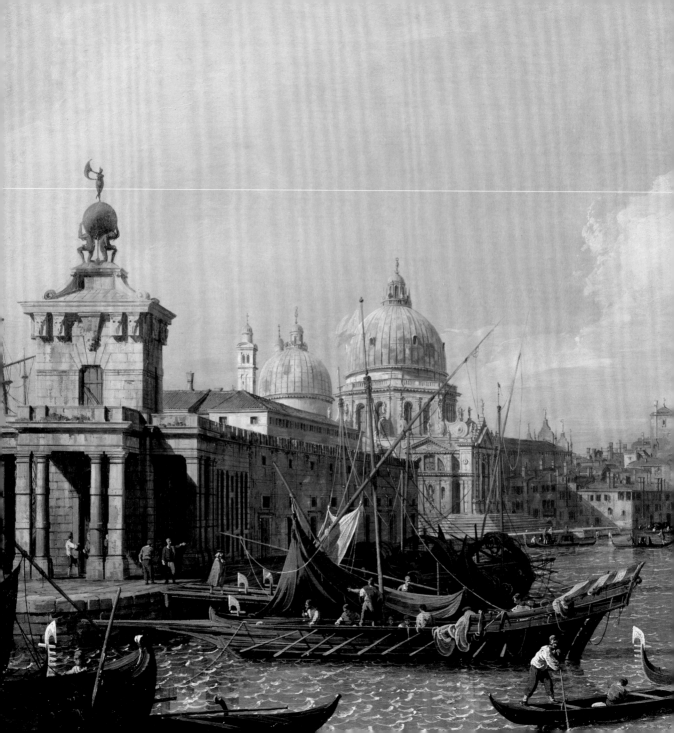

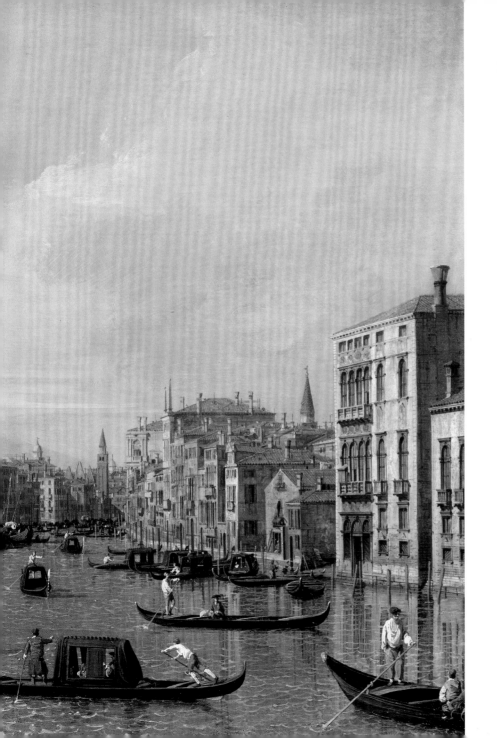

12 The mouth of
 the Grand Canal
 looking west
 towards the Carità
 c.1729–30

12 The mouth of the Grand Canal looking west towards the Carità

*c.*1729–30

On the left is the Dogana da Mar, the customs house established at the eastern tip of the *sestiere* (literally a 'sixth' of the city) of Dorsoduro in the fifteenth century, and rebuilt around 1680 by Giuseppe Benon as work on Santa Maria della Salute reached completion. Crowning the low tower at the Punta della Dogana is a bronze sculpture by Bernardo Falcone, of male nudes supporting a gilded globe, surmounted by an allegorical figure of Fortune holding a sail, an appropriate symbol for the customs house of a state whose wealth depended on maritime trade.

Beyond the Salute are the flank and the cusps of the façade of San Gregorio, followed by the tower of Palazzo Venier delle Torreselle, demolished in the nineteenth century. At the turn of the canal are the belltower and pinnacles (lacking any statues – cf. nos. 8–9) of Santa Maria della Carità. The right bank is shown as far as Palazzo Corner della Ca' Grande, with Palazzo Tiepolo in the right foreground; above the rooftops can be seen the old belltower of Santa Maria del Giglio (or Zobenigo), demolished in 1774. Canaletto painted this view several times around 1730, and this may well be the earliest version.

Oil on canvas, 47.6 × 79.2cm (18¾ × 31⁵⁄₁₆")
RCIN 400519. Levey 389; C/L 161; Visentini 1735, no. VI;
London 1980–81, no. 12; Corboz 1985, no. P85; Venice 2001, no. 69

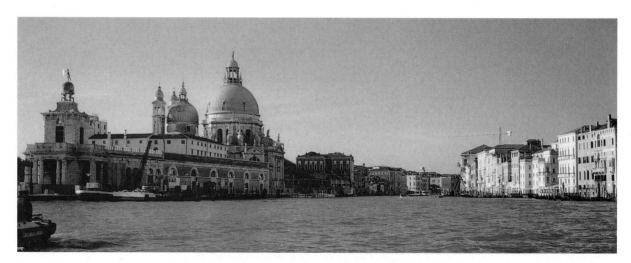

Fig. 7 *The mouth of the Grand Canal looking west*, 2005

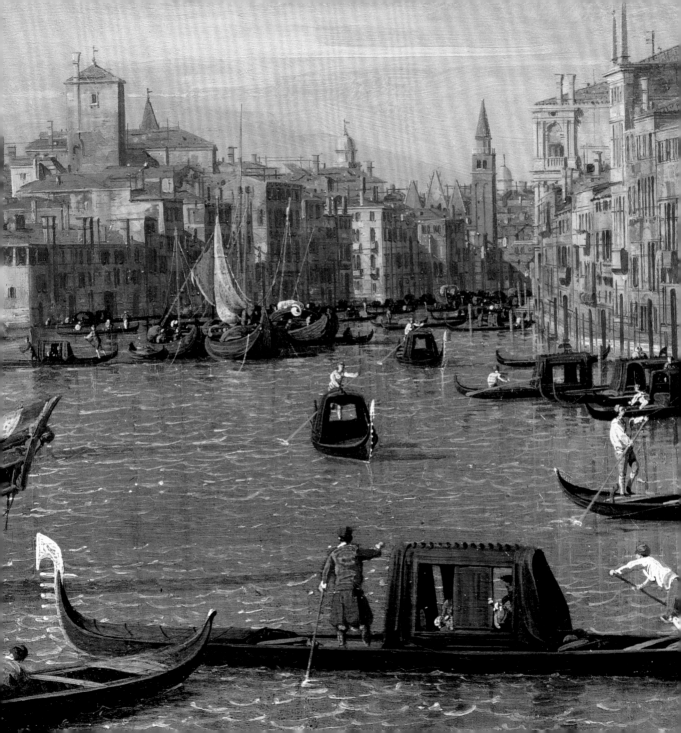

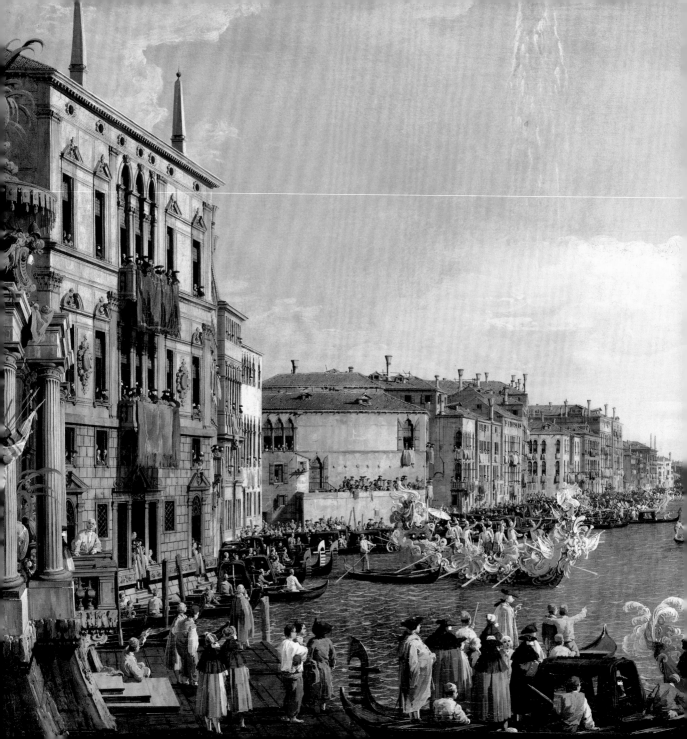

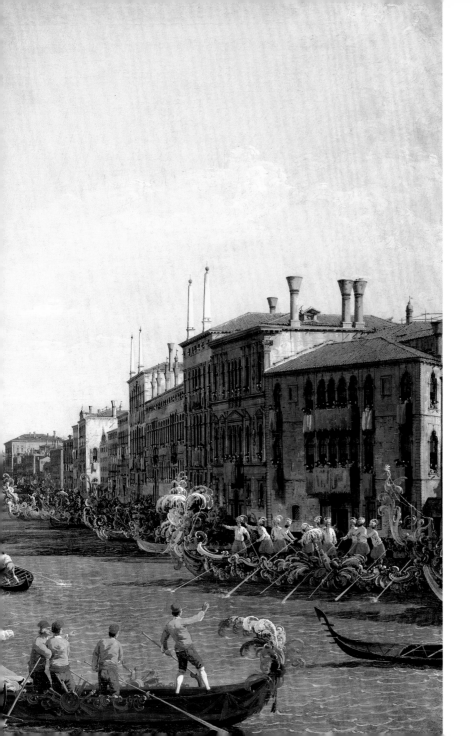

13 A regatta on
 the Grand Canal
 c.1733–4

13 A regatta on the Grand Canal

c.1733–4

This and the following painting form a pair, each much larger than the preceding series of twelve views on the Grand Canal, and engraved as the last two plates of Visentini's *Prospectus* of 1735. The view is of the entire central stretch of the Grand Canal, looking north-east from Ca' Foscari towards the Rialto, which can just be seen in the far distance – and thus the same stretch as no. 7 seen from the other end, and of no. 32 from further down the canal.

Races along the Grand Canal had been held annually on 2 February, the festival of the Purification of the Virgin, since 1315, and occasional regattas were also held to entertain distinguished visitors to Venice. The course ran from the Punta di Sant'Antonio at the south-east of the island (see no. 55), along the Riva and Molo, up the Grand Canal to Santa Croce, then back to the Volta di Canal at Ca' Foscari, a distance of some eight kilometres. The finishing line at the mouth of the Rio di Ca' Foscari was marked by the *macchina della regatta*, a canopied pavilion floating on a raft tethered to moorings, seen here in the left foreground.

The balconies and windows are hung with coloured cloths; spectators, many in the carnival *bauta* of black cape and white mask, crowd the buildings and the boats, including the ceremonial *bissone* of the noble families, that line the canal. To the left is Palazzo Balbi (seen frontally in no. 31), to the right, Palazzo Nani-Mocenigo, followed by Palazzo Contarini delle Figure and the complex of the Palazzi Mocenigo (the two *palazzi* known as 'Casa Vecchia' and 'Casa Nuova' each surmounted by a pair of obelisks). Catching the sunlight beyond are the sides of Palazzo Corner-Spinelli and Palazzo Grimani. The tower and dome of San Bartolomeo sit on the skyline at the far end of the canal.

Canaletto based his composition on a painting of 1709 by Luca Carlevarijs (Frederiksborg Castle, Denmark), but opened out the right bank and diminished the distance to make the race more dramatic. Levey pointed out that the coat of arms on the *macchina* is that of Carlo Ruzzini, Doge from June 1732 to January 1735, and therefore the painting must ostensibly depict the regatta of 1733 or 1734. From the *macchina* a figure dressed in yellow turns to look straight out of the painting at the viewer, and it has been speculated that this may be a portrait of Joseph Smith, whose likeness is not known. Naturally, the regatta was a popular subject, and Canaletto and his followers turned out many versions of the scene (C/L 347–54).

Oil on canvas, 77.2 × 125.7cm (30¾ × 49½")
RCIN 404416. Levey 396; C/L 347; Visentini 1735, no. XIII;
London 1980–81, no. 19; Corboz 1985, no. P83;
New York 1989–90, no. 43

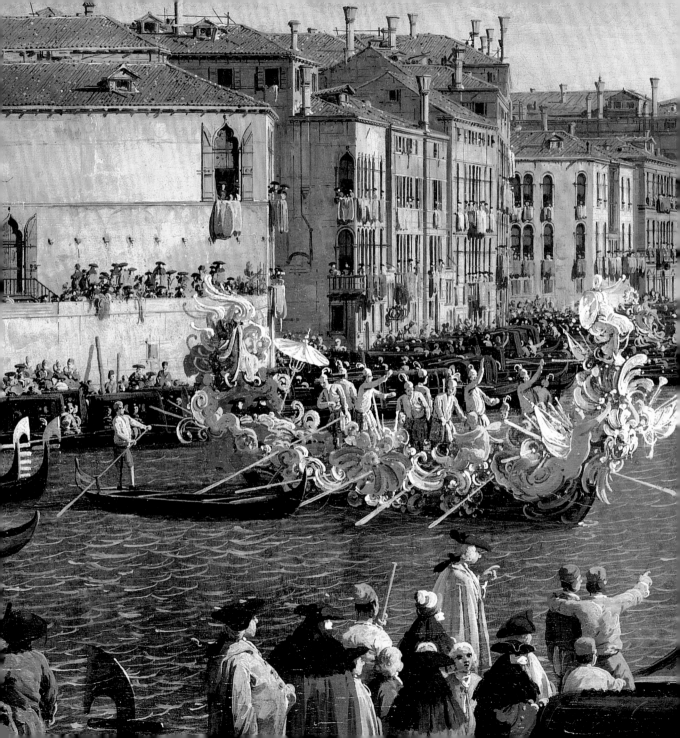

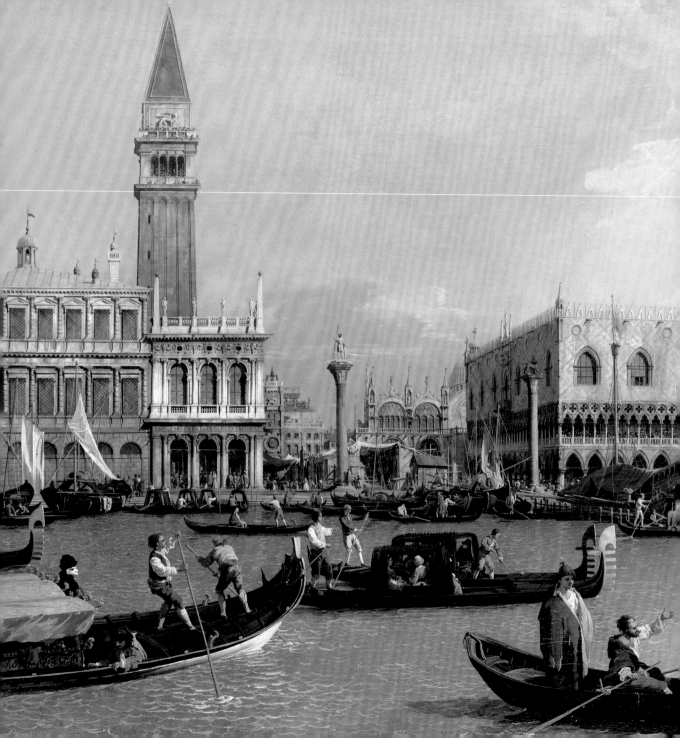

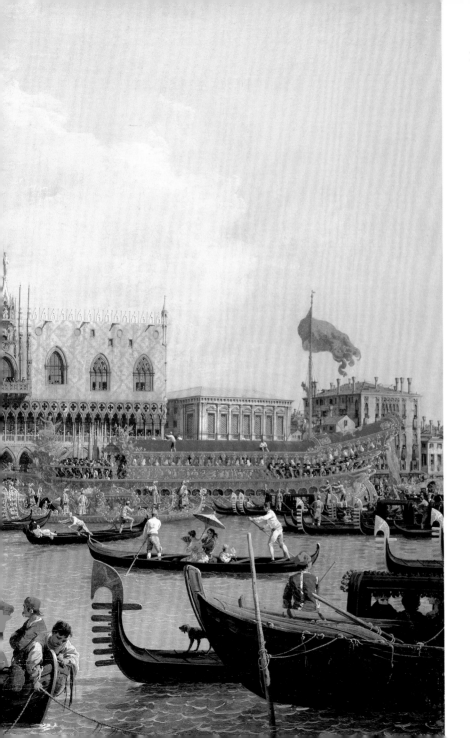

14 The Bacino di San Marco
on Ascension Day
*c.*1733–4

14 The Bacino di San Marco on Ascension Day

c.1733–4

The scene depicted is the return to the Molo of the Bucintoro, the ceremonial vessel used only once a year for the *Sposalizio del Mar*, the Wedding of the Sea, held on Ascension Day and thus otherwise known as the *Festa della Sensa*. Venice's principal annual ceremony was of uncertain origin: it commemorated, according to one tradition, the sailing on Ascension Day in the year 1000 of a war fleet to assert Venetian power along the Istrian coast; according to another, the gift of a ring by Pope Alexander III to Doge Sebastiano Ziani – the greatest of Venice's medieval doges – to sanction Venice's authority in the Adriatic, in gratitude for Ziani's support for the Pope against the Holy Roman Emperor, Frederick Barbarossa (Pope and Emperor were reconciled in San Marco on Ascension Day 1177).

In the ceremony the Bucintoro was rowed in procession out of the lagoon into the Adriatic, where the Doge cast a ring blessed by the Patriarch into the waters, symbolising the marriage of Venice to the sea. The Bucintoro depicted here was to be the last, constructed in 1728–9 and crowded with gilded wooden allegorical sculptures by Antonio Corradini. After the fall of Venice to Napoleon's army in 1797, the upper part of the Bucintoro was burnt to recover the gold, after which the Austrians armed the hulk with cannon and placed it to guard the entrance to the lagoon. It was finally broken up in its birthplace, the Arsenale, in 1824.

The view is taken from some way out in the Bacino, directly in front of the Zecca, the south façade of which is seen to the left together with the Libreria. Beyond is the Campanile, shortened to fit it into the painting (four small windows serving the staircase running up the shaft should be visible). In the Piazzetta is the marquee of the Ascension Day market, clearly regarded as an integral part of the festival, as Visentini's engraving after the painting was entitled *Bucentaurus et Nundinae* [market] *Venetae in die Ascensionis*, and the overall title of the *Prospectus* referred only to the market. Beyond are the Torre dell'Orologio and the south flank of San Marco, with the western dome reduced in size and moved eastwards to be largely obscured by the Palazzo Ducale. To the right of the Palazzo Ducale (much diminished in width) are the Prigioni and Palazzo Dandolo (today the Hotel Danieli); moored to the left of the Bucintoro with its oars raised is the *fusta*, the Doge's usual single-masted galleon.

Canaletto probably first depicted the scene in 1729, in the drawing below (no. 24), and the composition was painted many times by the artist and his followers (C/L 335–9). This version must have been painted at around the same time as its companion piece, no. 13.

Oil on canvas, 76.8 × 125.4cm (30¼ × 49⁷⁄₁₆″)
RCIN 404417. Levey 397; C/L 335; Visentini 1735, no. XIV; London 1980–81, no. 20; Corboz 1985, no. P82; New York 1989–90, no. 44

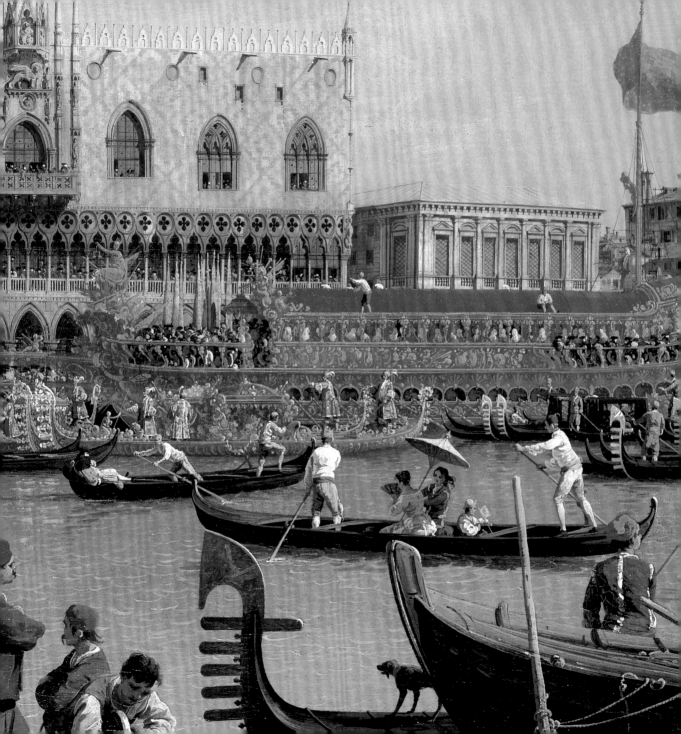

Early drawings around San Marco

Possibly the first paintings that Canaletto executed expressly for Joseph Smith were six large views around San Marco. The paintings are all approximately the same size, about 172 × 135cm (67½ × 53″), four vertical and two horizontal, and they fall into three pairs, with the bulk of the buildings emphatically alternating from the left side of one painting to the right side of another. Millar (in London 1980–81, p. 31) suggested that they may have been designed for a specific interior, presumably in Smith's residence, Palazzo Mangilli-Valmarana (see no. 5).

The paintings are not documented. The unusually large size of the canvases, the many other works that Canaletto produced around this time, and most significantly the plainly visible revisions, all suggest that they may have been painted over a considerable period of time. A small piece of topographical evidence – the form of the belltower of San Giorgio Maggiore in no. 20 – has been adduced to demonstrate that the series must have been at least conceived before c.1726–8; and while this evidence need not be interpreted strictly, most scholars have proposed a date of c.1726–9 for the whole series. But an earlier dating of Canaletto's first works is now generally accepted, and Succi (in Belluno 1993) and Kowalczyk (in Venice 2001) both dated the series several years earlier, to around 1723. A date in the middle of the 1720s is maintained here: those paintings by Canaletto that are convincingly of the early 1720s exhibit a somewhat immature stormy tonality and a more self-conscious theatricality than the grand and spacious compositions seen in the San Marco paintings.

Corresponding with the original composition of each of these six paintings is a drawing (nos. 15–20). Like the paintings, the drawings are all the same size, around 23 × 18cm (9 × 7″). Though they are rapidly drawn, these are not sketches done on the spot; nor are they experimental works drawn in the studio as Canaletto played around with a composition, for there is no searching for form, and the artist must have determined his compositions in earlier sketches. The drawings lack any detail, and it is unlikely that they could have been of much use to Canaletto once he began work on the large canvases. It is therefore suggested that they were compositional

Background detail taken from *The Grand Canal looking west with the Scalzi and San Simeon Piccolo* (no. 2)

schemata, intended when seen together to give an idea of how the paintings would work as a set, for discussion between artist and patron. They were probably the first drawings by Canaletto acquired by Smith, and in function unlike any others acquired in later years.

The drawings were laid out with only a little free pencil underdrawing (and no ruled pencil lines or pinpricking). Though many of the pen lines appear at first glance to have been drawn with a ruler, this is the case in only a few of the more dramatic perspectives. The acid of the heavy ink has in places eaten through the paper, and the paper has yellowed all over apart from an irregular zone around the edges, where an early paste seems to have buffered this degradation. The two horizontal drawings are more carefully (or tentatively) drawn than the four upright views from the same series, with a lighter, more even tone and no heavy shadows. Where figures are present, they are rendered as the merest scribbles, far from the mechanical but legible shorthand of Canaletto's later years, and they give no indication of the importance that the figures assumed in the paintings.

15 San Marco and the Piazza, looking east

*c.*1725

The view is obtained by standing before the first column from the south along the west range of the Piazza. At the centre is the basilica of San Marco, drawn narrower and taller than in reality, and with its northern dome shifted to the left; the flagpoles have also been heightened and bunched up to the left. The end of the Procuratie Vecchie (the offices of the Procurators of San Marco) and the Torre dell'Orologio (clocktower) run down the left of the composition, and the Procuratie Nuove in shadow and steep perspective down the right. Beyond the base of the Campanile, with traders' awnings set up against its base, is the sunlit façade of the Palazzo Ducale, reduced in size – it should be level with the cusp of the upper central arch of San Marco. As the basilica has been heightened, the Campanile appears to be less tall than in reality, and Canaletto has radically slimmed its proportions to prevent it dominating the composition. The shadow of the Campanile falls across the flagpoles and the east end of the Procuratie, identifying the time as just before noon.

The painting (fig. 8) follows the drawing closely, the only major difference being the Piazza itself. By raising his viewpoint a little Canaletto increased the importance of the foreground, though this may also be due to the large figures, who are barely indicated in the drawing.

Pen and ink, over traces of free pencil
18.1 × 23.4cm (7⅛ × 9³⁄₁₆")
RL 7429. P.5; C/L 524; Venice 1962, no. 3; Corboz 1985, no. D17

Fig. 8 Canaletto, *San Marco and the Piazza, looking east, c.*1725
Oil on canvas, 135 × 173cm (53 × 68"). Levey 378

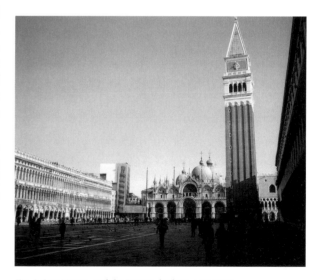

Fig. 9 *San Marco and the Piazza, looking east*, 2005

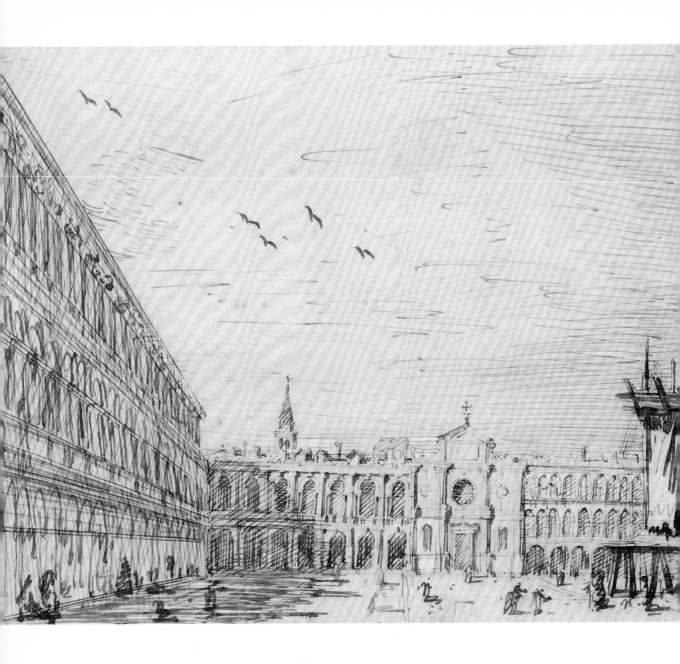

16 The Piazza, looking west

c.1725

To the left, in steep perspective loosely constructed with ruled lines, are the civil offices of the Procuratie Nuove. The building had been planned by Jacopo Sansovino to continue the design of the Libreria, but had not been begun by his death in 1570. Vincenzo Scamozzi amended Sansovino's designs and commenced the building in 1582, but by Scamozzi's own death in 1616 only the ten eastern bays had been completed. Work was continued by Marco Carità and Baldassare Longhena, and was finally completed around 1660. The Procuratie extended around the south-west corner of the Piazza, consisting of three storeys on their southern range (as today) but only two on the western range, to harmonise with the contiguous church of San Geminiano, seen here at lower right. The ancient church had been moved in the late twelfth century to form the western end of the Piazza, and was entirely rebuilt by Sansovino in the sixteenth century. The top of the fourteenth-century belltower of San Moisè projects over the top of Procuratie Nuove; today the belltower is mostly hidden by the cold neoclassical attic storey of the Ala Napoleonica, intended as a palace for Napoleon, for which the whole of the west range of the Piazza was demolished in 1807–10.

The painting (fig. 10) differs in important respects from the drawing. It appears to take a viewpoint further to the east, close to San Marco, thus moving out of the shadow of the Procuratie and Campanile and flooding the foreground

Pen and ink, over traces of free pencil
18.0 × 23.1cm (7¹⁄₁₆ × 9¹⁄₈˝)
RL 7434. P.6; C/L 530; London 1980–81, no. 46; Miller 1983, no. 1; Venice 2001, no. 15

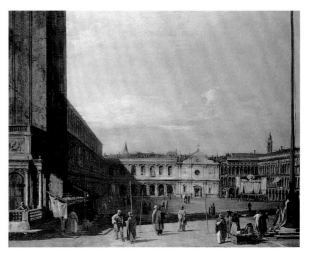

Fig. 10 Canaletto, *The Piazza, looking west*, *c*.1725. Oil on canvas, 135 × 173cm (53 × 68˝). Levey 379

with sunlight. Canaletto effected this shift in viewpoint by painting in a flagpole to the right, and the Loggetta and part of the Campanile to the left; the roof-line of the Procuratie shows plainly through the paint of the Campanile. These additions were presumably made as the composition began to appear excessively simple when scaled up to the large canvas. The north-west corner of the Piazza is visible, near which stands the temporary stage seen here in the right foreground. Canaletto diminished the height of the belltower of San Moisè, and introduced another belltower to the right (possibly that of Santo Stefano, which actually lies 500 metres west of the Piazza).

17 The Piazza looking north-west with the narthex of San Marco
c.1725

Fig. 11 *The Piazza looking north-west with the narthex of San Marco*, 2005

Fig. 12 Canaletto
The Piazza looking north-west, with the narthex of San Marco
*c.*1725
Oil on canvas
173 × 134cm (68 × 52½˝)
Levey 380

Canaletto's viewpoint can be located precisely, standing against the north end of the west arcade of the Palazzo Ducale. The Campanile (shortened to include a section of the bell-storey) runs up the left side of the composition, with awnings against Sansovino's Loggetta. The south wall of the narthex (vestibule) of San Marco is on the right, built out at this point as an open single-bay arcade with two stages of columns. By the corner column is loosely indicated the stump of porphyry known as the Pietra del Bando, from which decrees were proclaimed. One of two sixth-century pillars supposedly brought from Acre in 1256 (see p. 9) stands at the lower right edge. Beyond, the arcades of the Procuratie Vecchie recede into the distance. A portion of the western range of the Piazza is shown, though in reality the corner of the Piazza cannot be seen from this viewpoint (fig. 11). A couple of figures sit or stand under the arcade of the narthex, but the drawing is otherwise unpopulated, and the afternoon sun casts the shadow of the Campanile across the foreground.

In the painting (fig. 12) Canaletto first laid in then eliminated the Campanile, leaving a ghostly line down the left edge of the picture. The foreground shadow was replaced with bright light from a midday sun, giving prominence to the large figures introduced in the foreground, including a senator or procurator with his entourage, and an official standing at the Pietra del Bando.

Pen and ink, over traces of free pencil
23.3 × 18.0cm (9⁵⁄₁₆ × 7¹⁄₁₆˝)
RL 7444. P.1; C/L 532; Venice 1962, no. 1; London 1980–81, no. 48; Miller 1983, no. 3; Frankfurt etc. 1989–90, no. 31; Venice 2001, no. 16

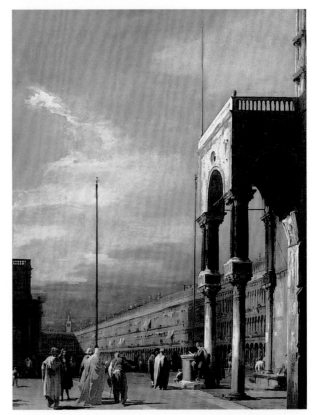

18 The Piazzetta looking north
c.1725

The view is ostensibly taken from the edge of the Molo, the quay running in front of the Palazzo Ducale, Piazzetta, Libreria and Zecca. To the left is the south front of the Libreria, the library of San Marco, begun in 1537 to the designs of Jacopo Sansovino. Its east front in deep afternoon shadow cuts across the Campanile, drawn, as usual, taller and more slender than in reality. Standing in such a position as to see the Libreria from this angle, the Campanile is in fact largely hidden from view. In the distance are the Torre dell'Orologio and the first few bays of the Procuratie Vecchie, and to the right is the façade of San Marco, in steep perspective. The column of San Teodoro, which should stand right in the middle of the composition, lies along the right edge – Canaletto has moved it well to the east to make room for his view of the Piazzetta.

The painting (fig. 13) takes a slightly higher viewpoint, renders the east front of the Libreria in even steeper perspective, and moves the Campanile to the left to hide more of its shaft. The buildings on the far side of the Piazza are shown on a larger scale, and the flagpoles, absent in the drawing, are prominent in the Piazza, though in incorrect perspective (the façade of San Marco and thus the line of the flagpoles are not parallel to the east front of the Libreria). San Marco is shown even closer to the viewer and in grossly distorted perspective, effectively eliminating the Palazzo Ducale from the topography of the area. The painting preserves the direction of lighting of the drawing, and the scribbles in the foreground are fleshed out to include a procurator in his red robe. By placing the nearest and most distant elements of the painting next to each other, Canaletto enlivens the surface and ensures that it does not appear to be simply an exercise in pictorial space.

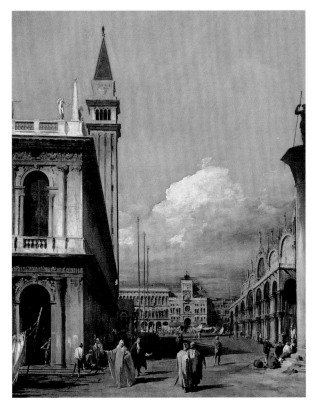

Fig. 13 Canaletto, *The Piazzetta looking north*, c.1725
Oil on canvas, 172 × 135cm (67½ × 53″). Levey 381

Pen and ink, over a few traces of free pencil
23.3 × 18.0cm (9¹⁄₁₆ × 7¹⁄₁₆″)
RL 7443. P.2; C/L 548; Venice 1962, no. 2; Corboz 1985, no. D31; New York 1989–90, no. 88; Venice 2001, no. 19

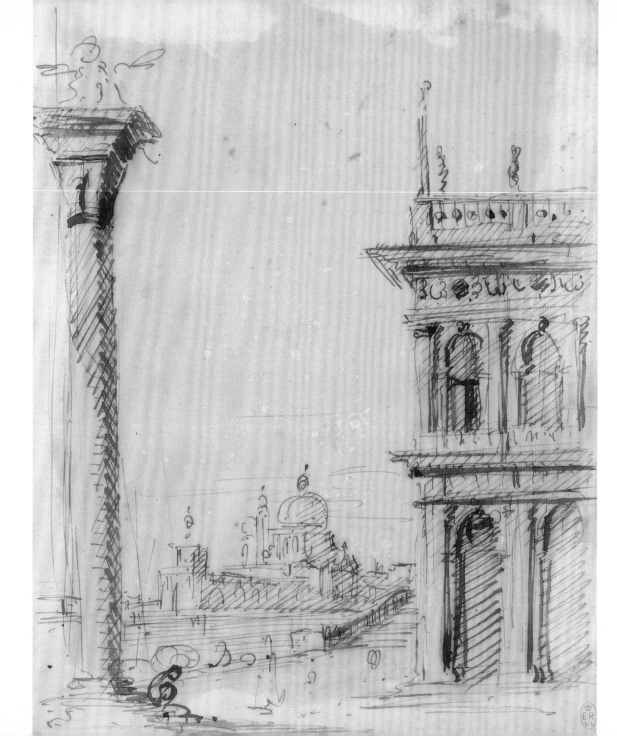

19 The Piazzetta, looking towards Santa Maria della Salute

c.1725

To see the column of the lion at roughly the same level as the Libreria, as here, one must stand close to the corner of the Palazzo Ducale, from where Santa Maria della Salute is almost hidden from view in the distance. Walking closer to the Libreria, the Salute comes into view, but the column of the lion then towers over the spectator (fig. 14). Canaletto thus opened out the space between the column of the lion and the Libreria, and inserted a rapid sketch of the Salute and the (abbreviated) Dogana, entirely omitting the column of San Teodoro. In the painting (fig. 15) he reverses the situation, including San Teodoro (though shrunk against the façade of the Libreria) and – after first including it along the left edge of the canvas – painting out the column of the lion, leaving a heavy mass to the right which is barely balanced by the sail and mast of a boat moored at the Molo.

The drawing is substantially less dark and contrasty than the other three in this small group, and the fading of the ink towards the edge of the sheet gives the appearance of a vignette. Again, the figures that are prominent in the painting are barely indicated here, little more than a single scribble hunched at the base of the column.

Pen and ink, over some free pencil
23.2 × 18.2cm (9⅛ × 7³⁄₁₆")
RL 7445. P.3; C/L 580; London 1980–81, no. 49; Miller 1983, no. 4; Corboz 1985, no. D60; New York 1989–90, no. 89; Venice 2001, no. 20

Fig. 14 *The Piazzetta, looking towards Santa Maria della Salute*, 2005

Fig. 15 Canaletto *The Piazzetta, looking towards Santa Maria della Salute*, *c*.1725
Oil on canvas
172 × 136cm
(67½ × 53½")
Levey 383

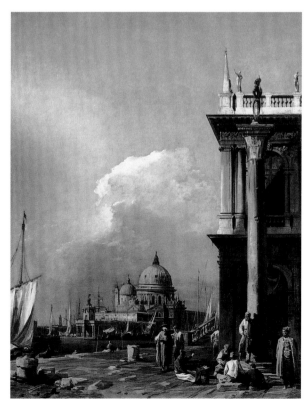

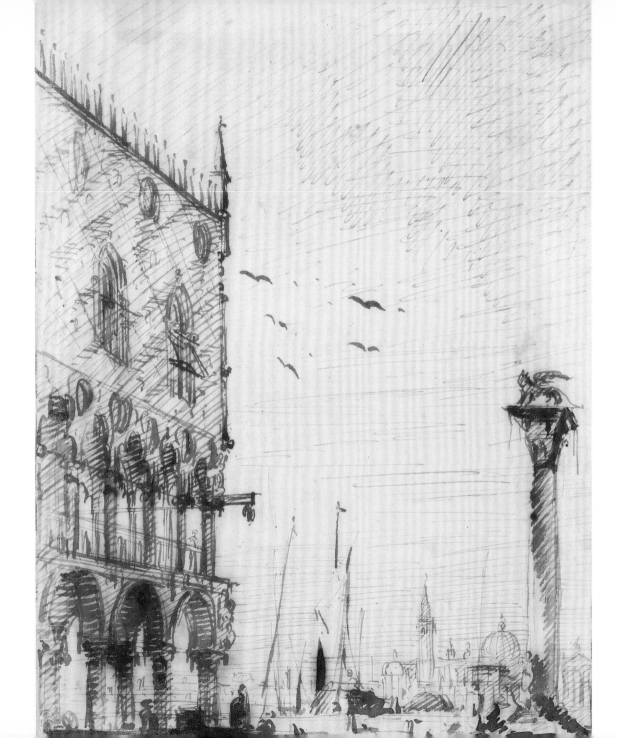

20 The Piazzetta, looking towards San Giorgio Maggiore

*c.*1725

Canaletto has drawn the view from a point in the middle of the Piazzetta, looking across the Bacino. The southernmost three arcades of the Palazzo Ducale are included to the left; above them should be six openings on the first floor (Canaletto has drawn five) and one large window and two small round openings in the principal floor. That single large window would have been pictorially oppressive, so Canaletto substituted two smaller windows to break up the expanse of pink and white patterned wall. From the corner of the Palazzo protrudes a winch, omitted in the painting. The column of the lion is correctly located, though rather too massive. In the distance is the church of San Giorgio Maggiore, stretched so that its portico is seen to the right of the column. The top of the belltower of San Giorgio was changed from a tall pyramid to an onion shape during building works begun in June 1726 and completed in 1728 (see no. 40 for the onion); it was returned to the current pyramidal shape later in the eighteenth century. This might provide evidence for a date for the drawing, but it is not known exactly when the cusp itself was dismantled, and Canaletto could easily have been working from memory or earlier notes.

Canaletto reversed the direction of the sunlight in the painting (fig. 16) – here the morning sun leaves the façade of the Palazzo in shadow, whereas in the painting the Palazzo is lit by an afternoon sun, and the shadows of the column and Libreria fall across the foreground. A drawing in the Ashmolean Museum (C/L 543), less boldly but no more tidily drawn, shows essentially the same composition, with the portico of San Giorgio to the left of the column (in which the Oxford drawing agrees with the painting),

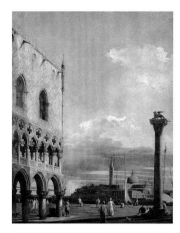

Fig. 16 Canaletto
*The Piazzetta, looking towards San Giorgio Maggiore, c.*1725
Oil on canvas
173 × 135cm (68 × 53″)
Levey 382

Fig. 17 *The Piazzetta, looking towards San Giorgio Maggiore*
2005

and three windows in the principal floor of the Palazzo Ducale. It is hard to discern any difference in purpose between the Oxford and Windsor drawings, and both may have served as trials for the composition of the painting.

The composition appears in the Venice Sketchbook (f. 2v), though given the probable date of the project it is doubtful that the sketch is preparatory for this work, as most of the Sketchbook seems to date from around 1730.

Pen and ink, over some free pencil
23.2 × 17.8cm (9⅛ × 7″)
RL 7446. P.4; C/L 542; London 1980–81, no. 47; Miller 1983, no. 2

Early drawings around the Molo and Bacino

Whereas nos. 15–20 may have been models for discussion between artist and patron, the next five drawings (nos. 21–5) are more typical of the type of compositional study that Canaletto produced towards the end of the 1720s. They are not casual sketches, for they fall into two groups essentially identical in style and size: nos. 21–2, each measuring close to 19.6 × 30.5cm (7 $\frac{11}{16}$ × 12″), and nos. 23–5, each close to 21.3 × 31.7cm (8⅜ × 12½″). While this could be explained by Canaletto or Smith later trimming the sheets to a uniform size, the compositions do not appear to have been cut at all, and it must be concluded that Canaletto conceived the drawings as more than just studies for possible future paintings.

To these five drawings can be added a sixth at Darmstadt (fig. 18) that is close in style and size, 21.0 × 31.5cm (8¼ × 12⅜″), to nos. 23–5, has essentially the same composition as no. 21, and is dated 1729. A rougher version of no. 23 (C/L 545) is also dated 1729, and it is very likely that no. 24 records the Ascension Day celebrations of that year. Few of Canaletto's drawings can be dated accurately, and these studies are valuable in displaying his confident, expansive sketching style at the moment that his painting style was reaching full maturity.

Three of the drawings (nos. 22–4) are inscribed in the centre of the verso *Smith*, apparently in Canaletto's hand. As these do not correspond with paintings executed for Joseph Smith, it may be that the notes were a reminder that Smith had requested the drawings for his collection after Canaletto had his full use of them. They may therefore mark the beginnings of Smith's deliberate collecting of the artist's drawings (rather than the acquisition of nos. 15–20 as probable by-products of the commissioning of paintings). The following decade was to see the production of scores of finished drawings expressly for Smith, among which were nos. 26 and 27, based on the composition of no. 25 and showing how the composition of a rough study was transformed into a drawing as an independent work of art.

Background detail taken from *San Geremia and the entrance to the Cannaregio* (no. 3)

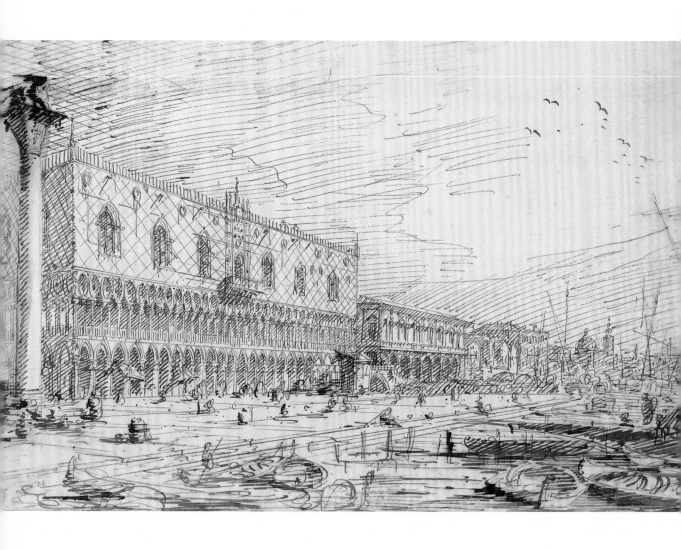

98

21 The Molo and Riva degli Schiavoni, looking east
1729

The view is taken from just off the Molo, probably from a landing stage, though the numerous infelicities suggest that Canaletto constructed the view in the studio. To the left, the column of the lion is increased in size such that it appears to tower over the Palazzo Ducale, whose south windows have all been drawn on the same level (the two to the right should be lower, as in no. 50). A hut stands before the far corner of the Palazzo, obscuring the steps of the Ponte della Paglia. Beyond are the Prigioni and Palazzo Dandolo, followed by an undifferentiated jumble of buildings and boats. In the right foreground is the prow of the Doge's *fusta* (seen in full in no. 24). On the skyline are a dome and belltower, of either San Giorgio dei Greci or San Pietro di Castello, though neither is visible from this position.

A drawing at Darmstadt, dated March 1729 (fig. 18), shows the same view and is drawn in the same style as the present drawing. It is hard to establish precedence, though the uncertain spatial relationship of the Ponte della Paglia to the Palazzo Ducale in the Darmstadt drawing may suggest that no. 21 is a slightly later refinement. The Windsor and Darmstadt sheets are the only two known drawings of this view, but Canaletto painted variants of the scene repeatedly (C/L 111–19). While none corresponds exactly, there are many similarities to a painting at Tatton Park (C/L 111; New York 1989–90, no. 33), one of a pair that we know from letters to have been worked on during 1730. Its companion corresponds generally with the following drawing, and it is likely that these two drawings were the immediate models for that pair of paintings.

Pen and ink, over free and a little ruled pencil
19.6 × 30.6cm (7¹¹⁄₁₆ × 12¹⁄₁₆″)
RL 7452. P.10; C/L 574; Venice 1962, no. 5; Venice 1982, no. 9; New York 1989–90, no. 93; Venice 2001, under no. 25

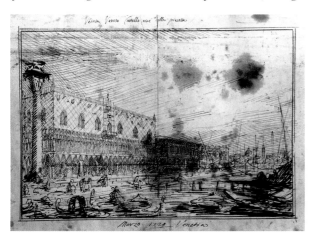

Fig. 18 Canaletto, *The Molo and Riva degli Schiavoni, looking east* 1729. Pen and ink, 21.0 × 31.5cm (8¼ × 12⅜″)
Hessisches Landesmuseum, Darmstadt (C/L 573)

22 The Molo, looking west
1729

The view is from roughly the same point as the previous drawing (and is essentially identical in size and style), but looking in the opposite direction. Here too Canaletto enlarged the column, this time that of San Teodoro, relative to buildings beyond – the Libreria, followed by the Zecca (the mint of Venice), then the broad staircase of the Ponte della Pescaria, the site of a fishmarket whose awnings Canaletto indicated with a series of horizontal scribbles. Then comes the Granai di Terranova, a huge brick building erected in the fourteenth century as the state granaries, demolished during the Napoleonic occupation and replaced by gardens to give a view from the end of Napoleon's intended palace (see no. 16) across the Bacino. Next are the buildings of the Fontegheto della Farina, better seen in nos. 70–73, and finally the mouth of the Grand Canal, including the tower of Palazzo Venier delle Torreselle.

Canaletto painted variants of this view several times (C/L 95–8), usually as pendants to the views east along the Molo mentioned in no. 21. All the paintings extend the view to the left to include Santa Maria della Salute, and that church appears in a rapid sketch in Philadelphia (fig.19) that seems to be preliminary to the present drawing, though with a lower viewpoint and the buildings on the right in more dramatic perspective. The Philadelphia sketch is virtually identical in size and style to a sketch of the Piazzetta (mentioned under no. 23) dated 1729 by the artist, and it is very likely that the same date applies to the present drawing.

Pen and ink, over free and ruled pencil, 19.6 × 30.5cm (7¹¹⁄₁₆ × 12˝)
Inscribed in pencil on the verso, *Smith*
RL 7460. P.9; C/L 565; Venice 1962, no. 6; London 1980–81, no. 51; Miller 1983, no. 6; Corboz 1985, no. D73

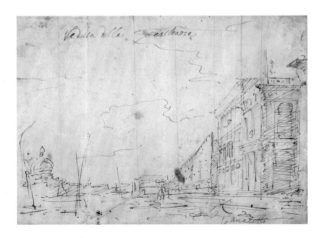

Fig. 19 Canaletto, *The Molo, looking west*, 1729
Pen and ink, with ruled pencil lines
18.6 × 27.3cm (7⁵⁄₁₆ × 10¾˝)
Philadelphia Museum of Art (C/L 568)

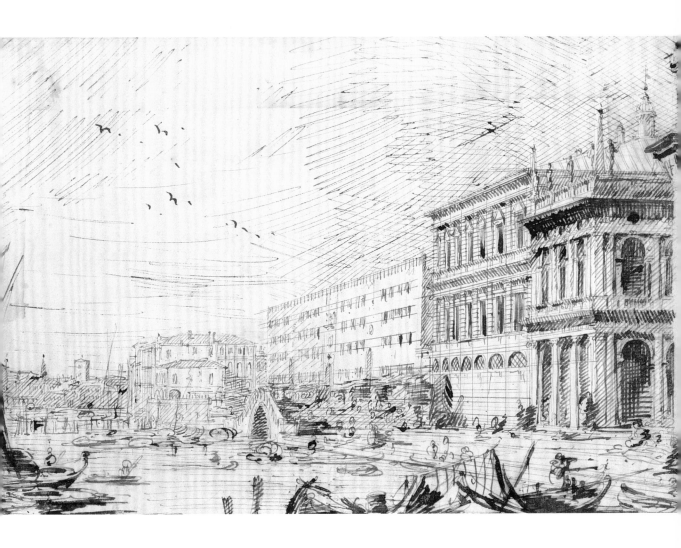

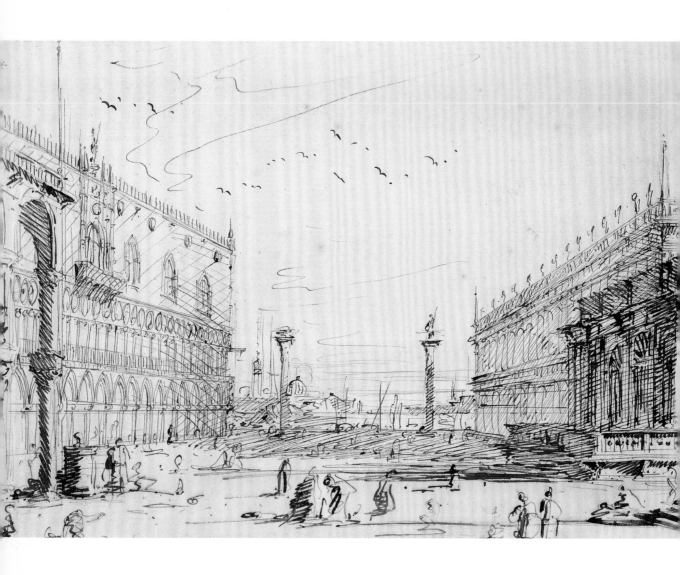

23 The Piazzetta looking south
1729

This is one of the few drawings in the catalogue that was apparently done on the spot – or rather, on two spots. While the façades of the Palazzo Ducale, to the left, and the Libreria, to the right, are not quite parallel, their receding horizontals should not converge towards vanishing points as wildly divergent as Canaletto has drawn them here. The left side of the view was drawn standing in front of the second bay of San Marco, almost between the two northern flagpoles (fig. 20). But from that point, the Libreria is mostly hidden by the Loggetta at the base of the Campanile; Canaletto walked about ten metres (thirty feet) to the south-east to stand in front of the central door of San Marco, thus obtaining the view recorded in the right side of the drawing (fig. 21). The width of the Piazzetta has been reduced – most of San Giorgio should be visible between the Palazzo Ducale and the column of the lion, and by placing the column too close to the Palazzo (cf. no. 20), Canaletto had to draw the dome of San Giorgio to the right of the column. The belltower of San Giorgio has the onion dome that was completed in 1728.

It is conceivable that Canaletto constructed the drawing in the studio on the basis of two sketches done on the spot, and the inadvertent reversal of the lion of St Mark, apparently facing to the right, might support this. But there is, unusually, no pencil underdrawing, and it may be observed that the diagonal shading of the narthex and Palazzo is hatched as if with the left hand, and that of the Libreria and shadow across the Piazzetta as if with the right. There is a clear break in the drawing at the corner of the Palazzo Ducale, suggesting that that was the boundary between one phase of sketching and the next. While Canaletto drew the buildings from a normal standing height, he dashed in the foreground figures as if from a much more elevated position, and thus their scale and perspective are drastically at odds with the surrounding architecture.

Canaletto drew this view of the Piazzetta rarely, and never painted it. His only other rendering is an even more rapid and rudimentary sketch (private collection, C/L 545), with the perspectives accurately drawn from a single standpoint, inscribed by the artist with the title *Veduta della piaza Versso il Mar* and the date 1729. While not simply a refined version of that sketch, the present sheet may well have followed it directly, 'improving' the composition by bringing the two sides of the Piazzetta closer together and thus concentrating the visual interest.

Pen and ink, 21.3 × 31.7cm (8¾ × 12½″)
Inscribed in pencil on the verso, *Smith*
RL 7441. P.8; C/L 546; Venice 1982, no. 7; Corboz 1985, no. D18

Figs. 20–21 *The Piazzetta looking south*, 2005

24 The Bacino di San Marco on Ascension Day

1729

The view is taken from the Bacino, directly in front of the Zecca. On the left are the Zecca and Libreria with the excessively slender Campanile behind. Beyond the Piazzetta, with both columns correctly placed, are seen the Torre dell'Orologio and the south flank of San Marco with only the western dome visible. Next is the Palazzo Ducale, drawn in exaggerated two-point perspective, and to the right, rapidly diminishing in size, the Prigioni and indications of the Palazzo Dandolo. Canaletto narrowed and heightened most of the buildings – especially the Palazzo Ducale, which should be much wider – to squeeze a panoramic view into a normally proportioned composition.

In front of the Palazzo Ducale are moored the Doge's galleon, the *fusta*, covered with a striped awning, and the Bucintoro: the scene depicted is thus the Ascension Day celebration (see no. 14). It is likely that Canaletto here recorded the ceremony of 26 May 1729, the first *Sensa* at which the new gilded Bucintoro appeared. Although it had been used for the ceremony the previous year, the allegorical sculptures decorating the new Bucintoro had not then been gilded, and the excitement generated by the spectacle of 1729 must explain why Canaletto was commissioned to produce at least three large paintings of the scene soon thereafter: for the ambassador of the Holy Roman Emperor (private collection, C/L 336 – a pair to a painting of *The Reception of Conte Giuseppe Bolagnos at the Palazzo Ducale on 29 May 1729*); for the French ambassador (Pushkin Museum, Moscow, C/L 338); and reputedly for Louis XV (Bowes Museum, Barnard Castle, C/L 337).

In all of these paintings the perspectival effects of the Palazzo Ducale are reduced, and the Doge's galleon is greatly foreshortened to lessen its visual impact and thus give more prominence to the Bucintoro. The foreground boats are much larger, with incidental detail such as an imminent collision between two gondolas, and it is clear that in this drawing Canaletto simply jotted in a few boats without any thought of their final effect. A few years later Canaletto painted the scene again for Joseph Smith (no. 14), flattening the perspective a little further and playing down the drama of the foreground boats.

The drawing is freely sketched in pale ink with horizontal and diagonal scribble-hatching. There is a horizon line ruled in pencil, and three vertical lines dividing the sheet exactly into quarters widthways. While these lines do not coincide with any salient features and can hardly have been used to lay out the composition, it does seem likely that the drawing was not made on the spot – bobbing around in a boat on the Bacino – but was constructed in the studio from brief sketches and from memory.

Pen and ink, over a little free and ruled pencil
21.3 × 31.7cm (8¾ × 12½")
Inscribed in pencil on the verso, *Smith*
RL 7451. P.7; C/L 642; Venice 1962, no. 4; London 1980–81, no. 50; Venice 1982, no. 5; Miller 1983, no. 5; Corboz 1985, no. D16; New York 1989–90, no. 92; Venice 2001, no. 26

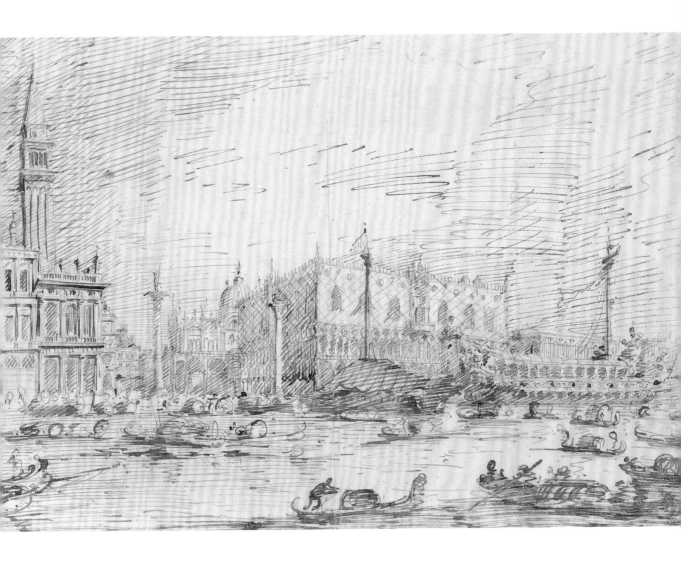

105

25 The Bacino looking west from San Biagio
1729

The view is taken from in front of the church of San Biagio, on the Riva (waterfront) as it curves round the Canale di San Marco east of the Bacino. From left, Canaletto has drawn the dome and north flank of San Giorgio Maggiore; the Bucintoro at anchor; the dome of Santa Maria della Salute; the Campanile; the Riva degli Schiavoni, with two belltowers on the skyline, those of San Giorgio dei Greci and San Giovanni in Bragora (the latter demolished in 1826); and the buildings of the Riva della Ca' di Dio and Riva di San Biagio, drawn in very uncertain perspective. Beyond the bridge over the Rio dell'Arsenale, to the right, is the broad Forni Militari, the state bakery that supplied the Republic's ships as they left the Arsenale. On the façade of the Forni is a pencil inscription, presumably by Canaletto, which has not been satisfactorily deciphered,

though the last part of the first line may read *Smartino* (the church of San Martino lies a little behind the Forni).

The drawing is close to a larger sheet at Darmstadt (fig. 22), in which the buildings to the right are increased in scale, and the Bucintoro is replaced by a moored boat that dominates the foreground. In those respects it closely resembles the following drawing and it is likely that the Darmstadt drawing was a revision of the present sketch, framing its rather uniform middle ground with a couple of blocky foreground elements.

Pen and ink, over free pencil and two ruled vertical lines
21.3 × 31.8cm (8⅜ × 12½")
RL 7457. P. 11; C/L 577; Miller 1983, no. 11; Corboz 1985, no. D12

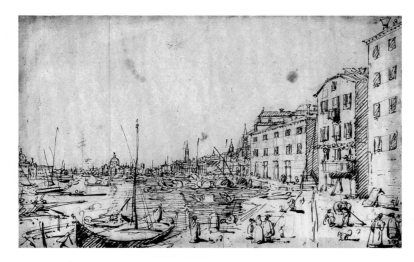

Fig. 22 Canaletto, *The Bacino looking west from San Biagio*, 1729
Pen and ink, 23.0 × 38.5cm (9⅟₁₆ × 15¹³⁄₁₆")
Hessisches Landesmuseum, Darmstadt (C/L 575)

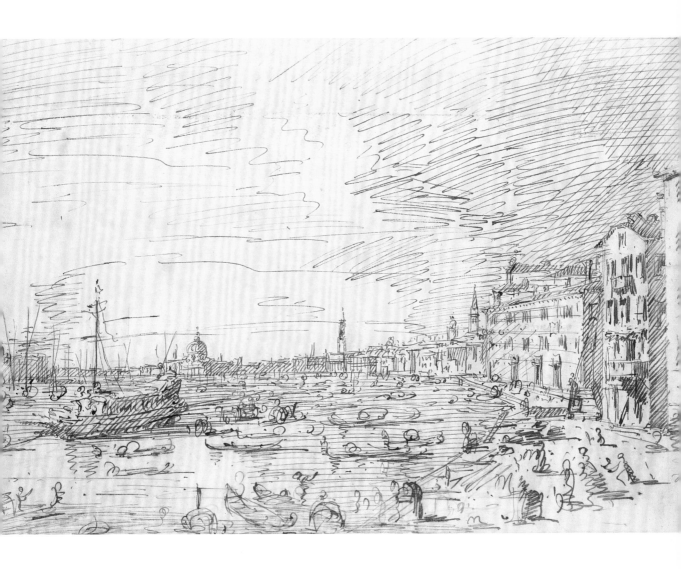

26 The Bacino looking west from San Biagio
c.1735–40

As described above, Canaletto revised his sketch of the Bacino (no. 25) in fig. 22, emphasising the foreground elements. The present finished drawing agrees with fig. 22 in most particulars, such as the presence of two bays of windows in the building to the right, but with the dominant foreground mast eliminated and the Campanile moved to the right. While the excessive scale and discordant perspective of the Forni Militari (third from the right) in fig. 22 have been tamed, there remains a spatial discontinuity between the Forni and the buildings beyond, making it appear that the Riva stepped back at that point. The line of buildings along the horizon was transcribed from a succession of six openings of the Venice Sketchbook (ff. 40v–46r). Canaletto also used the composition for two variant paintings (Vienna and Sir John Soane's Museum, C/L 121–2).

The normal assumption would be that this finished drawing was executed soon after the Windsor and Darmstadt sketches. But the style of the drawing is that of Canaletto's works of a decade later, with looping figures and two different shades of ink – relatively pale and applied with a fine nib for the outlines and lighter shading, much darker and dashed in with a broad nib for the pools of shadow. It seems that, as so often in the later 1730s, Canaletto based the composition of a finished drawing on a work of several years before.

Pen and ink, over free and ruled pencil and pinpointing
20.5 × 37.6cm (8¹/₁₆ × 14¹³/₁₆")
RL 7455. P.23; C/L 576; Corboz 1985, no. D13

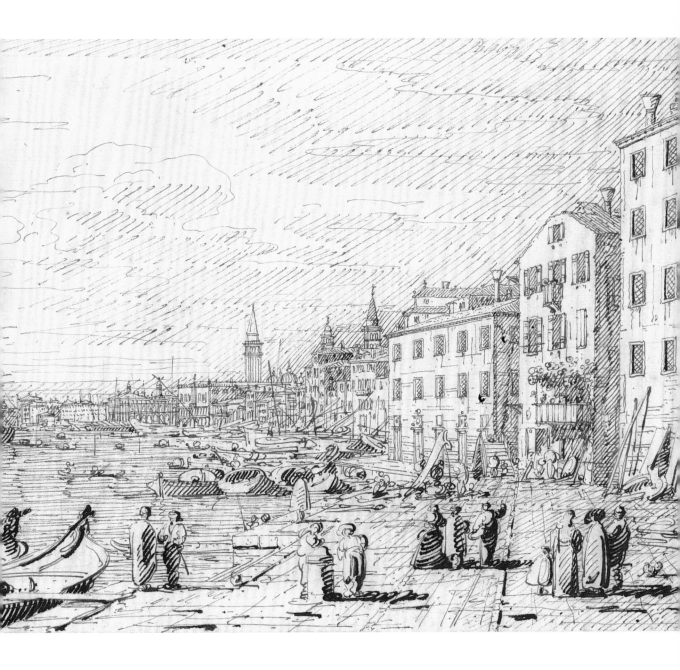

27 The Bacino looking west
*c.*1734

As there is no connection between the foreground and the distant buildings, it is difficult to identify the intended viewpoint, though it appears to be close to that of the two previous drawings. This is therefore essentially an enlarged version of the left two-thirds of nos. 25–6, eliminating the less picturesque buildings to the right of the composition, and swinging the Riva around a little further to fill the entire lower portion of the sheet (a feature that it shares with a number of related paintings, C/L 138–9*). It is not entirely clear what Canaletto's model was for some of the details – the façade of the Libreria, for example, is here more meticulously drawn than in either the previous drawing or the Venice Sketchbook (f. 40v), and Canaletto must have used a number of different pictorial sources to compile the image.

The drawing of the figures, and the crispness of definition of the buildings, of this and the following sheet are close to the Grand Canal drawings (nos. 29–34) of around 1734, and both may be dated to the same period. What appears to have been a reaction between the ink and an early mounting paste has caused the ink to fade more around the edges of the drawings.

Pen and ink, over free and ruled pencil and pinpointing
26.8 × 37.5cm (10 %₁₆ × 14¾")
RL 7454. P.24; C/L 579; Venice 1962, no. 15; London 1980–81, no. 52; Miller 1983, no. 7; Corboz 1985, no. D85

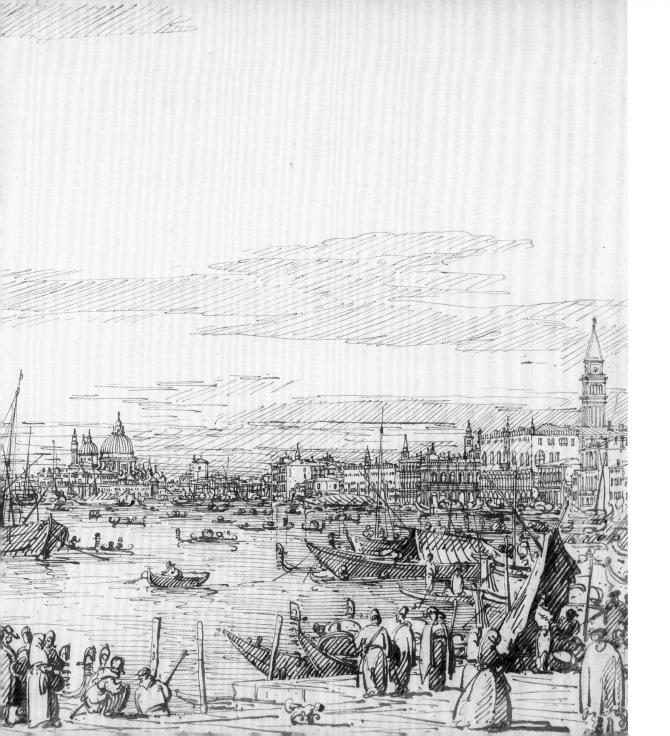

28 The Bacino looking west on Ascension Day
c.1734

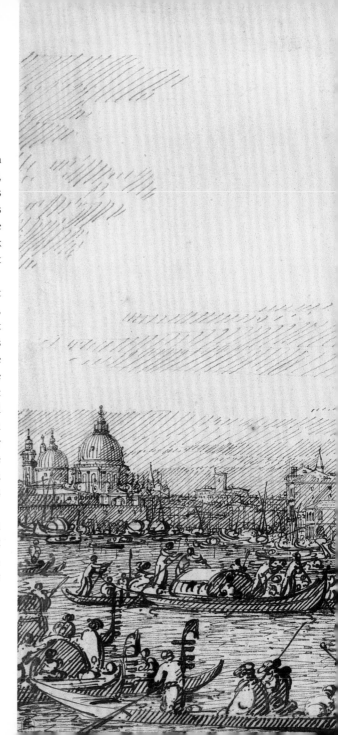

The drawing is very close in size and style to no. 27, though the present sheet is more extensively shaded in the water, and they may have been intended to form a pair of views in the Bacino. It is even closer to the Grand Canal series (nos. 29–34) than the previous sheet, and may have been intended as an 'introduction' to that sequence of six views; the following drawing shows the view from the most distant point visible here.

To the left is Santa Maria della Salute; on the distant horizon, the tower of Palazzo Venier delle Torreselle, strangely less dominant than in the previous, more distant view; to the right of the turn in the canal are the buildings around the Fontegheto della Farina, seen from close quarters in nos. 70–73. The church belltowers of the *sestiere* of San Marco protrude above the waterfront sequence of Granai, Zecca, Libreria, Palazzo Ducale and Prigioni, dominated by the massive Campanile, drawn unusually at its correct width but heightened significantly (only half of the shaft seen here should be visible over the roof of the Palazzo Ducale). Moored in front of the Piazzetta is the Bucintoro, indicating that this is Ascension Day, as depicted in nos. 14 and 24.

The composition of the buildings has much in common with a painting at Woburn Abbey (C/L 332), one of two that are larger than the other twenty-two in the Woburn series, though that painting raises the viewpoint and extends the composition to the right.

Pen and ink, over ruled and free pencil and pinpointing
27.0 × 37.5cm (10⅝ × 14¾")
RL 7453. P.22; C/L 643; London 1980–81, no. 53;
Miller 1983, no. 8; Corboz 1985, no. D28

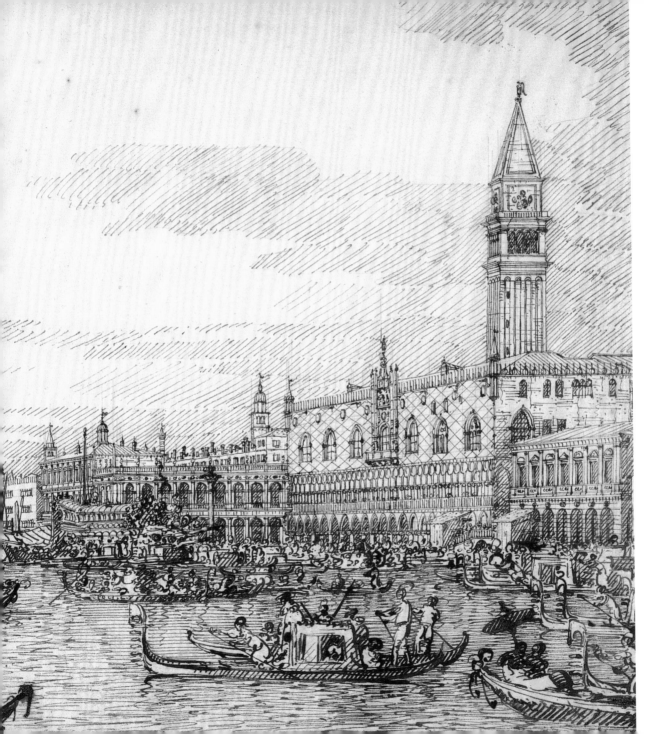

The Grand Canal drawings

Canaletto's paintings of the Grand Canal executed for Joseph Smith (nos. 1–12) were followed a few years later by a set of seven finished drawings. The drawings record the views from six points on the canal, with two versions of no. 29 from essentially the same point. All are of Canaletto's standard 'full size' for his finished drawings, around 27 × 37.5cm (10½ × 15″), except one (no. 30) the same width but 22cm (8¹¹⁄₁₆″) high; they are drawn in a single shade of dark brown ink, over a careful construction of pinpoints, ruled vertical lines and a little freehand sketching for the figures and boats in the foreground.

In their richness and variety of tone and descriptive effect, the Grand Canal drawings are the most accomplished pieces of sustained penmanship of Canaletto's whole career. The buildings are meticulously constructed with dense, even lines and regular patches of parallel hatching to block in the shadows. The water is composed of columns of rapid horizontal scribble, the edges of each column suggesting the reflections of the buildings in the water. In the foregrounds are large, boldly drawn boats and figures, rounded counterpoints to the rigorous lines of the buildings beyond. Only the manner of drawing the sky varies, ranging from light and regular parallel hatching, through looser horizontal and diagonal scribbling, to dramatically gradated cross-hatching.

The compositions were constructed from a continuous run of twenty-four openings in the Venice Sketchbook (ff. 10v–34r), probably of the early 1730s. They do not correspond with Smith's Grand Canal paintings, and unlike that set of views, there was no attempt to cover the whole of the Grand Canal. There are versions of all six compositions in the Woburn Abbey group of c.1731–6, but there are further paintings of the Grand Canal at Woburn, some derived from the Sketchbook but not corresponding

Background detail taken from *The Grand Canal looking west from Palazzo Vendramin-Calergi towards San Geremia* (no. 4)

with drawings here (C/L 245, 247, 256), others derived not from the Sketchbook but from earlier paintings by the artist (C/L 164, 215, 225).

Though the consecutive nature of the source sketches indicates that these six views were conceived as a group, the sketches cannot have been executed expressly for the set of drawings. They have colour notes, indicating that paintings were envisaged. Further, no. 34 here does not match the viewpoint of the sketches, and Canaletto made a fresh study of the revised composition from a viewpoint further south (figs. 24–25), inscribed with the date 1734. It is thus likely that several years elapsed between the compilation of the sketches and the execution of the Grand Canal drawings.

There are same-size replicas by Bellotto of all the Grand Canal drawings at (or formerly at) Darmstadt (K.10, 11, 13, 14, 18, 19), together with two further views on the Grand Canal (K.9, 17) that, though of the same format, do not mimic Canaletto's style exactly and are probably inventions by the younger artist. A puzzling case is that of no. 31, where Bellotto's version agrees in most respects with Canaletto's, while including a number of buildings that Canaletto recorded in the Sketchbook but omitted from his drawing. In dating Bellotto's drawings to 1735–8, Kozakiewicz (K., p. 64) argued that they were based directly on Canaletto's Sketchbook rather than on the present drawings, but the consonance of size and style of Bellotto's drawings with nos. 29–34 would therefore require Canaletto to have been copying Bellotto. An alternative explanation is that Canaletto produced more than one version of several of the drawings; two versions of no. 29 survive, and Bellotto copied only fig. 25, but there may also have been two versions by Canaletto of no. 31, and Bellotto copied the second version, now lost.

29 The lower reach of the Grand Canal, c.1734

Dominating the right bank is Palazzo Corner della Ca' Grande, begun in 1533 to the designs of Sansovino and now the Prefettura. Beyond, towering over its neighbours, is Palazzo Pisani, just completed by Girolamo Frigimelica when Canaletto made his drawing. In the furthest distance, with a small roof-tower, is Palazzo Contarini degli Scrigni, which occupies the left foreground of the following drawing. To the left is the belltower of Santa Maria della Carità (see no. 9); further left, the tall façades of Palazzo da Mula and Palazzo Centani, in sharp foreshortening. At the left edge of the sheet is the gothic Palazzo Venier dei Leoni, pulled down in the 1740s to make way for a new palace; only the ground floor was completed before work came to a halt, and the stump of the building now houses the Peggy Guggenheim collection. In the left foreground men perilously handle a huge barrel on a *sandolo*, while to the right others punt a long raft downstream.

The view, excluding Palazzo Corner, was constructed from four openings of the Sketchbook (ff. 10v – 14r). Also at Windsor is a second version of the drawing that replicates most of the composition but reduces the scale of Palazzo Corner and includes more of Palazzo Venier at the left, and it was this second version that Bellotto reproduced in the drawing at Darmstadt (K.10). The buildings here agree closely with the painting at Woburn Abbey (C/L 193). Visentini's engraving for the 1742 *Prospectus* reproduces the two sides of the composition on different scales, radically enlarging the left with respect to the right.

Pen and dark ink, over ruled pencil and pinpointing
27.0 × 37.3cm (10⅝ × 14¹¹⁄₁₆")
Inscribed in pen on the verso, *antonio*
RL 7470. P.18; C/L 585; Venice 1962, no. 9; London 1980–81, no. 55; Venice 1982, no. 11; Miller 1983, no. 10

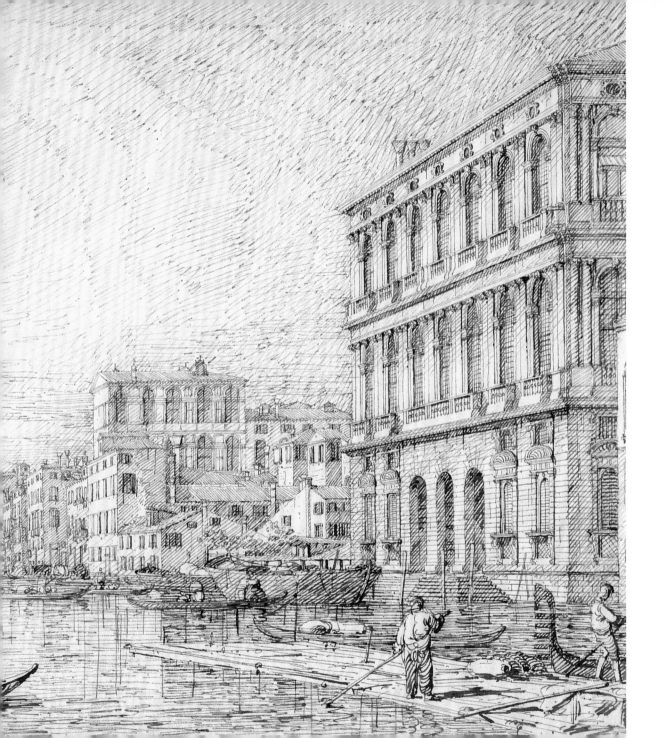

30 The lower bend of the Grand Canal, looking north-west

*c.*1734

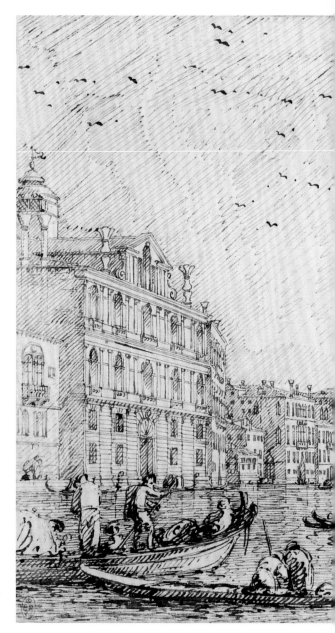

In the left foreground is Palazzo Contarini degli Scrigni, remodelled by Vincenzo Scamozzi after 1609 to unify the pre-existing buildings on this site. In the distance, as the canal turns to the right, is Ca' Rezzonico with a pitched roof, prominent in the foreground of the following drawing. Seen to its right with two obelisks on the roof are Palazzo Giustinian-Lolin (an early work by Longhena), then Casa Civran Badoer, followed by the low buildings gathered around Campo San Vidal, the site of the *Stonemasons' Yard* in the National Gallery, the masterpiece of Canaletto's early period.

The view is essentially that obtained today from the Accademia bridge, though Canaletto has not shown the two banks of the canal in register, for Palazzo Giustinian-Lolin should actually be closer to the viewer than Palazzo Contarini degli Scrigni. This inaccuracy must have arisen in the process of assembling the composition from three openings of the Sketchbook (ff. 14v–17r). The painting at Woburn Abbey (C/L 200) shows more to the left, and alters the proportions of the buildings; much closer to the present composition is a second painting (private collection, C/L 201) that even reproduces most of the boats on the canal.

Pen and dark ink, over ruled pencil and pinpointing
22.0 × 37.6cm (8¹¹⁄₁₆ × 14¹³⁄₁₆")
RL 7474. P.19; C/L 586; Corboz 1985, no. D57;
Bomford and Finaldi 1998, p. 47

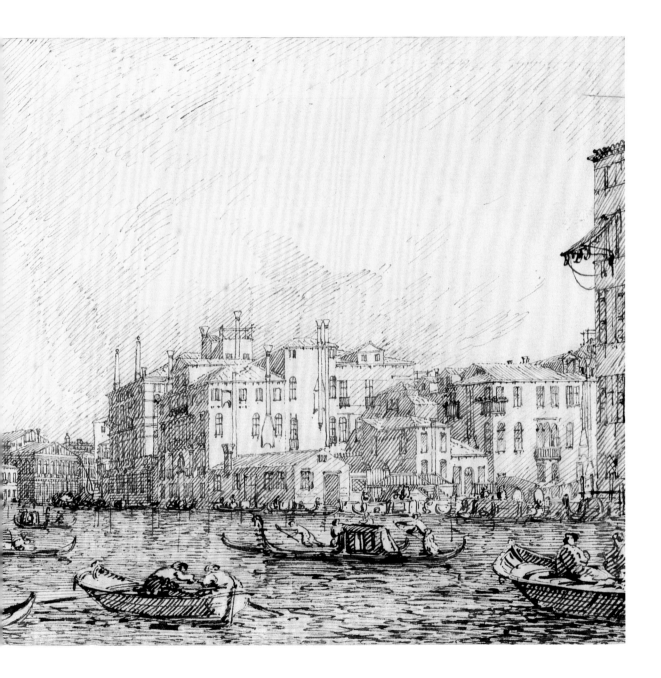

31 The lower bend of the Grand Canal, looking north

*c.*1734

The view is taken from the point in the Grand Canal seen in the distance in no. 30, and shows the sharp bend at the south-west of the Grand Canal, known as the Volta del Canal. To the left is the incomplete Ca' Rezzonico, begun in 1649 by Longhena for the Bon family but built only as far as the first floor by the time of Longhena's death in 1682. A temporary roof was placed over this part, as seen here, and work did not resume until the Rezzonico family bought the palace in 1750 and commissioned Giorgio Massari to complete the building. It now houses the Museum of Eighteenth-Century Venice.

Beyond are two large fifteenth-century palaces, Palazzo Giustinian and Ca' Foscari. As the canal curves around, Palazzo Balbi is seen almost frontally, built in the late sixteenth century to the designs of the sculptor Alessandro Vittoria, with the belltowers of the Frari to the left and San Tomà (the upper part seen here since demolished) to the right. In shadow on the right bank is the foreshortened façade of Palazzo Moro-Lin, and at the right edge of the sheet the corner of Palazzo Malipiero. The motley buildings in between, bordering Campo San Samuele, were replaced after 1749 by Massari's Palazzo Grassi, now an exhibition centre. A *burchiello* (passenger barge) is under tow in the right foreground.

The drawing was constructed from four openings of the Sketchbook (ff. 17v–20v), though here Canaletto moved Palazzo Malipiero in to the left to eliminate some of the buildings in Campo San Samuele; Bellotto's copy (fig. 23) shows all the buildings seen in the Sketchbook and may record an alternative version of the drawing by Canaletto. The painting at Woburn Abbey (C/L 202) maintains the proportions of the buildings to the left, but dramatically opens out the façade of Palazzo Moro-Lin to dominate the right side of the composition.

Pen and dark ink, over ruled and free pencil and pinpointing
27.2 × 37.5cm (10¹¹⁄₁₆ × 14¾˝)
RL 7468. P.20; C/L 588; Corboz 1985, no. D37

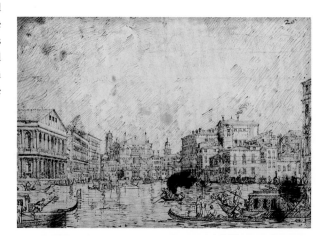

Fig. 23 Bellotto, *The lower bend of the Grand Canal, looking north*
*c.*1735–40. Pen and ink, 26.7 × 38.3cm (10½ × 15˝)
Hessisches Landesmuseum, Darmstadt (K.13)

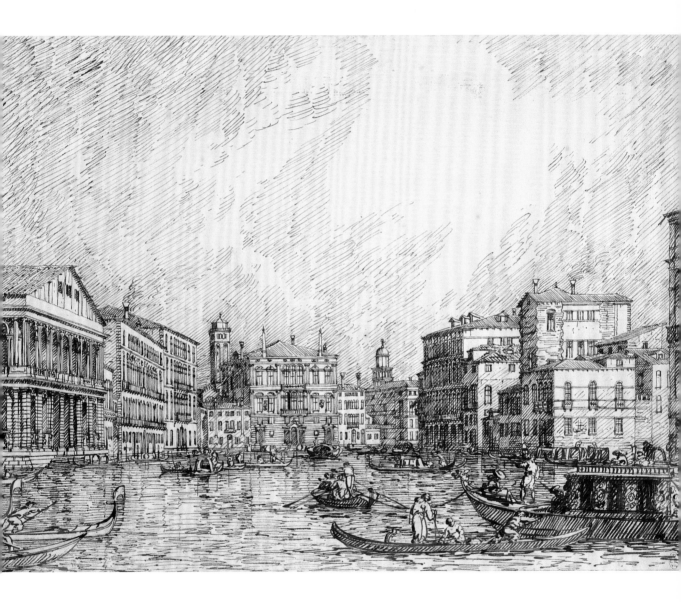

32 The central stretch of the Grand Canal
*c.*1734

No. 32 looks north-east along the central stretch of the Grand Canal from opposite Palazzo Barbarigo (now near the *vaporetto* stop of Sant'Angelo). Half of the Rialto bridge can just be seen in the distance as the canal bends to the left. In the right foreground is Palazzo Corner-Spinelli, built around 1490 by Mauro Codussi; beyond, the tallest building is the sixteenth-century Palazzo Grimani. On the left are the low Palazzi Cappello-Layard and Grimani-Marcello, followed by the taller Palazzi Giustinian-Querini and Bernardo. Further down the canal, surmounted by twin obelisks, is Palazzo Papadopoli (formerly Coccina-Tiepolo). On the horizon is the pointed belltower of San Bartolomeo, replaced after 1747 by a taller baroque structure.

Canaletto laid out the view on four openings of the Sketchbook (ff. 21v–25r), which as usual records only the outlines of the buildings, with no indication of shading. In the Woburn Abbey painting (C/L 209) the light falls from the right (the usual direction), here from the left (which would require a late afternoon in the summer).

Pen and dark ink, over ruled pencil and pinpointing
27.0 × 37.5cm (10⅝ × 14¾")
RL 7471. P.21; C/L 590; Toronto etc. 1964–5, no. 37; New York 1989–90, no. 95

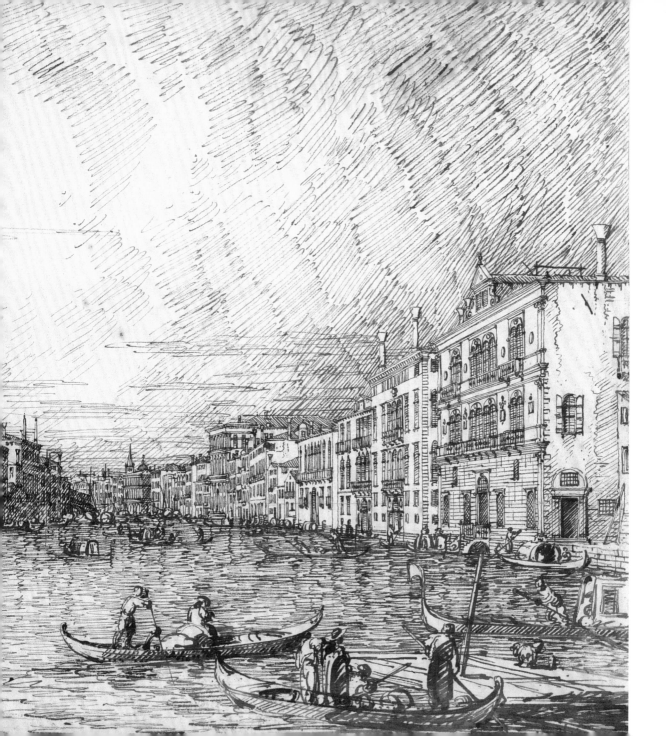

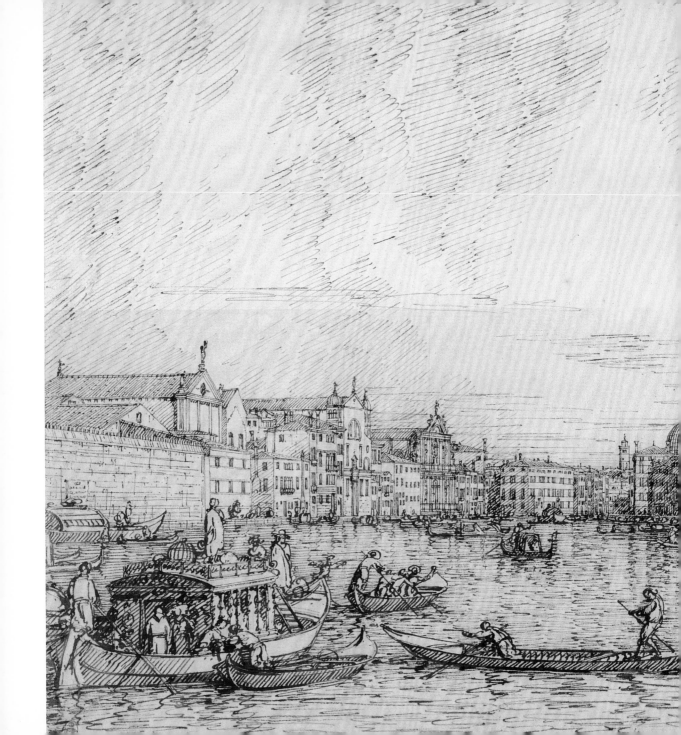

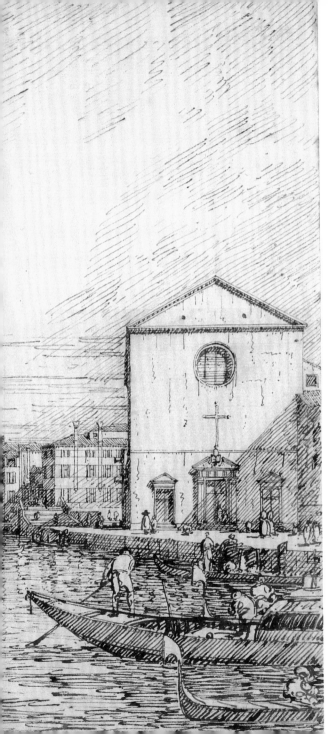

33 The Grand Canal, looking east from the Fondamenta della Croce

c.1734

The drawing shows the same stretch of the Grand Canal as no. 2, looking in the opposite direction. In the right foreground is the simple conventual church of Santa Croce that gave its name to this *sestiere* of Venice, demolished in 1810 and replaced by communal gardens. Canaletto has omitted an arched window above each lateral door, an error corrected in the following drawing. Beyond is the dome of San Simeon Piccolo (no. 43), rather reduced in height, with the belltower of San Geremia (no. 4) in the distance. To the left is the low pitched roof of Corpus Domini behind its convent wall, quickly followed by the tall façade of the Scuola dei Nobili, and further along the canal the churches of Santa Lucia and the Scalzi. Only the Scalzi remains today; the convent was demolished after its suppression in 1810, and all the other buildings to the left were pulled down by 1860 to make way for the railway station. In the left foreground is a *burchiello* being towed into the city.

The view was constructed from four openings of the Sketchbook (ff. 25v–29r). The painting at Woburn Abbey (C/L 263) contrives a more distant view of the scene; a painting from the Harvey collection (C/L 262) takes a higher viewpoint but otherwise agrees with the present drawing in most respects. The Harvey composition was engraved by Visentini for the 1742 *Prospectus*, and this became a popular view of Venice, repeated many times by Canaletto's followers.

Pen and dark ink, over ruled and a little free pencil and pinpointing
26.9 × 37.6cm (10⁹⁄₁₆ × 14¹³⁄₁₆")
RL 7472. P.16; C/L 599; London 1980–81, no. 54; Miller 1983, no. 9; Corboz 1985, no. D25; Bomford and Finaldi 1998, pp. 25–6

34 The upper reach of the Grand Canal, looking south, *c.*1734

The view is taken from the centre of the upper end of the Grand Canal, looking south towards the sharp bend by Santa Croce. The three extant buildings seen at the left of no. 1 are here at far right, the tallest cut by the edge of the sheet. The Piazzale Roma *vaporetto* stop now occupies the right foreground of the view. The circular sign attached to the balcony at near right marks the house of the British Secretary-Resident (not to be confused with the Consul). Only one other building along the waterfront survives, the seven-bay palazzo in the centre distance, from where Canaletto took the view of the preceding drawing. The windowless façade with an external chimneybreast lies where the Rio Nuovo, opened in 1933, now gives onto the Grand Canal. At the left of the composition is the church of Santa Croce (with two arched windows above the lateral doors), whose façade is seen frontally in no. 33. Beyond is the tribune and belltower of San Nicolò da Tolentino, and just to the left, shown larger than in reality and thus appearing too close, the belltower of the Frari. At far left is the corner of the convent wall of Corpus Domini.

The history of the composition is more than usually complicated. Canaletto's studies in the Sketchbook (ff. 29v–34r) show this stretch of canal from further north, with more buildings to the right and Santa Croce hidden behind the convent wall, and that view was the basis for paintings in the Woburn Abbey and Harvey groups (C/L 266–7). But here, perhaps wishing to show the façade of Santa Croce, Canaletto took a new viewpoint to the south, sketched on both sides of another sheet at Windsor dated 16 July 1734 (figs. 24–25; the Sketchbook would still have served for the details of the façades). From this new composition derived paintings in the Wallace Collection and the Musée Cognacq-Jay, Paris (both under C/L 268); the Paris version was the basis for Visentini's engraving in the 1742 *Prospectus*. Bellotto reproduced the drawing twice, once faithfully, the second time enlarging the distant buildings and changing the foreground boats (K.19–20).

Pen and dark ink, over ruled and a little free pencil
and pinpointing, 27.0 × 37.8cm (10⅝ × 14⅞")
RL 7473. P.14; C/L 600

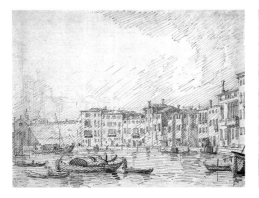

Figs. 24–25. Canaletto
*The upper reach
of the Grand Canal,
looking south*, 1734
Pen and pale ink
17.5 × 24.2cm (6⅞ × 9½")
P.15r–v

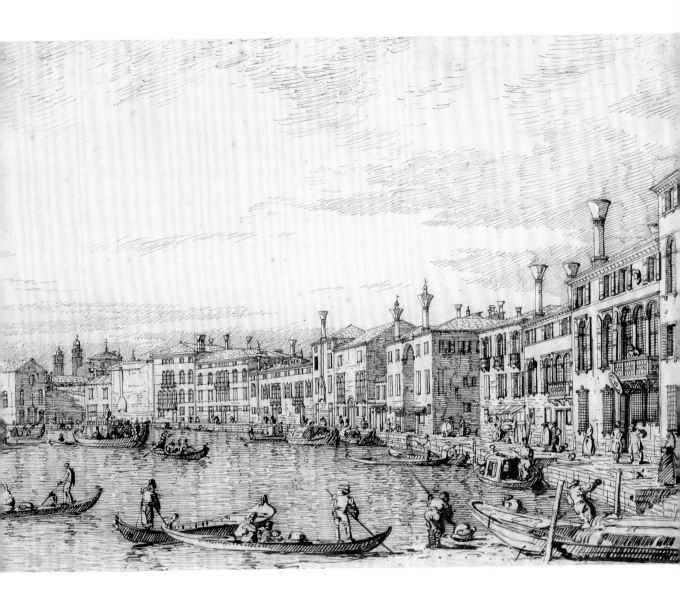

Churches and squares of Venice

A series of ten drawings (and one replica, of no. 36) at Windsor depicts the churches and squares of Venice, ranging from some of the most famous sights in the city (the Piazzetta, the churches of San Giorgio Maggiore and the Redentore, the *campi* of Santi Giovanni e Paolo and Santa Maria Formosa) to less obvious choices, such as San Giovanni Battista dei Battuti on the island of Murano. Eight of the drawings are of Canaletto's standard 'full size', roughly 27 × 38cm (10½ × 15″); the other two are the same width but about 23cm (9″) high. They are drawn in pen and dark brown ink, sometimes of two shades, over an underdrawing of ruled and freehand pencil and a little pinpointing; the versos are blank.

Eight of the compositions correspond more or less closely with paintings from the early to mid-1730s measuring around 47 × 78cm (18½ × 31″) – one of Canaletto's standard canvas sizes at this time – four of which form part of the group at Woburn Abbey. Of the two remaining compositions, one (no. 44) reproduces a larger painting probably of the late 1720s, and the other (no. 43) was first sketched by Canaletto around 1730 and is found in a small studio painting of a few years later. As with the Grand Canal drawings (nos. 29–34), therefore, none of the compositions was devised expressly for these drawings. The correspondences with the respective paintings, however, are of such varying degrees of closeness that it is impossible to accept the proposal that the drawings were records of paintings that Joseph Smith had handled as a dealer, or any other practical motive of this nature. The drawings were not simply a series of separate images, but were intended to be seen as an aesthetically pleasing group, and Canaletto took pains to harmonise the pictorial effects. His skilful manipulation of perspective allowed him to disguise the radically different angles of view and the consequent range of foreshortenings that should be disconcertingly obvious – the views of Campi Santa Maria Formosa and Santi Giovanni e Paolo encompass an angle as wide as 120°, those of

Background detail taken from *The Grand Canal looking north-west from near the Rialto* (no. 5)

San Giorgio Maggiore and the Redentore one as narrow as 20°.

The blocks of shading are hatched straight over the architecture, obscuring many painstaking details in the process, and it may be that the immediate models were outline drawings that Canaletto transcribed to a standard format before articulating the forms with shadows. The drawings are characterised by a general evenness of tone, though there is some variety in the graphic conventions: the skies, for instance, vary from loose patches of irregularly diagonal hatching (no. 37) to carefully outlined and shaded clouds (no. 38). In some drawings the foreground is populated with a few large figures, heavily hatched (nos. 40, 44), in others the small figures form unemphatic clumps in the middle ground (nos. 36–7). This may have been a compositional device, depending on whether the artist wished to balance a distant motif with strong foreground accents or allow a more even panoramic effect.

There is little hard evidence for the date of these drawings, and any internal topographical information (e.g. for no. 43) can only provide a date after which the drawing must have been made. Nothing compels a dating after the middle of the 1730s, but it may be that the drawings were produced over a period of several years – the best of the sheets, *Campo Santo Stefano* (no. 37), has a richness and flexibility barely inferior to the Grand Canal series of *c*.1734, but *San Pietro di Castello* (no. 42), for example, shows the dead line and hollow figures to which Canaletto's later drawings occasionally succumbed. Four of the compositions are known in drawings by Canaletto's nephew Bellotto (nos. 36–9, the first two following the dimensions of the Windsor drawings, the second two significantly enlarged); one of these (copying no. 38) is dated 1740, and a conservative range of *c*.1735–40 is suggested here for the group, with any more precise dating for individual drawings probably unachievable.

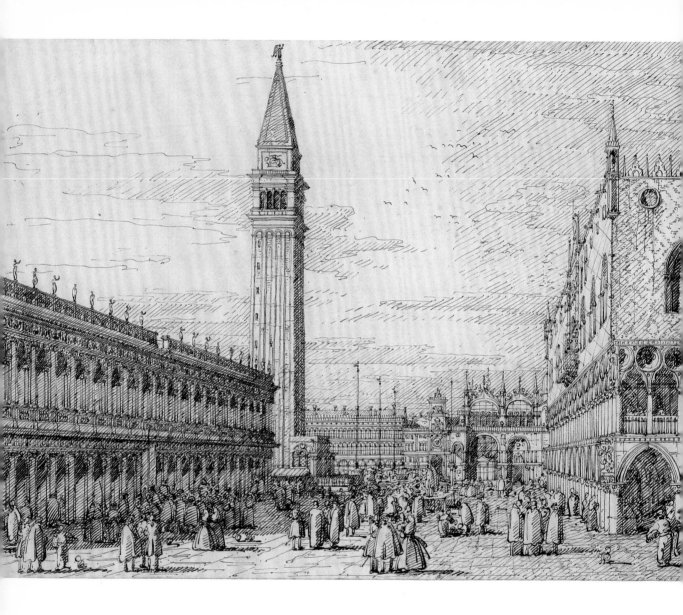

35 The Piazzetta, looking north

c.1735–40

The viewpoint is ostensibly a little off the Molo, though it is likely that Canaletto assembled the composition from studies taken on dry land, not entirely successfully – San Marco appears to merge with the distant Torre dell'Orologio, the scale of the figures in the Piazzetta is inconsistent, and the perspective of the Palazzo Ducale is slightly fudged such that its near corner seems to be sinking into the Piazzetta. As usual, Canaletto has heightened and slimmed the Campanile, but the most significant deviation from reality is the omission of the column with the lion of St Mark, which should dominate the centre foreground.

Canaletto painted the composition several times, the prime version being a painting at Woburn Abbey (C/L 64), in which the sunlight falls from the right and the Libreria is diminished in size and further away across a widened Piazzetta. In those respects the painting follows a schematic drawing at Darmstadt, dated July 1732 (fig. 26), but the eye-level perspective was corrected in the Woburn painting, and here, to give the impression of a view from a height of about five metres.

Pen and dark ink (two shades), over ruled and free pencil and pinpointing, 27.0 × 37.5cm (10⅝ × 14¾")
RL 7437. P.25; C/L 550; Venice 1962, no. 12; Corboz 1985, no. D34; Frankfurt etc. 1989–90, no. 32

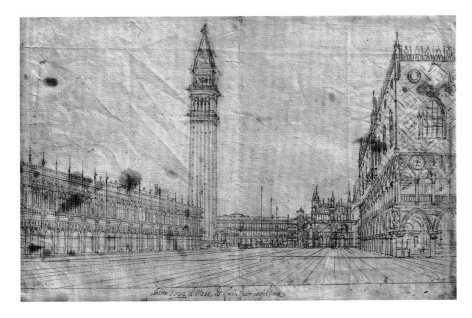

Fig. 26 Canaletto
The Piazzetta, looking north, 1732
Pen and ink
25.5 × 41.0cm (10 1/16 × 16⅛")
Hessisches Landesmuseum,
Darmstadt (C/L 551)

36 Campo Santa Maria Formosa
c.1735–40

The church of Santa Maria Formosa was, according to tradition, founded in the seventh century on the site of a vision of a particularly beautiful Madonna; hence *Formosa*, in the sense of 'shapely'. The church was rebuilt after 1492 to the designs of Mauro Codussi, on the plan of a Greek cross with arms of equal length. Unusually, it has two façades, the main entrance facing the *rio* (out of sight beyond the belltower in this view, which is drawn too slender), and a ponderous façade added to the north transept at the start of the seventeenth century, seen here looking onto the Campo. Canaletto has taken a very wide-angle view, ostensibly from a first-floor window in the Palazzo Ruzzini in the northern corner of the Campo. To the left in shadow are the gothic façades of the complex Palazzo Donà; in the distance, seen square on, is the Renaissance Palazzo Malipiero Trevisan, now disfigured by a roof extension. Little else has changed to this day.

Both Carlevarijs and Lovisa depicted this view in their collections of engravings of 1703 and *c*.1720, but Canaletto did not depend on their prints, and constructed the drawing from a series of three openings in the Sketchbook (ff. 36v–39r). Canaletto painted the composition several times, adjusting the perspectives, lighting and figures on each occasion; what was probably the first version, at Woburn Abbey (C/L 278), renders the buildings to the left in steeper perspective. A later version (private collection, C/L 280) was engraved by Visentini for the *Prospectus* of 1742. A replica of the drawing by Bellotto agrees in all details except the sky (Darmstadt, K.22). Uniquely, a second version by Canaletto is also at Windsor (fig. 27), replicating the architecture with only small differences, such as the shading of the windows to the right and the shorthand for the rooftiles, but differing entirely in the figures, and drawn with a sharper pen in a darker ink.

Pen and ink, over ruled and a little free pencil and pinpointing
27.1 × 37.8cm (10¹¹⁄₁₆ × 14⅞")
RL 7478. P.38; C/L 604; Corboz 1985, no. D49

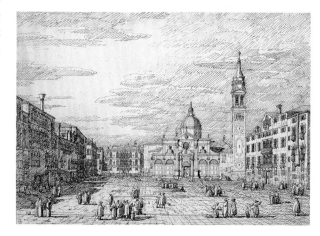

Fig. 27 Canaletto, *Campo Santa Maria Formosa*, *c*.1735–40
Pen and ink over pencil, 27.0 × 37.6cm (10⅝ × 14¹⁵⁄₁₆"). P.39

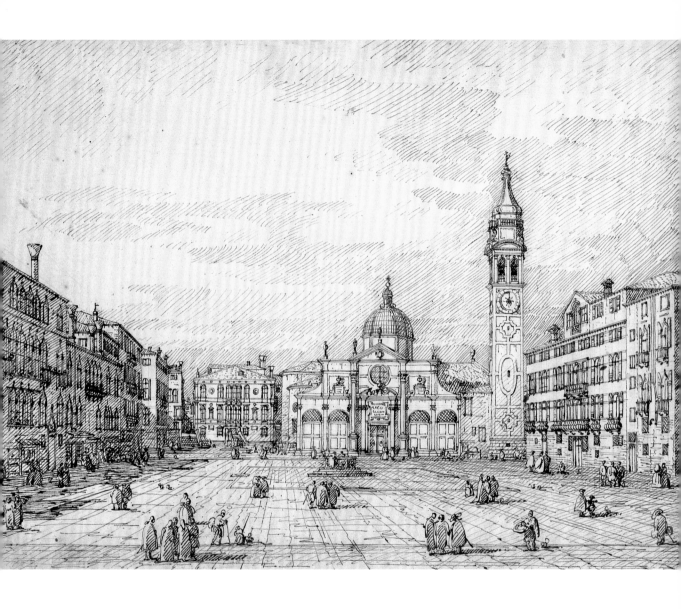

133

37 Campo Santo Stefano
c.1735–40

Campo Santo Stefano lies in the southern bend of the Grand Canal, west of San Marco. Canaletto has taken his view looking south from the first-floor window of the house on the corner of Calle delle Botteghe and Calle dei Frati; the church of Santo Stefano itself, forming the north-east side of the square, is thus out of sight beyond the left of the composition.

This is one of the largest squares in Venice, with two well-heads. The pair that can still be seen today, in the left foreground and middle distance here, were recent replacements (of 1724) when Canaletto made his drawing. To the left the buildings have unusually extravagant examples of the typically Venetian flared chimneystacks. Beyond is Palazzo Morosini, with its imposing gateway in the far corner of the square. To the right is the Palladian-style northern façade of Palazzo Loredan (formerly Mocenigo), added in 1618 to the pre-existing Renaissance building. The *palazzo* was converted in 1810 into the Istituto Veneto di Scienze, Lettere e Arti.

The drawing corresponds, excepting the figures, with a painting at Woburn Abbey (C/L 284), the composition of which was engraved by Visentini for the *Prospectus* of 1742. A version of the drawing by Bellotto (Darmstadt, K.21) extends the composition a little to the left to include another chimneystack, but otherwise agrees in all respects.

Pen and ink, over ruled and free pencil and pinpointing
27.2 × 37.7cm (10¹¹⁄₁₆ × 14¹³⁄₁₆")
RL 7480. P.41; C/L 607

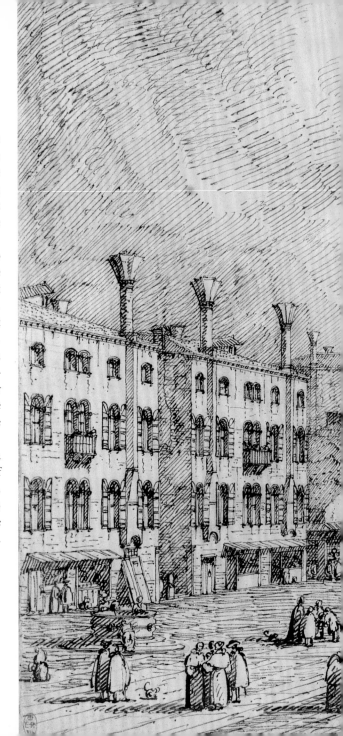

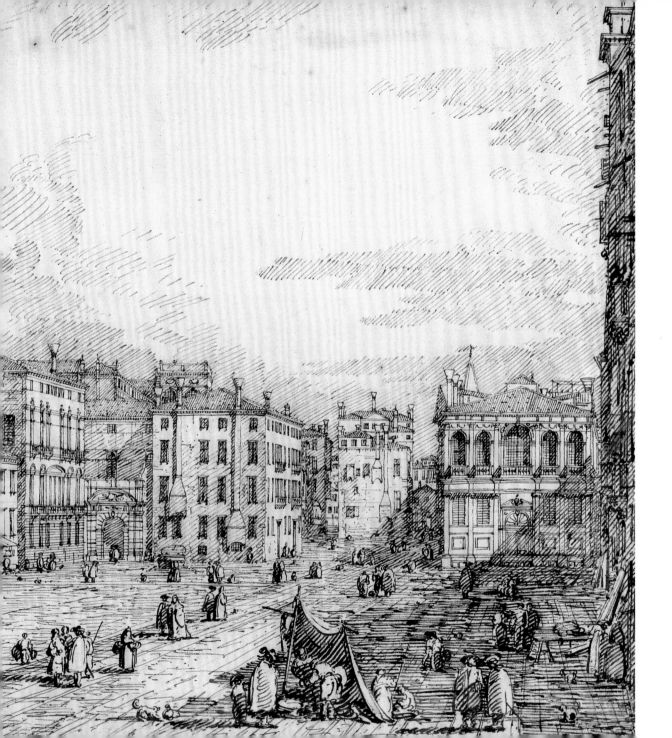

38 Campo Santi Giovanni e Paolo
c.1735–40

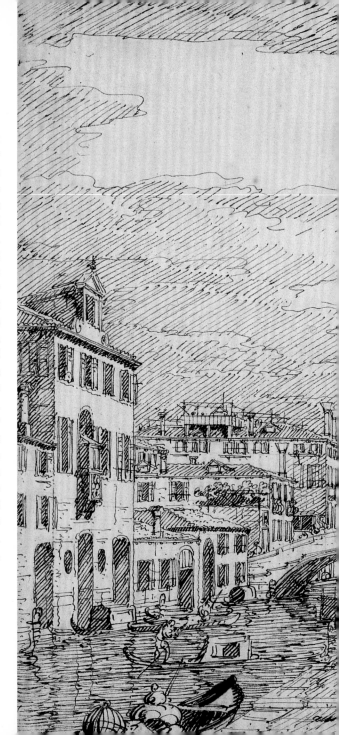

At the centre is the ornate late fifteenth-century façade, in coloured marbles with *trompe-l'oeil* arcades in the lower arches, of the Scuola Grande di San Marco, suppressed in 1807 and now part of the city hospital. To the right is the huge gothic brick church of Santi Giovanni e Paolo (in Venetian dialect San Zanipolo), built between 1234 and 1430 and the burial place of many of the greatest Venetians. Running up the left of the composition is the Rio dei Mendicanti; at the right is Andrea del Verrocchio's equestrian monument to Bartolomeo Colleoni, mercenary leader of the Venetian forces. On his death in 1475 Colleoni left a large bequest to the Republic, with the condition that his monument be placed in front of the basilica of San Marco. After much debate the Senate wilfully misinterpreted the terms of the bequest and allowed the erection of the monument in front of the Scuola of the same name, a less prestigious site. The scene has changed little in five centuries.

Canaletto constructed his view from a first-floor window of a house on the south side of the Campo, but in reality the façades of those houses rise from a line corresponding with the lower edge of the drawing. He has thus rendered the foreground buildings 'invisible' to take in an angle of some 120° without having to resort to extreme perspectival effects. Canaletto first painted the composition as early as 1725 and he and Bellotto repeated it several times, sometimes expanding the view even further (C/L 304–7, K.24–5).

Pen and dark ink, over ruled and free pencil and pinpointing
27.1 × 37.9cm (10¹¹⁄₁₆ × 14¹⁵⁄₁₆")
RL 7481. P.40; C/L 613; Rome 2005, no. 34

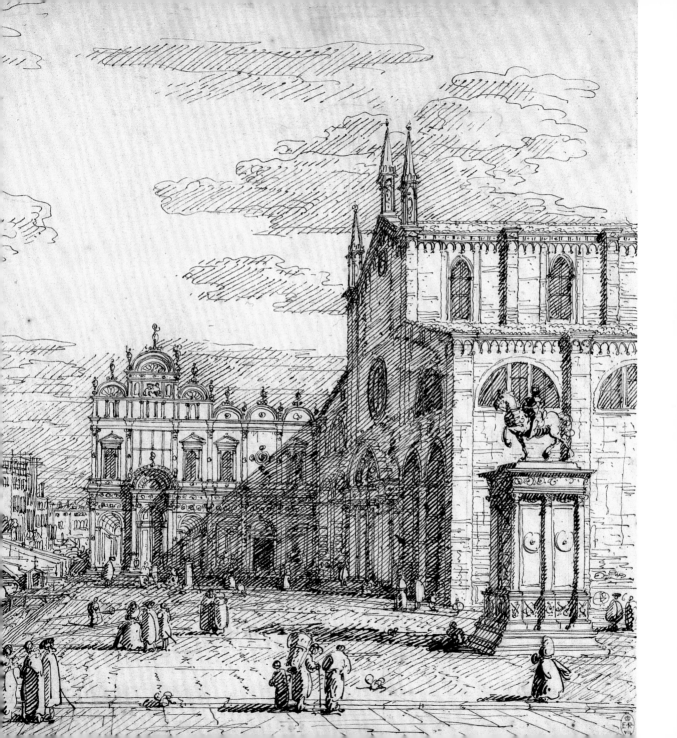

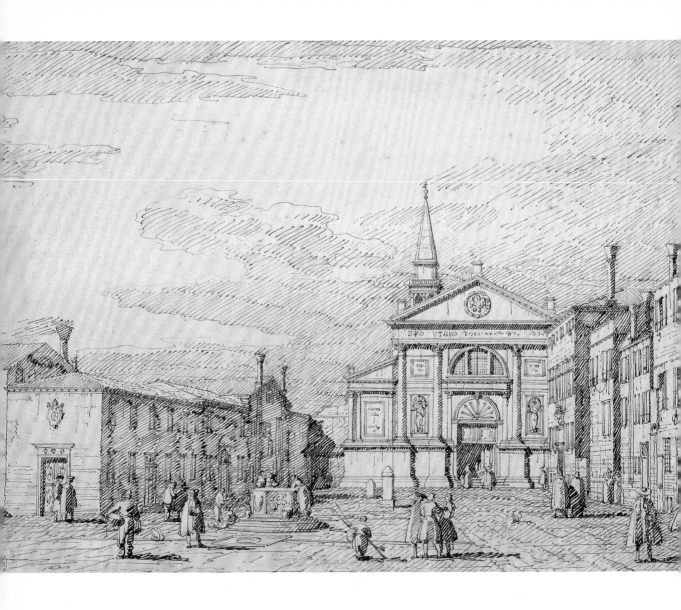

39 Campo San Francesco della Vigna
c.1735–40

The church of San Francesco della Vigna is situated in a quiet area in the north-east of Venice little visited by tourists. It was founded in the thirteenth century on the site of a vineyard, hence its name, and was rebuilt after 1534 by Sansovino, with the façade added in the 1560s by Palladio. The belltower to the rear of the church, one of the tallest in Venice, was completed in 1581 in emulation of that of San Marco.

Canaletto took a wide-angle view from the west side of the Campo in front of the church, and included the top of the belltower, visible from all over the city but hidden behind the façade when standing in front of the church. To the left are the low buildings of the Franciscan monastery, suppressed in 1810 and subsequently completely rebuilt. To the right, partially blocking the view of the façade, is the sixteenth-century Palazzo Gritti (or della Nunziatura). The

Palazzo actually obscures more of the façade of the church than Canaletto has drawn; a corresponding painting from the Harvey group (private collection, C/L 295, of the early 1730s) shows the correct arrangement of the buildings, and that feature was followed in an enlarged version of the drawing by Bellotto (fig. 28), which however agrees in most other details with the present sheet. Bellotto was thus not simply copying Canaletto's finished drawing, but both probably based their drawings on the same source material in the studio, material that Canaletto adjusted in that detail.

Pen and ink, over ruled and free pencil and pinpointing
27.3 × 37.7cm (10¾ × 14¹¹⁄₁₆")
RL 7494. P.36; C/L 609; Toronto etc. 1964–5, no. 38;
Venice 1982, no. 22; Corboz 1985, no. D71

Fig. 28 Bellotto
Campo San Francesco della Vigna
c.1735–40
Pen and ink over pencil
29.2 × 54.1cm (11½ × 21⁵⁄₁₆")
Hessisches Landesmuseum,
Darmstadt (K.26)

40 San Giorgio Maggiore
*c.*1735–40

The island of San Giorgio lies 400 metres to the south of the Palazzo Ducale, across the Bacino. A primitive church dedicated to St George became the home of a Benedictine monastery in 982; this was rebuilt several times before Andrea Palladio first remodelled the refectory, then in 1565 presented a model for a new church. Much of the body of the new church was completed before Palladio's death in 1580, but the façade in Istrian stone was not begun until 1599, and it is unclear how faithful this was to Palladio's designs. The monastery was suppressed during the Napoleonic occupation, and the buildings adjacent to the church were used as a military magazine and as warehouses. They were restored and ceded to the Fondazione Giorgio Cini in 1951, since when they have been the venue for several notable exhibitions of Canaletto's work (including Venice 1962, 1982, 2001).

Standing opposite the Molo and Riva, San Giorgio Maggiore occupies the most prominent site of any church in Venice. The rounded quayside in the foreground of the present drawing, and the panorama of the Riva to the left, imply that the view was taken from the Punta della Dogana, the easternmost point of Dorsoduro. But from that point San Giorgio is seen from slightly to the right of its central axis; in the drawing the church is seen as if from the Fondamenta della Farina, to the left of its axis. This 'long shot' of the church, from a distance of 500 metres, gives a foreshortening as strong as the view of the Redentore (no. 41) and, combined with the wide-angle view of the church's setting, greatly reduces the apparent width of the Bacino.

Pen and ink (two shades), over a little ruled and free pencil and pinpointing, 26.8 × 37.7cm (10⁹⁄₁₆ × 14¹³⁄₁₆")
RL 7482. P.35; C/L 612; Corboz 1985, no. D66

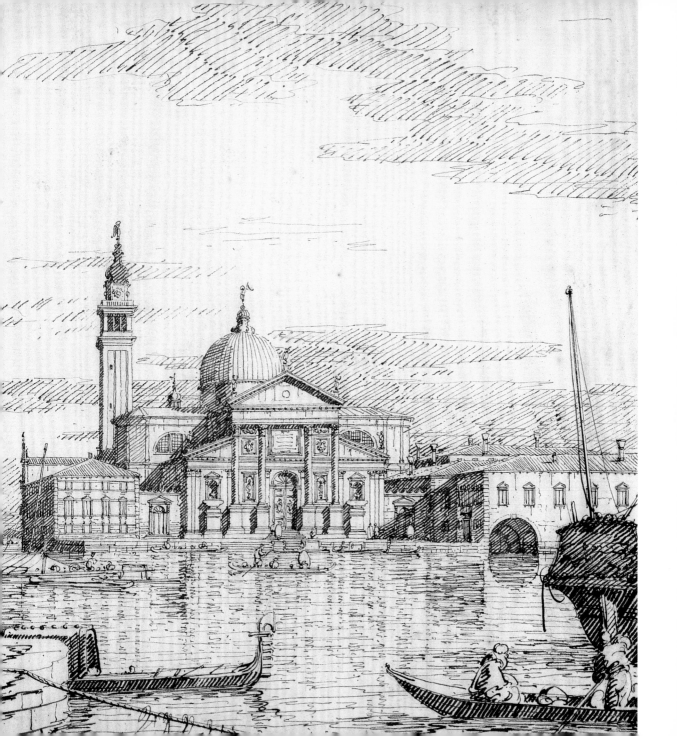

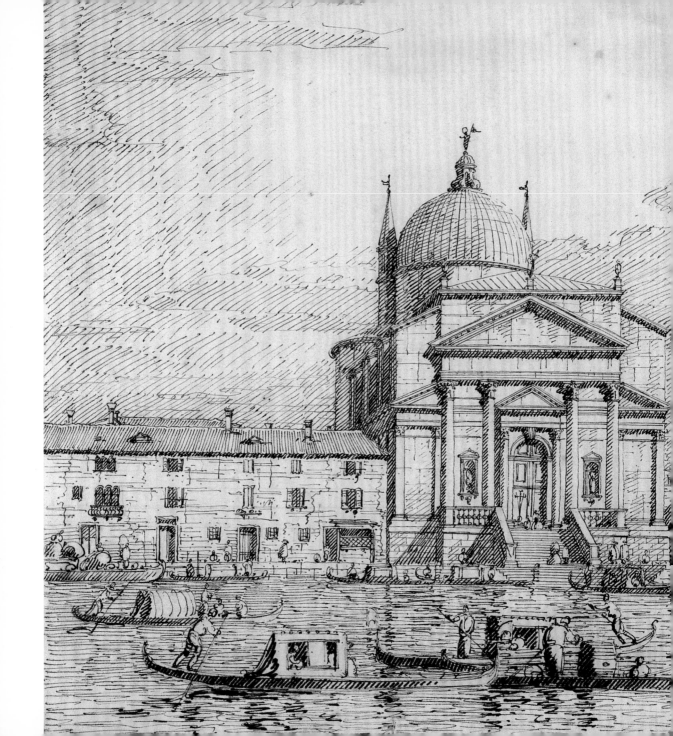

41 The Redentore
c.1735–40

The Franciscan church of the Redentore ('Redeemer') stands on the Giudecca, to the south of the main island of Venice. It was built between 1577 and 1592 to the designs of Palladio, as a votive offering for the eventual deliverance of Venice from the terrible plague of 1575–7 which killed around 50,000 people, a quarter of the city's population. Each year on the third Sunday in July, the Doge crossed the Canale della Giudecca from the Fondamenta delle Zattere on a pontoon bridge of boats to attend a thanksgiving service in the Redentore. The festival is still held annually.

Canaletto's view is taken from in front of the salt warehouses on the Zattere, the long quay running along the south of Dorsoduro named after the cargo rafts that unloaded into the warehouses there. The church is therefore seen from a distance of 400 metres, strongly foreshortening the building and compressing its long nave, which is better seen in the view of the church from the Riva, no. 51 below. Several similar paintings of the Redentore exist, the first version being that at Woburn Abbey (C/L 316), which shows the Redentore from exactly this angle but introduces the church of San Giacomo (seen in no. 51) to the right of the composition and several more boats in the foreground.

Pen and dark ink, over a little ruled and free pencil and pinpointing
26.8 × 37.3cm (10 9/16 × 14 11/16")
RL 7484. P.34; C/L 621; Corboz 1985, no. D84

42 San Pietro di Castello
c.1735–40

The church of San Pietro, on its island in the *sestiere* of Castello in the east of Venice, served as the cathedral of the city and the seat of the Patriarch of Venice from the eleventh century until 1807, when it was supplanted by San Marco. It was founded probably in the seventh century and rebuilt several times; the façade received its present form in the late sixteenth century, in white Istrian stone to an old design by Palladio, very similar to his Redentore (no. 41) and taller in its proportions than Canaletto has drawn it here. To the right of the façade is the palace of the Patriarch, now divided into apartments. The slightly leaning fifteenth-century belltower, visible from all over the city, lost its dome in a lightning strike of 1822, and trees now grow from the grass in front of the church, but otherwise the view has changed little.

Canaletto took his wide-angle view from a first-floor window in a building to the left of the Calle Largo di Castello, looking east across the Canale di San Pietro, whose width is here exaggerated. The wooden footbridge to the right still runs from the alleyway to the Isola di San Pietro. To the left of the composition is a view of the Dolomites on the horizon across the lagoon, now obscured by boathouses. In the National Gallery is a painting of the composition (C/L 315), of disputed status but good enough to be from Canaletto's studio with many details painted by the master himself.

Pen and dark ink (two shades), over ruled and free pencil and pinpointing, 23.4 × 37.4cm (9⁵⁄₁₆ × 14¾˝)
RL 7485. P.33; C/L 620; Corboz 1985, no. D83

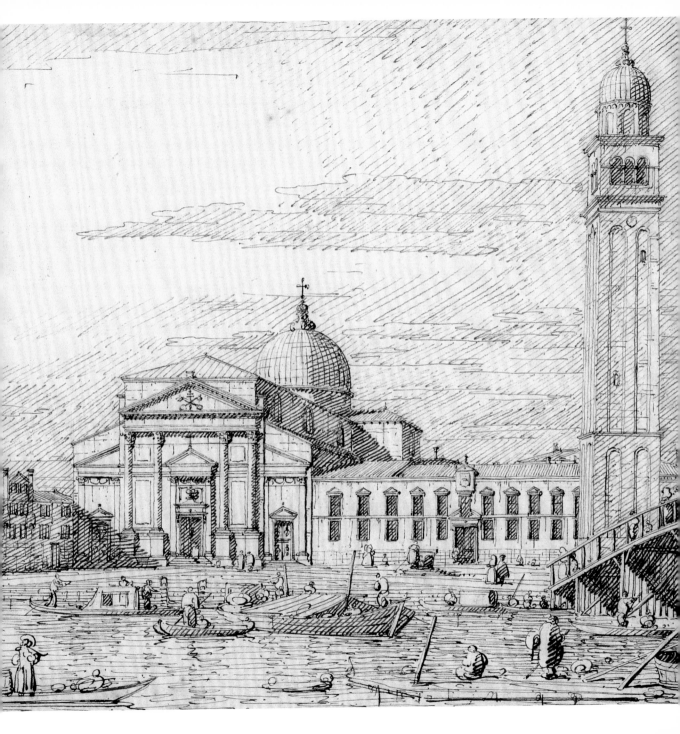

43 San Simeon Piccolo

c.1735–40

The church of Santi Simeone e Giuda, called by its common name of San Simeon Piccolo to distinguish it from the nearby church of San Simeone Profeta (known as San Simeon Grande), is one of the first sights encountered by the modern visitor to Venice arriving by train, on the Grand Canal opposite the railway station. To the left is the sixteenth-century Casa Adoldo, and to the right, set back from the edge of the canal with a large crucifix in a tabernacle at the centre of its façade, the small *scuola* of the wool-weavers, whose industry was concentrated in this area. Appearing at the left edge of the drawing is a *burchiello*, partly under tow by the *sandolo* to the right of centre.

San Simeon Piccolo was built on a circular plan between 1718 and 1738 to the designs of Giovanni Scalfarotto, following the demolition of the original ninth-century church, and is shown here as it nears completion. Blocks of undressed stone lean against the side of the church, and a temporary wooden staircase leads up to the portico. In that respect the drawing shows an earlier stage of construction than the painting of this stretch of the canal (no. 2), where the steps can be seen running the full width of the portico. But the drawing does not date from before the painting, for it follows the studies on two openings of the Venice Sketchbook (ff. 52v–54r) that were the basis of a finished drawing of the early 1730s (C/L 622b; repr. Byam Shaw 1983, I, fig. 79). It would appear that the present drawing is a version of the later 1730s, but Canaletto has made no attempt to update the topographical details. Though the colour notes on the sketches indicate that they were intended to serve for future reference should a painting be required, no equivalent painting by Canaletto himself is known, though there is a version by a follower in the National Gallery (C/L 320) that shows the church with the steps completed.

The perspective of this drawing requires a viewpoint some way back from the edge of the canal. In Canaletto's day, however, what is now the square in front of the station was crowded with buildings, and it is not clear where he can have stood to get this view (the Sketchbook views demonstrate that he has not manipulated the perspectives). The architect did not intend the church to be seen from a distance, and the dome was built unusually high to be seen clearly over the top of the portico from close quarters. Canaletto therefore reduced the height of the dome a little, and significantly diminished the size of the lantern, to play down the top-heavy effect of the dome when seen in a long view.

Pen and dark ink (two shades), over ruled and free pencil and pinpointing, 22.7 × 37.5cm (8¹⁵⁄₁₆ × 14¾″)
RL 7467. P.32; C/L 622; Toronto etc. 1964–5, no. 40;
Corboz 1985, no. D43; Bomford and Finaldi 1998, pp. 23–5

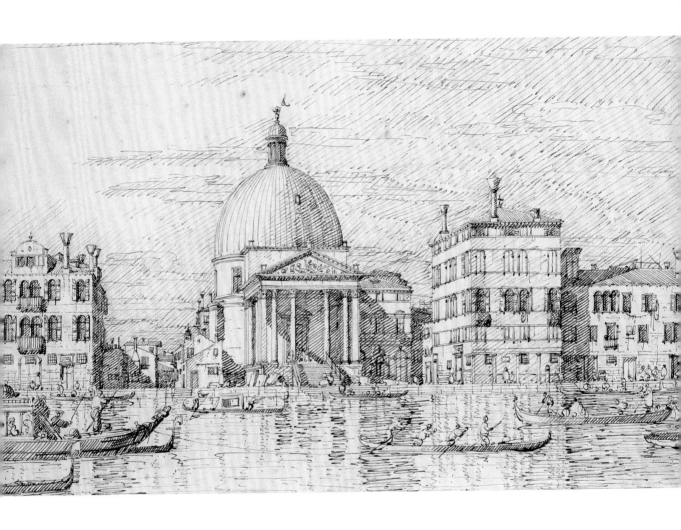

44 San Giovanni Battista dei Battuti, Murano

c.1735–40

The view is from the south-east of Murano, an island a kilometre to the north of Venice, looking south-west towards the city from the Fondamenta Navagero (or di San Giacomo), whose *motoscafo* jetty now occupies the foreground of this view. The arcaded building to the left still stands; the church of San Giovanni Battista dei Battuti ('of the metalbeaters'), on the far shore of the Grand Canal of Murano, was demolished in 1833, and replaced by the glass factories and lighthouse that occupy the site today. Along the horizon is Venice, the tower of San Francesco della Vigna prominent to the left, and the Campanile of San Marco and the dome of Santi Giovanni e Paolo at the centre of the sheet.

Canaletto based the drawing on a sketch (private collection, C/L 655b) that, as here, seems to show the façade of the church somewhat awkwardly, as if turned to the front. Also derived from that sketch is a smaller drawing, finished with the addition of wash (Rotterdam, C/L 655a). A corresponding painting – surprisingly, Canaletto's only painting from a viewpoint on Murano – is in the Hermitage (C/L 368; Venice 2001, no. 53), differing as usual in the figures and boats.

Pen and ink (two shades), over free and ruled pencil and pinpointing
27.0 × 37.8cm (10⅝ × 14⅞')
RL 7458. P.69; C/L 655; Corboz 1985, no. D94

Small pen drawings

The following eight drawings are executed in pen and ink (with the addition of a little wash in one case), each measuring approximately 19 × 27cm (7½ × 10½″), Canaletto's standard 'half-size'. Further members of the group are nos. 70 and 72 below, the first a view on the Fontegheto della Farina, the second a *capriccio* incorporating the buildings of that view. Five of the compositions (nos. 47–50 and 70) are studied on consecutive pages of the Sketchbook (ff. 3r–7r). Unlike the sketches for the Grand Canal series discussed above (pp. 114–15), there are no colour notes and none of the five studies relates closely to a painting. The conclusion must be that Canaletto was here not making finished drawings as by-products of his composition of paintings, but was thinking in his sketches about the need to restrict himself to a few relatively large elements when working with such small-scale compositions. Replicas of several of the small pen drawings exist, shaded with grey wash rather than hatched with the pen (see also nos. 71 and 73). These replicas appear all to be by Canaletto, though they are of varying quality and style, and while some may have been executed at roughly the same time as the pen versions, others may have been dashed off many years later.

Both no. 45 and figs. 24–25, which relate closely to no. 46, are inscribed on the verso with the date 16 July 1734. Those two drawings are, superficially at least, markedly different in style from each other, which should caution against dating Canaletto's drawings closely on grounds of style alone. In fact all are fundamentally alike in conception and should probably be dated to around that year.

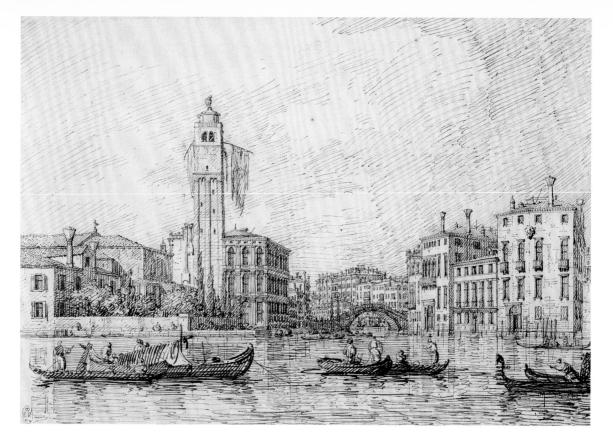

45 San Geremia and the entrance to the Cannaregio, 1734

The composition is essentially the same as that of the painting (no. 3), but from a lower viewpoint, as seen standing on the Riva di Biasio. The belltower of San Geremia is here lower, and thus closer to reality, and Palazzo Emo, second from the right, has been rebuilt.

The drawing is dated on the verso to 16 July 1734, the same date as that on figs. 24–25 (see p. 126). Unlike that sketch, however, the present drawing is carefully constructed with ruled lines and pinpointing, and was surely not made in front of the motif. Canaletto's reason for dating the drawing is unknown.

The drawing corresponds in all details with a painting in the National Gallery (C/L 251c), which must be based more or less directly on this drawing; the consensus is that the painting is of that problematic but numerous class, a 'good product of Canaletto's studio'.

Pen and ink over ruled and free pencil and pinpointing
18.8 × 27.0cm (7⅜ × 10⅝″)
Inscribed in pen on the verso, .1. 16 Luglio 1734
and in pencil, effaced, ...Regio
RL 7475. P.37; C/L 598; Potterton 1978; New York 1989–90, no. 96; Rome 2005, no. 25

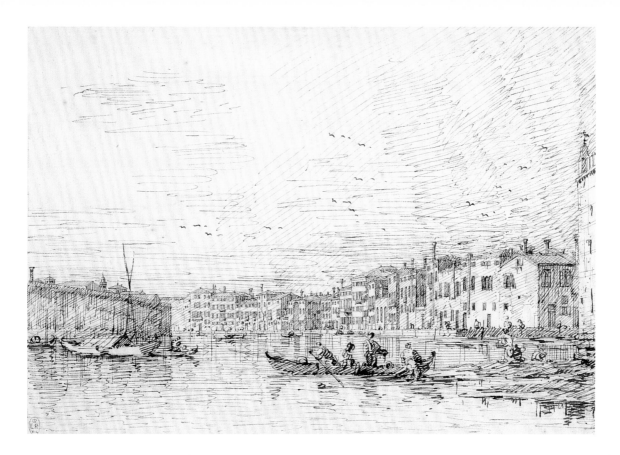

46 The upper reach of the Grand Canal, looking south, *c*.1734

At the left, in shadow, is the convent wall of Corpus Domini, above which protrudes the belltower of that church, the roof of Santa Croce, and the belltower and tribune of San Nicolò da Tolentino. At far right is the corner of the convent of Santa Chiara, beyond which is the mouth of the canal of the same name, followed by the buildings lining the Fondamente di Santa Chiara and della Croce, few of which survive today. Today the view is dominated by the multi-storey car park of Piazzale Roma to the right.

Canaletto studied the view from exactly this point on five openings of the Sketchbook (ff. 29v–34r), which formed the basis for paintings at Woburn Abbey and from the Harvey group (C/L 266–7). The paintings correspond to the present drawing in overall composition but with the boats and figures changed in each case. This drawing should however be construed not as a study for those paintings, but as a modest work of art in its own right.

Pen and ink, over ruled pencil and pinpointing
19.9 × 27.1cm (7¹⁵⁄₁₆ × 10¹¹⁄₁₆˝)
RL 7476. P.13; C/L 602; Venice 1962, no. 7; Corboz 1985, no. D48

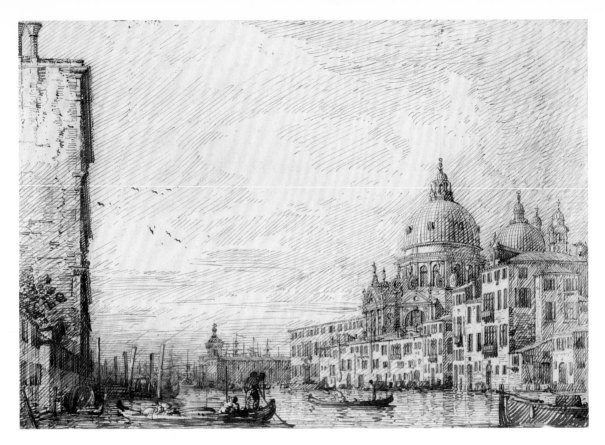

47 The lower reach of the Grand Canal, looking east

c.1734

The view was taken from a landing stage at the end of the Calle del Dose da Ponte. In the left foreground is the side of Palazzo Corner della Ca' Grande, seen in the painting from Campo San Vio (no. 10). In the distance are Santa Maria della Salute and the Dogana, with the masts of ships anchored in the Bacino beyond. All of the Salute, except for the domes, is now obscured from this position by the neo-gothic Palazzo Genovese, built at the end of the nineteenth century on the site of the abbey of San Gregorio, whose low waterside buildings are seen here.

This is one of the most beautiful of Canaletto's pen drawings, given an unusual degree of atmosphere by the application of a few dabs of wash at lower left. The composition is based on a free pencil study in the Sketchbook (f. 3r). Paintings of a similar view do exist (C/L 180–81), but none is closely related.

Pen and ink, over ruled and free pencil and pinpointing
with touches of wash, 18.9 × 27.3cm (7⁷⁄₁₆ × 10¾")
RL 7461. P.53; C/L 583; London 1980–81, no. 57; Miller 1983, no. 12; Corboz 1985, no. D90; New York 1989–90, no. 94

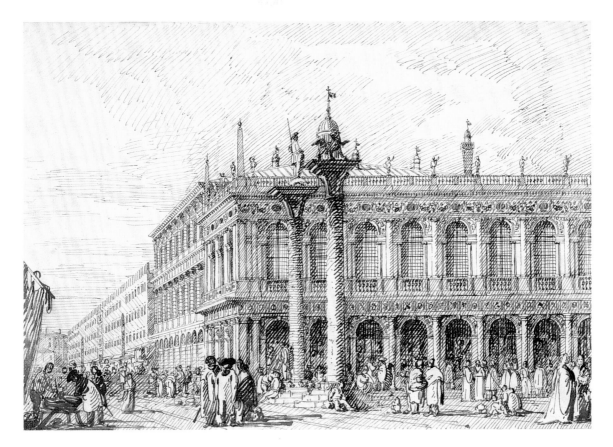

48 The Libreria and Molo

c.1734

Though the column of the lion seems too far to the left, this view can be obtained quite precisely by standing at the edge of the Molo before the centre of the Palazzo Ducale, whose corner lies just beyond the right side of the composition. Canaletto recorded the architectural details of the Libreria accurately, though he showed little interest in the sculptures standing on the balustrade, almost all of whom have here the same pose. He shifted the apex and lantern of the Libreria roof to the left – an odd decision, since it now confuses the outline of the lion on the column. Canaletto also opened out the perspective of the façades further along the Molo, thus exaggerating the width (impressive enough in reality) of the Granai.

The composition was roughed out in the Sketchbook (f. 6r), and was repeated, even to the figures, in a second drawing at Windsor – perhaps a little later in date – that uses grey wash instead of pen hatching.

Pen and ink, over ruled and free pencil and pinpointing
18.8 × 27.1cm (7⅜ × 10¹¹⁄₁₆″)
RL 7439. P.43; C/L 566; Venice 1962, no. 18; London 1980–81, no. 64; Miller 1983, no. 18; Corboz 1985, no. D87; Bonn 2002–3, no. 195; Rome 2005, no.26

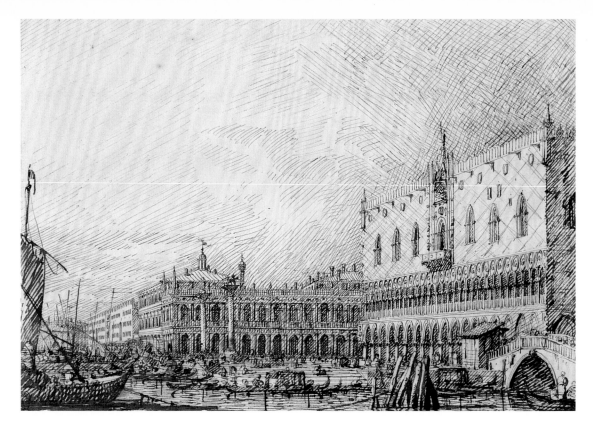

49 The Palazzo Ducale, Libreria and Molo

c.1734

The view is taken from a little way off the Riva degli Schiavoni. Canaletto has as usual narrowed the façade of the Palazzo Ducale to prevent it dominating the composition. In the right foreground, across the Rio di Palazzo, is the fourteenth-century Ponte della Paglia – the name supposedly records the straw that was unloaded here for the stables of the Palazzo Ducale and for the prisons.

Canaletto eliminated the Campanile, the bell-storey of which should protrude over the Palazzo Ducale, and widened the Piazzetta to show more of the Libreria, moving the column of the lion away from the Palazzo. Beyond the Zecca, the Granai are rather perfunctorily indicated, seeming too small in relation to the buildings of the Fontegheto della Farina in the distance. The basic outlines of the composition were recorded in the Sketchbook (f. 4r). The style of the drawing is essentially the same as that of no. 47, without the touches of wash that animate that drawing.

Pen and ink, over ruled and free pencil and a little pinpointing
19.6 × 27.1cm (7¹¹⁄₁₆ × 10¹¹⁄₁₆")
RL 7448. P. 46; C/L 563; Corboz 1985, no. D82

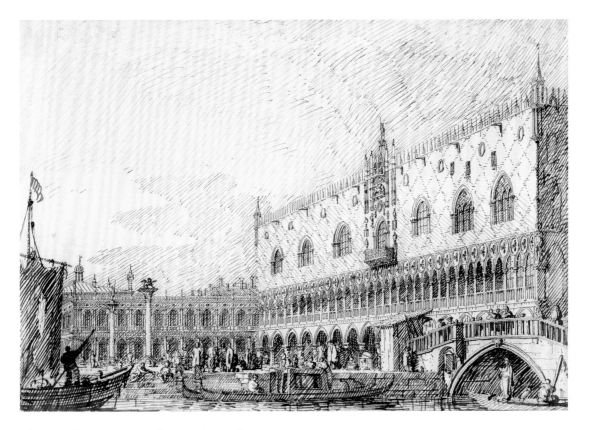

50 The Palazzo Ducale and Molo

c.1734

Here Canaletto took a different viewpoint from no. 49, seated low on the quay at the end of the Riva degli Schiavoni, and thus looking up at the figures standing on the Molo. The columns are in their correct locations, and Canaletto has drawn the façade of the Palazzo Ducale remarkably accurately, with the correct number of small arches (34) on the first floor of the Palazzo, and the differences between the windows on the main floor correctly shown – the four to the left simply criss-crossed with wooden glazing bars, the two to the right with gothic tracery and on a lower level. The Campanile has again been eliminated; its pyramid should be seen over the central balcony, which would confuse the line of the pinnacles.

Canaletto studied the Palazzo from this angle in the Sketchbook (f. 5r), in rough pencil clumsily overdrawn (possibly by a later hand) with pen and wash. He repeated the composition in a second drawing at Windsor (P.47), in a very mechanical style with wash rather than pen hatching, and probably drawn many years after the present sheet.

Pen and ink, over a little ruled pencil and pinpointing
18.8 × 27.1cm (7⅜ × 10¹¹⁄₁₆")
RL 7450. P.46; C/L 563; Corboz 1985, no. D82

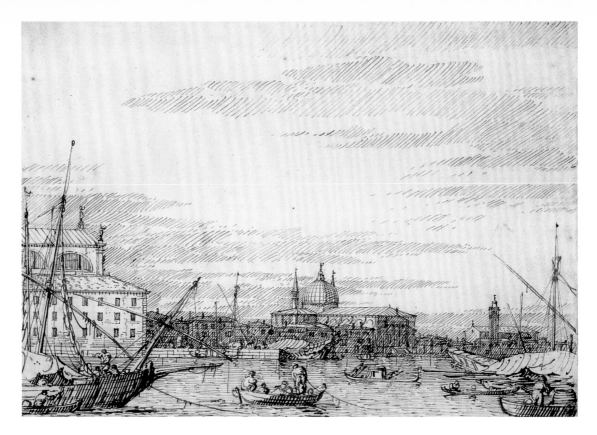

51 The Redentore from the Riva

*c.*1734

The Giudecca is seen from a standpoint on the Riva, looking across the Bacino di San Marco. No. 51 is essentially an enlarged version of the left-hand section of no. 27 (compiled from six openings of the Sketchbook), and the present 'detail' was studied on a single spread (ff. 45v–46r), with the buildings in the same relative proportions. The narrow angle of view has greatly condensed the space, compressing the boats into what appears to be a shallow foreground but is in fact several hundred metres of the Bacino. At the centre is Palladio's church of the Redentore (no. 41); to the left,

the flank of the monastery and church of San Giorgio Maggiore (no. 40). To the right of the Redentore is the church of San Giacomo, demolished in 1837.

While the drawing appears more pedestrian than others in this group, it is very close in style and technique to no. 28 above and should probably be dated with the others to the burst of drawing activity around 1734.

Pen and ink, over ruled and free pencil and pinpointing
18.8 × 27.1cm (7⅜ × 10¹¹⁄₁₆")
RL 7483. P.54; C/L 651; Corboz 1985, no. D65

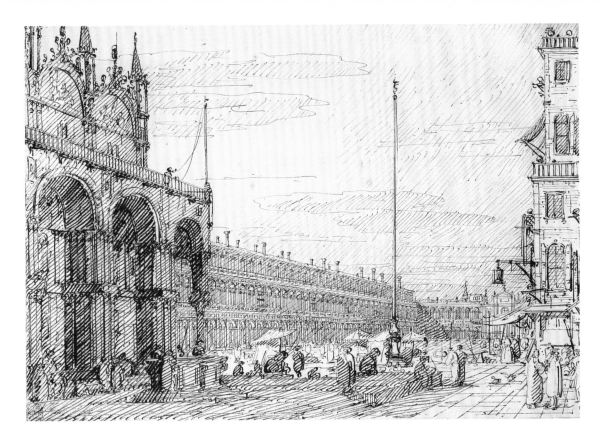

52 The Piazzetta dei Leoni

c.1734

The Piazzetta dei Leoni (or Campo San Basso, from its adjacent church), on the north side of San Marco, was laid out in its present form in 1722. The two lions that give the square its name were carved in pink Verona marble by Giovanni Bonazza in emulation of the medieval lions often found supporting the columns of church porches in northern Italy.

The buildings at the edges of the composition have been reduced in scale, and Canaletto has omitted the bell-storey of the Campanile that should be seen through the pinnacles of the basilica. Beyond is the Piazza, with the arcades of the Procuratie Nuove in shadow. San Geminiano at the far end of the square is partly hidden by an awning against the base of the Torre dell'Orologio, which is just out of view.

The composition is close to that of several paintings of the early 1730s (C/L 40–40*), and to a small etching by Canaletto (Bromberg 1974, no. 25). An outline copy of the composition by Bellotto (K.1) emulates the calligraphic notation for the figures that Canaletto was to develop around 1740.

Pen and ink, over free and ruled pencil
19.0 × 27.4cm (7½ × 10¹³⁄₁₆")
RL 7423. P.42; C/L 533; Venice 1982, no. 16; Corboz 1985, no. D59

Views in San Marco

The basilica of San Marco was founded in the ninth century to house the supposed body of St Mark the Evangelist, which was brought from Alexandria to Venice in AD 828 (see page 8). The present building dates from the latter half of the eleventh century, with a Greek-cross plan inspired by the great Byzantine churches of Constantinople, and five domes over the crossing and the four equal-length arms. During the next century the walls were faced with precious marbles from all over the Mediterranean, and the mosaics that cover the upper part of the basilica's interior were begun. The basilica was the ceremonial chapel of the Doge, but it became the cathedral of Venice only in 1807, in succession to San Pietro di Castello (no. 42), the seat of the Patriarch of the city.

Interior views by Canaletto are rare, and all his few drawings of interiors are in San Marco (C/L 556–61). The two sheets here, both of Canaletto's standard 'half-size' of roughly 27 × 19cm (10½ × 7½″), seem to date from around the middle of the 1730s, before Canaletto developed his familiar looping shorthand for the figures. Thirty years later he returned to the subject, making a highly finished drawing of a similar view to no. 53 with choristers in the south pulpit, proudly inscribed by the artist 'I, Giovanni Antonio da Canal, made the present drawing of the musicians who sing in the ducal church of San Marco in Venice, at the age of 68, without spectacles, in the year 1766' (fig. 30).

Background detail taken from *The Grand Canal looking south-west from the Rialto to Ca' Foscari* (no. 7)

53 The crossing of San Marco, looking north
c.1735

The drawing is an accurate view from a point along the west side of the south transept, looking towards the north transept. Despite the possible confusion caused by Canaletto's dense cross-hatching, the simple geometrical spaces of the basilica are clearly legible. Canaletto loosely indicated the Apostles in the twelfth-century mosaic of the Ascension in the central dome, and one of the enthroned Evangelists in the pendentive immediately below. At lower centre and right are the two polygonal pulpits, with the great marble rood screen surmounted by statues running between them at the entrance to the sanctuary. A strong horizontal light from the main doors of the basilica illuminates the worshippers at the crossing and the little of the nave that can be seen at the left of the drawing.

An unusually small painting in the Royal Collection (fig. 29), dating from a few years earlier, corresponds with the composition of the drawing, but in the painting the pulpits are conspicuously draped, indicating a specific, if unidentified, ceremony. The crowd here seems to be spilling up the steps in front of the rood screen, and the attention of the congregation is focused on the south pulpit. The drawing may therefore depict the traditional appearance of the Doge to the nobility of Venice from that pulpit following his coronation in the sanctuary of the basilica. Given the approximate date of the drawing based on its style, it might be intended to show the scene after the coronation of Doge

Alvise Pisani in 1735. However, no single figure is clearly distinguishable in the pulpit and the figures are too schematically drawn to be sure of this.

Pen and ink, over ruled and free pencil
27.2 × 18.8cm (10¹¹⁄₁₆ × 7⅜")
RL 7430. P.30; C/L 556; London 1980–81, no. 60; Miller 1983, no. 15; Corboz 1985, no. D24; New York 1989–90, no. 99

Fig. 29 Canaletto, *The crossing of San Marco, looking north*, *c*.1730
Oil on canvas, 33 × 22.5cm (13 × 8⅞"). Levey 398

54 An altar in the north transept of San Marco

*c.*1735

The subject of the drawing is the altar in the north transept of San Marco, seen in the background of no. 53. A sarcophagus, which must contain venerated relics, is covered by a *baldacchino* (canopy) and worshipped by figures kneeling on a carpet leading up the steps to the altar. The wall is hung with lengths of decorated cloth. The sarcophagus appears here much wider than in both the previous drawing and the finished sheet of 1766 (fig. 30), where it can again be seen in the background.

It has been thought that the drawing might depict the reception or veneration of the reliquary of the Blessed Doge Pietro Orseolo. It is clear that Canaletto was not too concerned with scale – the candelabra would be immense – but the size of the worshippers implies that the sarcophagus is much bigger than the femur-length reliquary of Orseolo, and the form corresponds only generically with that of the reliquary (recorded in an engraving by Visentini, Gorizia 1986, p. 216).

Pen and ink, over ruled and free pencil
26.9 × 18.8cm (10⁹⁄₁₆ × 7³⁄₈")
RL 7431. P.31; C/L 557; London 1980–81, no. 61;
Miller 1983, no. 16; Corboz 1985, no. D236

Fig. 30 Canaletto, *The crossing of San Marco, looking north, with choristers*, 1766
Pen and ink with wash over pencil, 35.9 × 27.5cm (14⅛ × 10¹⁵⁄₁₆")
Kunsthalle, Hamburg (C/L 558)

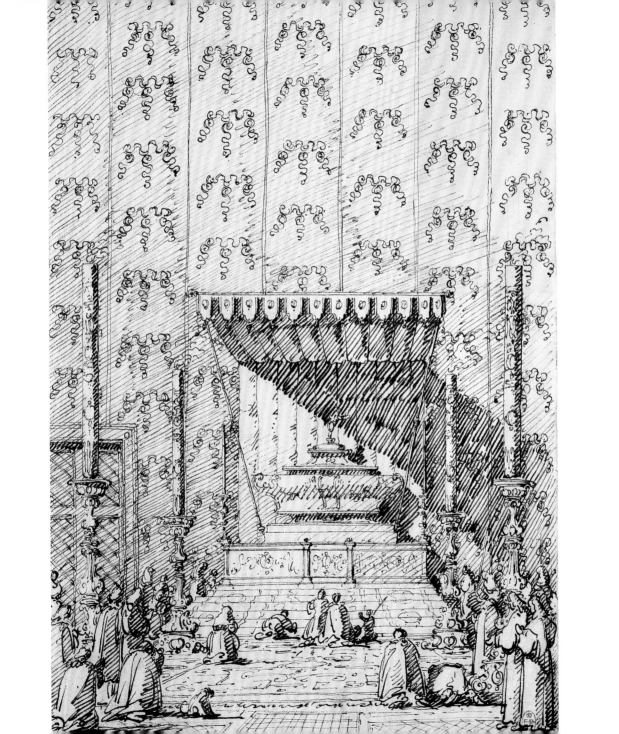

Views in the lagoon

The following four views are all taken from the east of Venice. Three (nos. 55–7) are from roughly the same point in the far south-east of the city, the Punta di Sant'Antonio (or Punta della Motta, or Motta di Sant'Antonio), now the public gardens and site of the Venice Biennale. The drawings look respectively west to the Bacino, north to San Pietro, and east to Sant'Elena, and while they are not continuous, they take in a panorama of some 270°. The fourth shows the island of Sant'Elena from San Pietro.

This is an area of Venice little visited by tourists, then or now, and no paintings correspond with these views. They must have been intended from the outset as complete works of art, and the combination of brown ink for the sharp pen-work and delicate layers of grey ink for the wash gives the drawings a sensitivity rarely, if ever, matched in Canaletto's oeuvre. The wide mud-flats and drifting smoke evoke a quiet sense of transience quite different from the hard and timeless views that dominate the artist's graphic output.

All four sheets measure roughly 15.5 × 35cm (6 × 13¾″) and are creased across the centre. While this might suggest that they formed spreads of a sketchbook, they have not been stitched and the versos are all blank. Many of the lines are drawn with a ruler (including the horizontals in the water of no. 58), and two of the four were extensively underdrawn in pencil. Some of the buildings in no. 56 seem to be inaccurately drawn, suggesting that they were reconstructed from partial sketches or from memory; the ink is not of a consistent colour – that of no. 58, for instance, is much more orange than that of no. 57; and, in general, the drawings are so carefully put together that they must be, as usual, studio works. It is not easy to date drawings of such unique character on grounds of style alone, but it is probable that they were executed in the years around 1740.

Background detail taken from *The Grand Canal looking south from Ca' Foscari to the Carità* (no. 8)

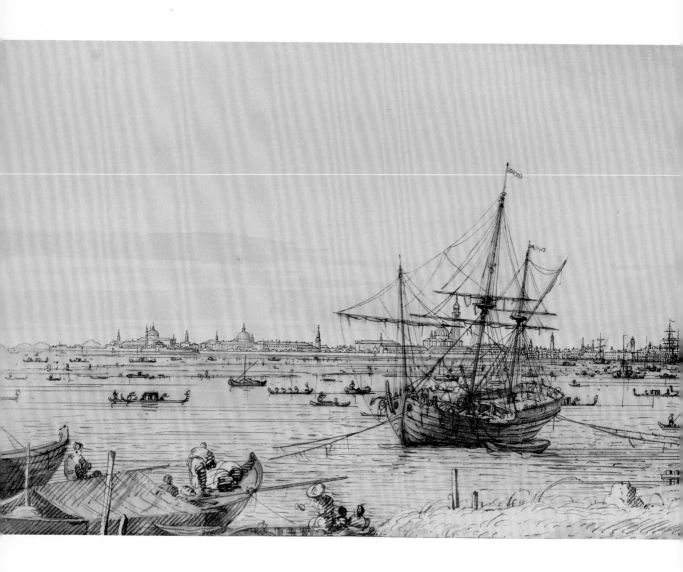

55 The Bacino from the Punta di Sant'Antonio

*c.*1740

San Giorgio Maggiore is seen through the rigging of the ship moored in the foreground. To the left is the Giudecca, with the domes of the Zitelle and the Redentore, and the Euganean hills on the horizon at far left. To the right of the Campanile, Palazzo Ducale and the domes of San Marco are the dome of San Zaccaria and the tower of San Giorgio dei Greci. The brown ink has bled slightly into the grey wash, giving a blurred appearance to the many boats in the Bacino.

Pen and brown ink with grey wash
15.7 × 34.8cm (6³⁄₁₆ × 13¹¹⁄₁₆″)
RL 7456. P.66; C/L 522; Venice 1962, no. 25; Toronto etc. 1964–5, no. 80; London 1980–81, no. 68; Miller 1983, no. 22; Corboz 1985, no. D107; New York 1989–90, no. 101

56 Castello from the Punta di Sant'Antonio

*c.*1740

The view (identified by Pignatti 1964, though with some inaccuracies noted in C/L) looks north from the Punta di Sant'Antonio towards the buildings of Castello and the island of San Pietro. To the left are the belltower and pediment of San Nicolò da Bari, with the square tower of Sant'Antonio closer to the viewer (both churches have been demolished); at the centre, the roof of San Giuseppe, with the pointed tower of Sant'Anna (also demolished) in the distance. To the right are the tower and dome of the cathedral of San Pietro, with the buildings on the Fondamenta Castel Olivolo jutting into the lagoon.

Pen and brown ink with grey wash, over ruled and free pencil
15.6 × 34.5cm (6⅛ × 13⁹⁄₁₆")
RL 7486. P.65; C/L 523; Venice 1962, no. 24; Pignatti 1964, p. 50;
Toronto etc. 1964–5, no. 83; London 1980–81, no. 69;
Miller 1983, no. 23; Corboz 1985, no. D108;
Frankfurt etc. 1989–90, no. 36

57 Sant'Elena and the Certosa from the Punta di Sant'Antonio
c.1740

The thirteenth-century Olivetan monastery of Sant'Elena stood on an island at the far east of Venice, separated from the Punta di Sant'Antonio by a broad muddy channel. The monastery was dissolved in 1810, though most of the buildings, including the fifteenth-century church, still exist. The Canale di Sant'Elena was mostly filled in and covered with apartment blocks and a sports stadium during the nineteenth and early twentieth centuries, and the area is now one of the least typical parts of Venice.

The island of La Certosa, seen to the left a little further away, retains its identity, though the monastery (originally of the twelfth century and rebuilt by Pietro Lombardo in the fifteenth) was likewise suppressed in 1806. The demolition of the church and the dispersal of its works of art was one of the greatest losses to Venice of the Napoleonic period. The island was subsequently considered as the location of a new cemetery, served as a military base for much of the nineteenth and twentieth centuries, and in the 1960s was even proposed as the site for a multi-storey car park serving a new causeway connecting the islands of the lagoon, a scheme that was mercifully abandoned. Long-term plans to turn the island into a public park have not been realised.

Pen and brown ink with grey wash, over ruled and free pencil
15.5 × 34.9cm (6⅛ × 13¾")
RL 7488. P.67; C/L 650; Venice 1962, no. 26; Toronto etc. 1964–5, no. 82; London 1980–81, no. 71; Venice 1982, no. 30; Miller 1983, no. 25; Corboz 1985, no. D125; New York 1989–90, no. 102

58 Sant'Elena from San Pietro
*c.*1740

The monastery of Sant'Elena, seen from the west in the previous drawing, is here seen looking south from Isola di San Pietro. The sparsely populated Lido runs along the entire horizon, with the church of Santa Maria Elisabetta at far right. The drawing is a masterpiece of monochrome wash, with the strongly lit monastery standing out against the overcast background. For some reason Canaletto decided to scratch out two of the boats with which he populated the broad Canale di Sant'Elena, and the areas of roughened paper at far left and to the right of centre have thus soaked up more wash and appear darker than their surroundings.

Pen and brown ink with grey wash
15.8 × 34.9cm (6¼ × 13¾")
RL 7487. P.68; C/L 649; Venice 1962, no. 27; Toronto etc. 1964–5, no. 81; London 1980–81, no. 70; Corboz 1985, no. D118; Frankfurt etc. 1989–90, no. 37

175

Drawings with integral borders

Nos. 59 and 60 are unexceptional in their subject matter – they depict perhaps the two most famous views of Venice – but as drawings they have the peculiarity of a decorative border drawn on the same sheet of paper as the views themselves. This must presumably have been done by the artist; and though many of his finished sheets have ruled framing lines (see the thick black lines of nos. 76, 79–85), such elaborate borders, with hundreds of short lines painstakingly ruled as transverse shading, are exceptional in Canaletto's output.

Parker (under P.64) expressed doubts about the status of the drawings, describing them as 'dull and mechanical' but excusing this with the suggestion that they may have been made as models for engravings. In truth there is little difference in quality between these and many other of Canaletto's less-considered works, and they may have been simply exercises in the effect obtained with integral borders, rather than studies in which the pictorial values interested the artist. On balance the drawings seem to predate Canaletto's English sojourn.

Background detail taken from *The Grand Canal looking east from the Carità towards the Bacino* (no. 9)

59 The Molo from the Bacino
c.1740–45

What is at first sight a straightforward view is distorted in several major respects. The Campanile is, as usual, too tall and too thin. Canaletto has extended the eastern façade of the Libreria, seen in plunging perspective and greatly enlarging the depth of the Piazzetta. The flagpoles are omitted in the Piazza beyond. In order to include the Prigioni at far right, Canaletto has squeezed the Palazzo Ducale widthways – the correct number of ground-floor arches (17) are shown, but they are much narrower than in reality. And while the degree of foreshortening (seen, for example, in the relative sizes of the Palazzo Ducale and the Torre dell'Orologio beyond) requires a viewpoint close to or on the Isola di San Giorgio, the boats moored off the Molo, especially the Doge's galley to the left of centre, give the impression of a view from just a little way into the Bacino.

The number and variety of related works (listed under C/L 109, including a painting reputed to have been painted between 1747 and 1750, when Canaletto was in England, and a schematic drawing from Bellotto's studio, K.Z65) demonstrate that this was one of Canaletto's stock compositions, and support the idea that he was more interested in the border than in the drawing itself.

Pen and ink, over ruled and a little free pencil and pinpointing
Sheet 26.7 × 37.2cm (10½ × 14⅝"), image 21.6 × 32.4cm (8½ × 12¾")
RL 7447. P.63; C/L 571; Corboz 1985, no. D33

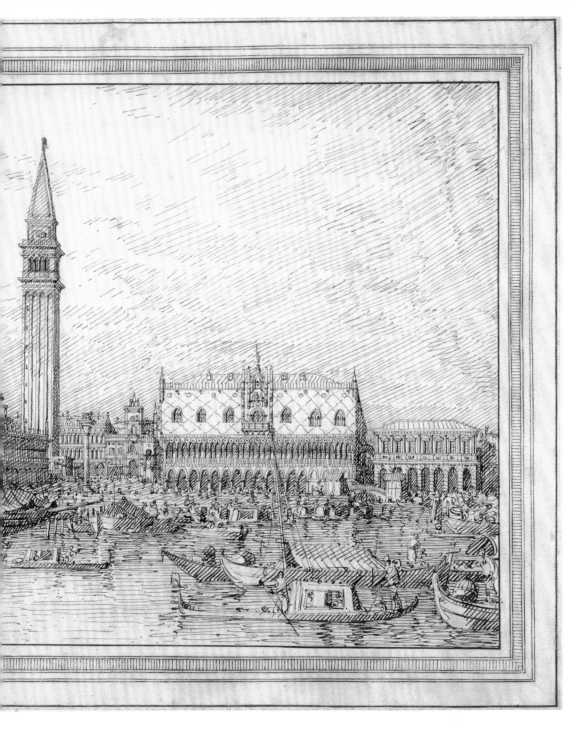

60 The Rialto bridge from the south-west
c.1740–45

The view is from the Riva di Ferro, where the Rialto *vaporetto* stop is now to be found; the booth seen at the lower left of no. 7 is in the right foreground here. The bridge itself is accurately drawn, but the Fondaco dei Tedeschi to the right beyond is too high and narrow (see no. 6 for a more accurate view from the other side of the bridge), and shown at too sharp an angle – the main façade should be turned more towards the bridge (fig. 31).

The composition is close to those of a painting at Woburn Abbey (C/L 225) and a ragged sketch in the Metropolitan Museum (C/L 592; New York 1989–90, no. 90), both of which probably date from a decade or more before the present drawing. There are several later variants known (C/L 226–7*), and like no. 59 this must have been a stock composition in the studio.

Pen and ink, over ruled and a little free pencil and pinpointing
Sheet 26.6 × 36.7cm (10½ × 14⁷⁄₁₆″), image 21.5 × 31.5cm (8⁷⁄₁₆ × 12⅜″)
RL 7466. P.64; C/L 591

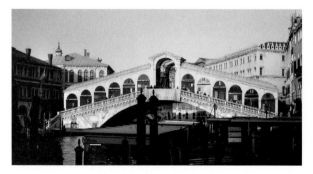

Fig. 31 *The Rialto bridge from the south-west*, 2005

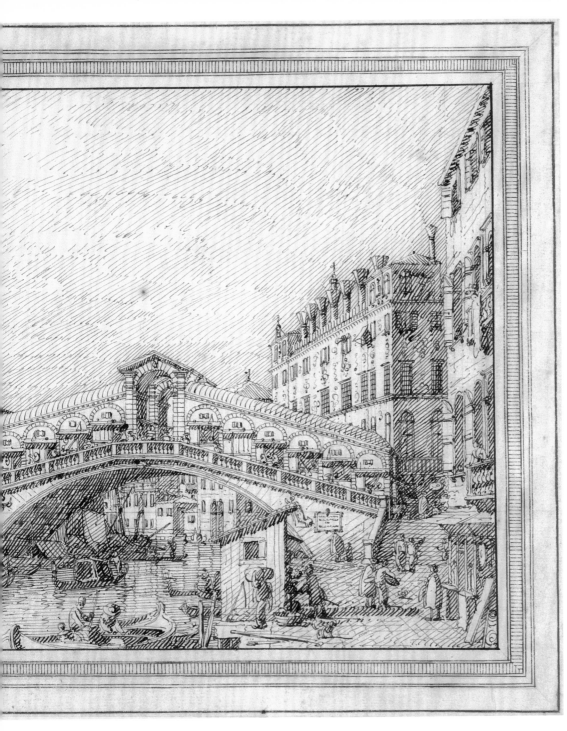

Two-stage pen drawings

A large number of drawings at Windsor show distinct signs of having been constructed in two phases – a light outline drawing in fine pen, followed by heavy diagonal hatching with dark ink and a broad nib. Normally this might be understood as simply two stages in the drawing process, but the outlines seem to have been drawn as self-sufficient images, and the shading is often a brutal overworking, in several cases (such as nos. 61–2) obliterating substantial detail that Canaletto had carefully drawn in the first stage.

Many of these drawings correspond closely in the outline stage with sheets by Canaletto's nephew and pupil, Bernardo Bellotto. These have sometimes been explained as simply 'outline copies' by the younger artist of Canaletto's finished drawings; but even where Canaletto obscured fine detail with his heavy hatching, Bellotto's drawings record that detail faithfully. There are perhaps three explanations for this phenomenon. Firstly, that Canaletto executed his drawings in two stages, an outline drawing that was copied by Bellotto, with a later phase of working up to make the drawing more pictorial. Secondly, that both Canaletto's and Bellotto's extant drawings depend on the same earlier outline drawings by Canaletto, now lost. Thirdly, that Bellotto's drawings are in fact the originals, and that these outlines were copied by Canaletto and then worked up into more dramatically shaded drawings. These alternatives are not mutually exclusive, and each scenario may have occurred at some point.

The majority of the drawings in this manner are of subjects in and around Padua and on the Brenta canal, and date from a trip that Canaletto and Bellotto probably made together around 1740. Bellotto was then about 20 years old, and his talents as an artist would have been clear to his uncle. The perhaps excusable prejudice, that the older artist could not have copied from the younger, may be misplaced here, and at this stage in their careers there may well have been a two-way exchange of ideas and compositions. Of six large views of Rome by Canaletto in this technique, only one corresponds to a Bellotto outline drawing; but that one drawing is crucial, for while we know that Bellotto visited Rome in 1742, there is no evidence that Canaletto ever returned to the city after 1720. A number of Canaletto's other later drawings of Rome (including the smaller two-stage P.108, and P.109–12 in the

capriccio style of nos. 75–7) are based on his own early studies there; but the six large two-stage drawings have no other known source, and it is quite possible that he based them on drawings that his nephew had made on that journey, only one of which has survived. Bellotto seems to have been particularly fond of outline drawings, and there are many surviving sheets by him dating from the period after he and Canaletto parted that are no different in style and approach from those in question here.

Canaletto's drawings in this manner are mostly in his two standard sizes, 19 × 27cm (7½ × 10½″) and 27 × 38cm (10½ × 15″), the former simply half the latter. For the record, the two-stage drawings by Canaletto, with their Bellotto equivalents where they survive, are:

Venice: P.26 (no. 61) = K.4–5; P.27 (no. 62); P.28 (no. 74); P.29 (no. 63).

In and around Padua: P.75 = K.31; P.76 = K.35; P.78 = K.46; P.79 = K.42–3; P.80 = K.30; P.81 = K.45; P.82 = K.34; P.92 = K.30; P.96 = K.49.

Rome: P.102–8 (P.103 = K.70).

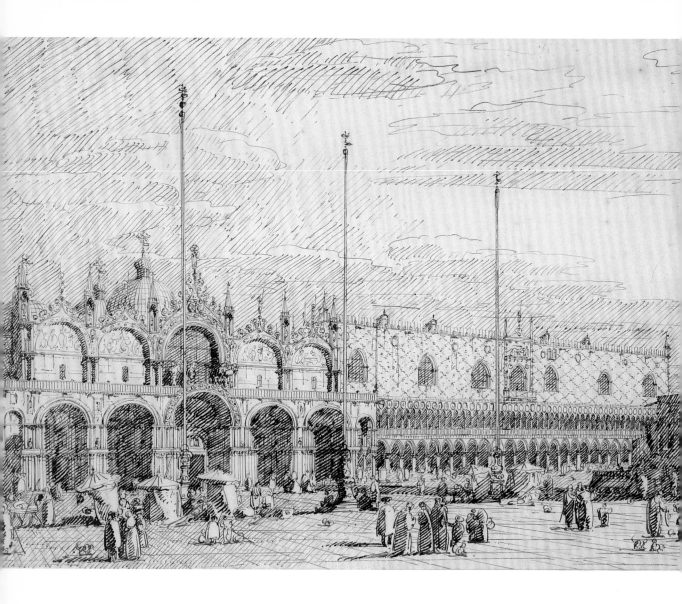

61 San Marco and the Palazzo Ducale
c.1740–45

The relationships of San Marco, the Loggetta and the Palazzo Ducale allow Canaletto's viewpoint to be located precisely, standing under the eighth arcade from the east end of the Procuratie Vecchie; it may even be observed that he must have raised his vantage point a little, by standing on a table or box. A modern photograph (fig. 32) shows that he did however make some adjustments to reality, primarily increasing the scale of the Palazzo Ducale by introducing many more arches, and reducing the central bay of San Marco and the size of the pinnacles between the lunettes.

The original drawing was a delicate outline study in light pen. At some point Canaletto turned this into a dramatically contrasty composition by adding areas of dense shading.

This is particularly apparent in the entrance bays of San Marco, where a great deal of detailed pen-work has been obliterated by the heavy hatching. Two drawings by Bellotto (K.4–5; fig. 33) correspond with Canaletto's drawing at the intermediate stage before the addition of the heavy shading, including the detail in the bays of San Marco. There is no closely related painting; a similar view in the National Gallery of Art, Washington (C/L 50) differs in all details.

Pen and ink (two shades), over free and ruled pencil and pinpointing, 27.0 × 37.7cm (10⅝ × 14¹³⁄₁₆")
RL 7428. P.26; C/L 535; Venice 1962, no. 16; Venice 1982, no. 26

Fig. 32 *San Marco and the Palazzo Ducale*, 2005

Fig. 33 Bellotto, *San Marco and the Palazzo Ducale*, *c.*1740–45
Pen and ink over pencil, 26.3 × 38.5cm (10⅜ × 15³⁄₁₆")
British Museum, London (K.5)

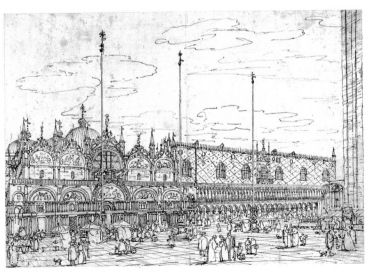

62 The Torre dell'Orologio and part of San Marco

c.1740–45

The Torre dell'Orologio (clocktower), at the eastern end of the northern range of Piazza San Marco, was built to the designs of Mauro Codussi in 1496–9 to house an astronomical clock constructed by Gianpaolo and Giancarlo Ranieri. The clock-face shows the hours of the day and the movements of the sun and moon through the zodiac; above the clock-face are doors from which, each hour, figures of the Magi emerge to bow before a statue of the Madonna in the central niche. On top of the tower is a bell struck on the hour by two monumental bronze Moors.

Canaletto has taken a long view of this corner of the Piazza, foreshortening the buildings to the left, including the eastern end of the Procuratie Vecchie. He eliminated the northern dome of San Marco, and as in no. 61 he altered the proportions of the façade, enlarging the upper lunettes and diminishing even further the pinnacles between them. The drawing was constructed in two stages, a crisp outline with a narrow pen, followed by dense diagonal hatching with dark ink and a broad nib, obscuring much detail in the entrance bays of San Marco and in the shops of the north range.

The view of San Marco served as the basis for the *capriccio*, no. 74, where it is found transcribed almost exactly. The composition corresponds generally to a painting in Ottawa (C/L 45; New York 1989–90, no. 55).

Pen and ink (two shades), over free and ruled pencil and pinpointing
27.0 × 37.5cm (10⅝ × 14¾")
RL 7425. P.27; C/L 539; Venice 1962, no. 13; Toronto etc. 1964–5, no. 33; London 1980–81, no. 58; Venice 1982, no. 25; Miller 1983, no. 13; Corboz 1985, no. D63

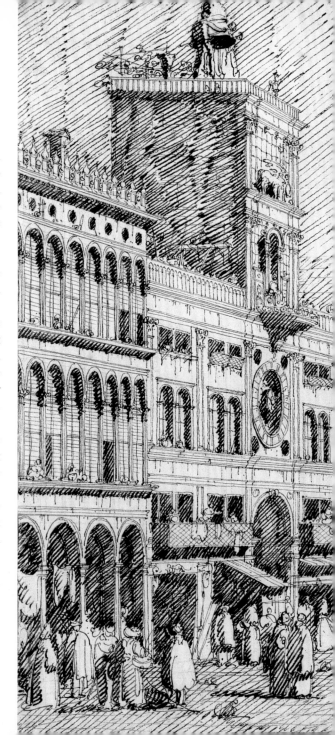

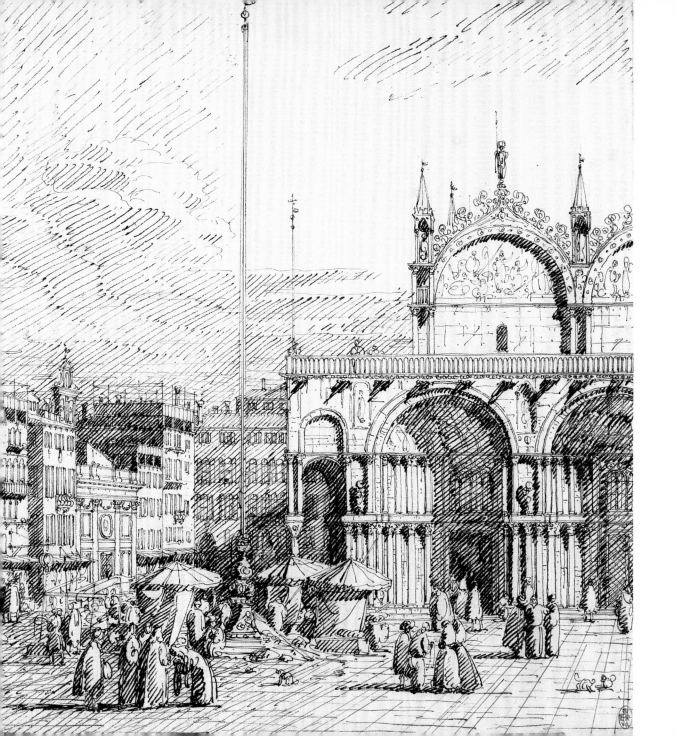

63 The entrance to the Arsenale

c.1740–45

The shipyards of the Arsenale (from the Arabic *darsinâ'a*, simply 'workshops') were founded probably in the twelfth century, and gradually expanded from a single dock to become, by the sixteenth century, a fortified site occupying 46 hectares (115 acres) of the east of the island and employing some 16,000 men. The south entrance to the Arsenale seen here is flanked by a pair of crenellated towers, reconstructed in 1686 when the Rio dell'Arsenale was widened. To the left is the pedestrian gateway begun in 1460 and held to be the earliest truly Renaissance structure in the city, with later additions including the relief of the lion by Bartolomeo Buon, a winged figure of Victory following the battle of Lepanto in 1571, and surrounding decorated pedestals with statues of 1692–4 by Giovanni Comin. The *rio* is here spanned by a wooden drawbridge, replaced by a fixed bridge in 1938. The small sixteenth-century oratory of the Madonna dell'Arsenale, seen to the right with a supplicant kneeling at its steps, was demolished in 1809. In the distance is a belltower, which has been claimed to be that of the church of Santa Maria Celeste, demolished in 1810, but is more likely to be that of San Francesco della Vigna (no. 39), which comes into view when standing closer to the bridge.

Although Carlevarijs had included a view very similar to this in his *Fabriche e vedute* of 1703, Canaletto studied the view 'from the life' on two openings of the Sketchbook (ff. 34v–36r). Those sketches include a more distant view of the gateway and the building seen along the left edge of the sheet here, suggesting that Canaletto had not at that stage decided on the scope of his composition. The sketches also include a note to make the towers *Piu largo* ('wider apart'), and Canaletto followed that memorandum in a painting at Woburn Abbey (C/L 271) and in a finished drawing in the Lugt collection (Byam Shaw 1983, no. 290, copied by Bellotto, K.27), both of the early 1730s. The present sheet returns to the spacing of the towers as seen in the Sketchbook, compressing the composition, and alters the boats and the distant view between the towers. This was originally a much lighter drawing that Canaletto transformed with heavy parallel hatching, the obliteration of earlier detail being most noticeable in the doorway of the monumental gate.

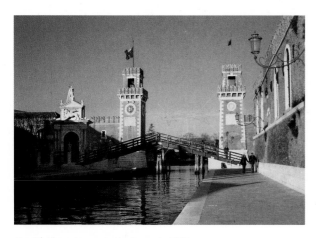

Fig. 34 *The entrance to the Arsenale*, 2005

Pen and ink (two shades), over free and ruled pencil and pinpointing, 27.1 × 37.4cm (10¹¹⁄₁₆ × 14¾")
RL 7477. P.29; C/L 603; London 1980–81, no. 59; Venice 1982, no. 27; Miller 1983, no. 14; Corboz 1985, no. D95; Frankfurt etc. 1989–90, no. 34

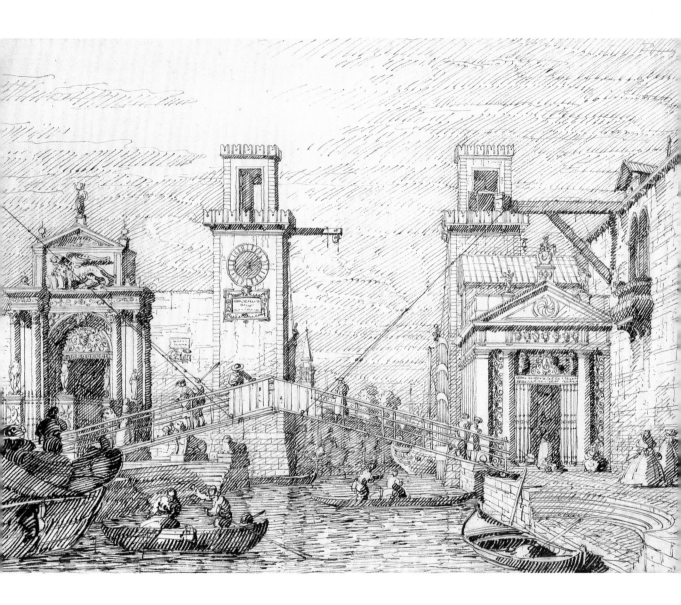

189

Late drawings in Piazza San Marco

The following three drawings are closely related in style and technique, all drawn with strong ruled pencil construction lines, crisp pen-work in the buildings and bold curls of the reed pen for the figures, and careful application of a bluish-grey wash. Nos. 65 and 66 form a pair, looking in opposite directions across the Piazza from under the arcade of the Procuratie Nuove, each measuring around 19.5 × 27.5cm (7¾ × 10¾″) and with a heavy ruled border line, standard features of many of Canaletto's later drawings.

The third drawing, showing repairs being carried out on the Campanile following a lightning strike, is unusual in several respects: its size and vertical orientation, the inscription which Canaletto added, and the fact that it depicts an actual 'event' rather than a scene. It is nonetheless very close in style to the smaller pair of drawings, and it is likely that Canaletto drew all three at around the same date. The lightning strike occurred on 23 April 1745, and Canaletto was in England by May 1746; the drawing can therefore probably be dated to the year following the lightning strike. The three drawings here would thus be some of the earliest datable examples of Canaletto's 'late style', dominated by heavy pen-work, looping figures and a rather artificial overall feel, which was to alter little over the last two decades of his career.

Background detail taken from *The Grand Canal looking towards the Riva degli Schiavoni* (no. 11)

64 The Campanile under repair

*c.*1745

The Campanile of San Marco, 98.5 metres (325 feet) tall and the highest point in Venice, was first built in brick in the late ninth century and owes its present form to restructuring carried out by the sculptor and architect Bartolomeo Buon in 1511–14. Buon added a bell-storey in white Istrian stone, with four open arches on each side, above which are reliefs of the lion of St Mark and an allegorical figure of Justice against a brick ground, a pyramidal spire faced in green copper, and at the pinnacle a figure of the archangel Gabriel.

The Campanile collapsed without warning in 1902, after which it was rebuilt as close as possible to its original form, externally at least (the use of modern materials for the internal structure was estimated to have left the tower 2,000 tonnes lighter). The collapse was blamed on a breach in the north-east angle of the structure caused by a lightning strike in 1745, and it is the repairs following that strike that Canaletto depicted here. His inscription records, 'On 23 April 1745, the day of St George the Knight, a thunderbolt struck the Campanile of San Marco'. A workmen's cradle is suspended from scaffolding erected in the bell-storey, with a windlass on the Loggetta; two sections of the balustrade of the Loggetta are missing, presumably damaged by the falling bricks. Because of the risk of collapse, work to repair the Campanile began almost immediately, and it must be presumed that Canaletto witnessed this scene before he left Venice for England in 1746. While it does not necessarily follow that the drawing was made at that time, its style is consistent with the *capricci* of the 1740s (nos. 77–84).

This is one of the few occasions that Canaletto depicted the Campanile in its correct, rather massive proportions. The angle of view of the bell-storey requires a standpoint some way off in the Bacino, though a view from the (widened) Piazzetta, near the corner of the Palazzo Ducale, is implied. The ruled pencil underdrawing is prominent, and it is odd that Canaletto should not have taken care to erase it in what was clearly intended to be a finished drawing. Links (in C/L) thought that the signs of erasure to the right of the tower indicated that the damage might have been drawn in later, but it is clear that the scaffolding and cradle were intended from the outset.

In the British Museum is an almost identical version of the drawing (C/L 553) that bears a 'Strassburg Lily' watermark, of Dutch origin, and it has been deduced that that drawing must have been executed when Canaletto was in England (a related painting by Canaletto also seems to be English in date, C/L 67*). But the great majority of the watermarks found on the drawings in the present catalogue are Strassburg Lilies, and Canaletto must have had a reliable source of northern European paper even when he was working in Venice (see pp. 18–20).

Pen and ink, over ruled pencil and pinpointing, with grey wash
42.5 × 29.2cm (16¾ × 11½")
Inscribed by the artist *A di 23 aprile 1745 giorno di S. Giogio Cavalier / diede la saeta nel Canpanil di S. Marco*
RL 7426. P.55; C/L 552; Venice 1962, no. 23; London 1980–81, no. 85; Venice 1982, no. 24; Miller 1983, no. 39; Corboz 1985, no. D259; Bomford and Finaldi 1998, pp. 48–51; Rome 2005, no. 67

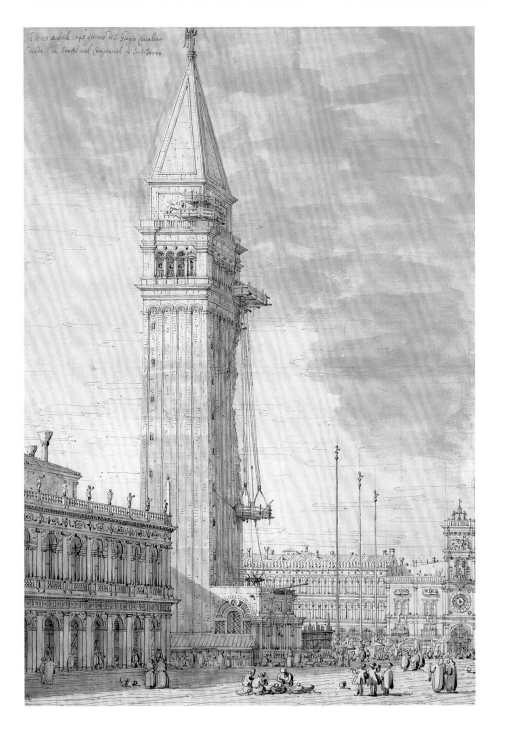

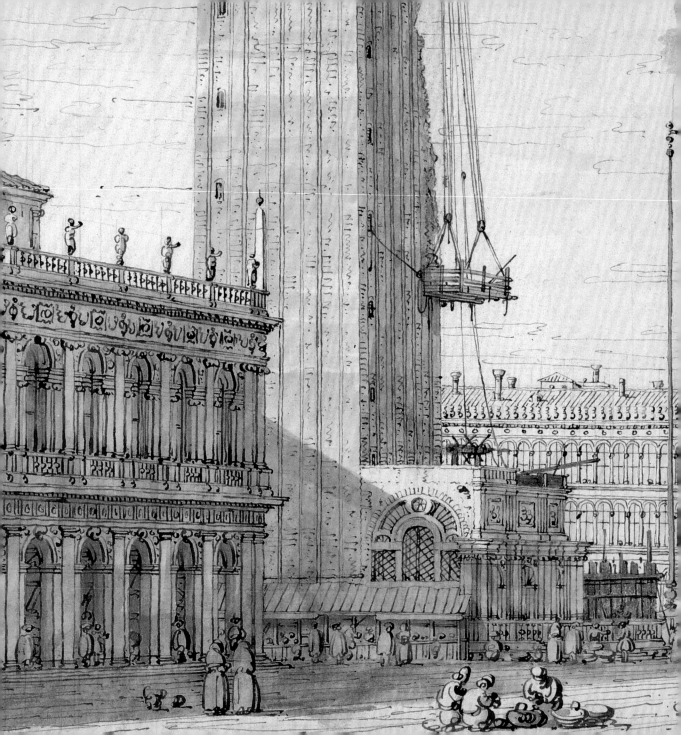

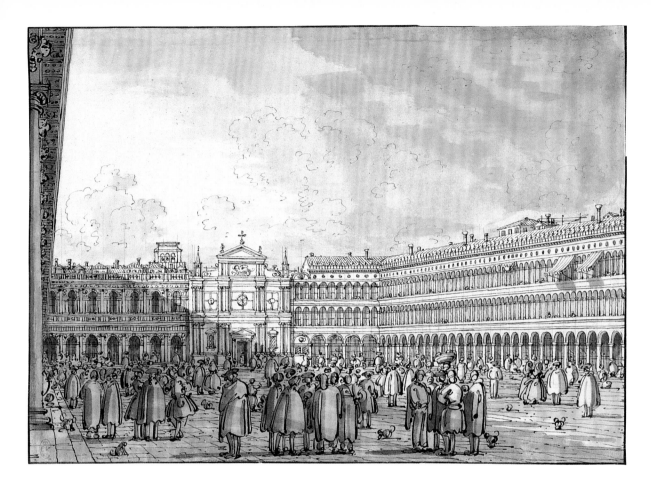

65 The Piazza, looking west from the Procuratie Nuove

c.1745

The lack of foreground detail makes the viewpoint hard to establish exactly, but the angle from which the corner of the Piazza is seen suggests that it is from a little to the east of the following drawing, perhaps ten bays from the end of the Procuratie Nuove. The legs of the river-gods in the spandrels, seen in no. 66, are not shown, but the heads of lions and warriors in the frieze have come into view. The figures in the distance are drawn too large, thus reducing the apparent width of the Piazza.

A variant in the Louvre (C/L 531) expands the view, reducing the size of the west range of the Piazza and showing many more bays of the Procuratie Vecchie.

Pen and ink with bluish-grey wash, over free and ruled pencil and pinpointing, 19.2 × 27.1cm (7³/₁₆ × 10¹¹/₁₆″)
RL 7433. P.56; C/L 529; London 1980–81, no. 91; Miller 1983, no. 45

66 The Piazza, looking north-east from the Procuratie Nuove

c.1745

The number of arches visible in the receding arcade of the Procuratie Nuove, and the point at which the Campanile overlaps the façade of San Marco, locate the viewpoint about fifteen bays from the east end of the Procuratie. Canaletto has introduced a stone platform for his conversing foreground figures to sit on, and has dramatically enlarged the size of the arches – they are in reality no more than 3 metres (10 feet) wide, and Canaletto has effectively removed a pillar to allow a view both into the Piazza and down the arcade.

A discoloured drawing in New York (fig. 35) is apparently identical at first glance, but is in fact significantly different. There the façade of San Marco (which has its northern dome, omitted here) and the Torre dell'Orologio are smaller, more of the Campanile and Procuratie Vecchie is visible, and many more bays of the arcade are seen to the right. The viewpoint is therefore further to the west, outside Florian's coffee house, and indeed a related painting in the National Gallery (C/L 20) has the standing figure to the right holding a coffee cup. But in fig. 35 Canaletto failed to amend the position of the Campanile with respect to San Marco, of which significantly more of the façade should there be seen (the National Gallery painting corrects this error). The Windsor composition must therefore have been executed first, with the New York version an autograph variant.

Pen and ink with bluish-grey wash, over free and ruled pencil and pinpointing, 19.7 × 28.0cm (7¾ × 11˝)
RL 7427. P.57; C/L 525; Toronto etc. 1964–5, no. 32;
London 1980–81, no. 92; Miller 1983, no. 46; Corboz 1985, no. D240;
New York 1989–90, p. 327; Bomford and Finaldi 1998, pp. 51–3

Fig. 35 Canaletto, *The Piazza, looking north-east from under the arcades of the Procuratie Nuove, c.*1745?
Pen and ink with wash, discoloured, 22.8 × 33.3cm (9 × 13⅛˝)
Metropolitan Museum of Art, New York (C/L 526)

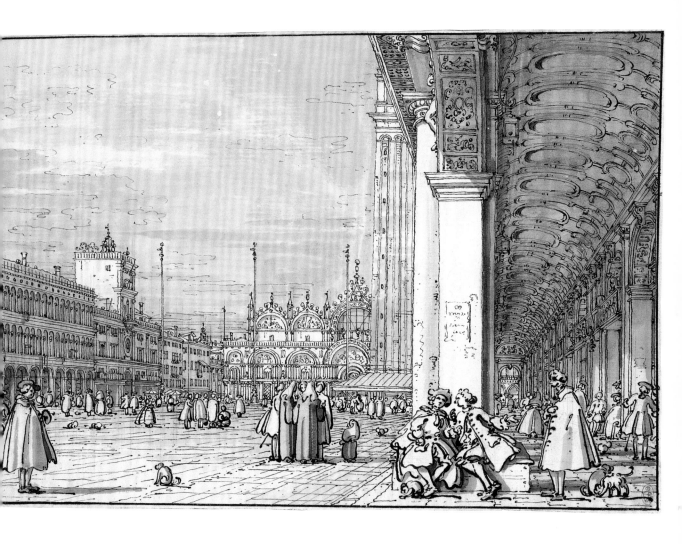

Wide-angle views

The following three drawings, together with half a dozen related paintings, are exercises in the playful manipulation of pictorial space, encompassing views approaching 180°. The conceit of the extreme wide-angle view was not Canaletto's; Andrea Vicentino's *Procession of the Dogessa Grimani* of *c*.1600 (Chatsworth), for example, has as a backdrop a view of the Piazzetta remarkably similar to no. 67. Luca Carlevarijs had included an engraving comparable to no. 68 in his *Fabriche e vedute di Venezia* of 1703, followed by Domenico Lovisa in his *Gran Teatro* of 1720, who added another very similar to no. 67. Canaletto first started to paint this sort of view in the early 1730s and the three drawings here, based on his earlier compositions, date from around 1740. They have been adduced as evidence of Canaletto's use of optical devices such as the *camera obscura*. In truth, they demonstrate the exact opposite, for no optical device would be capable of producing such images without extreme distortion.

The convention of single-point perspective – in which parallel lines perpendicular to the plane of the picture appear to converge towards a single point, whereas parallel lines in the plane of the picture are shown as parallel on the surface of the drawing or painting – remains valid only for small angles of view. As the view expands, the lines parallel to the picture surface start to converge at either end, giving a barrel-shaped distortion to rectilinear forms seen frontally, an effect that is seen with a wide-angle camera lens. But Canaletto was under no obligation to obey such laws of optics, and he could expand the field of view while maintaining a single-point perspective system. The compositions are thus perspectively both correct and incorrect, and this internal contradiction gives the work of art the quality of caprice. Such wide-angle views offered the client an entertaining example of rational artifice, together with an increased number of well-known buildings in a single view.

Background detail taken from *The mouth of the Grand Canal looking west towards the Carità* (no. 12)

67 The Libreria, Campanile and Piazzetta from the east
c.1740

The east façade of the Libreria is drawn in a simple elevation, which in itself can imply no one point of view. Canaletto added to the left side of this elevation a view through the columns to Santa Maria della Salute, as if from the south of the Piazzetta. To the right is a combination of views into the Piazza from the north of the Piazzetta, including the south end of the narthex of San Marco and the Procuratie Vecchie (greatly extended) beyond, essentially as in no. 17. While no single element of the drawing is impossible, the combination of different viewpoints assembled around the elevation of the Libreria has the effect of greatly expanding the apparent width of the Piazzetta, effectively dissolving the Palazzo Ducale.

The composition is possibly based on the first plate of Domenico Lovisa's *Gran teatro di Venetia* of *c.*1720, a similar wide-angle view from the column of the lion to the Torre dell'Orologio. Several extant paintings by Canaletto include this orthogonal elevation of the Libreria (C/L 69–72), but none expands the view so far into the Piazza as to include a portion of San Marco.

Pen and dark ink, over ruled and a little free pencil and pinpointing, 22.6 × 37.4cm (8⅞ × 14¾")
RL 7438. P.60; C/L 547; London 1980–81, no. 66;
Miller 1983, no. 20; Corboz 1985, no. D23

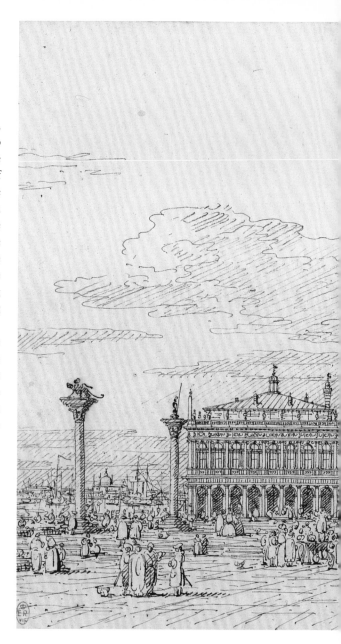

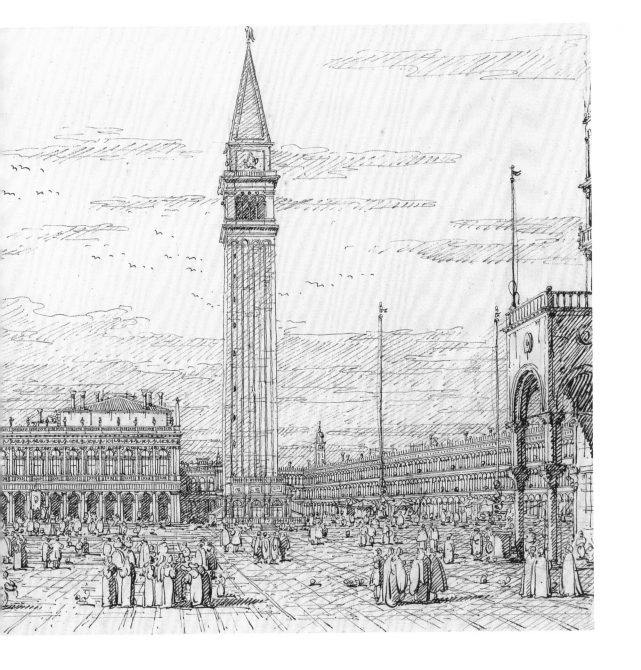

68 The Piazza from the Torre dell'Orologio
c.1740

The view is based around a simple elevation of the Procuratie Nuove, seen from a slight angle but not diminishing perspectivally. To this Canaletto added on the left a view of the façade of San Marco and down the Piazzetta, and on the right a splayed view of the west end of the Piazza with the church of San Geminiano. The two sides of the image are not in themselves impossible, but when looking from one side to another the inconsistency in the representation of the Procuratie Nuove becomes apparent.

Canaletto executed a number of similar paintings of the view (C/L 49–49*, 53–53*; see also K.Z24–5). The composition is particularly close to the version in the Cleveland Museum of Art (C/L 53), but here Canaletto has lengthened the Procuratie to make the pictorial effects even more extreme. The extensive pencil underdrawing shows that he had at first considered drawing the Campanile even higher and including the third flagpole in the right foreground.

Pen and dark ink, over ruled and a little free pencil and pinpointing, 18.3 × 37.7cm (7⁵⁄₁₆ × 14¹³⁄₁₆")
RL 7422. P.62; C/L 537; London 1980–81, no. 67; Miller 1983, no. 21; Corboz 1985, no. D26; New York 1989–90, no. 100; Rome 2005, no. 35

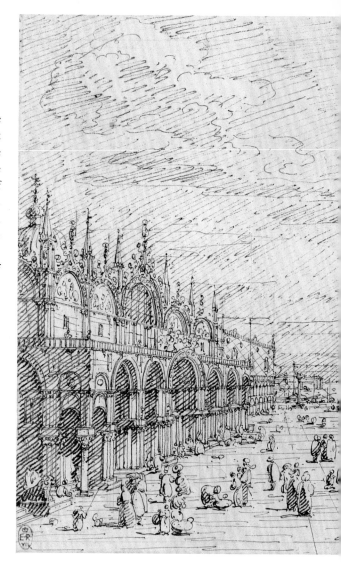

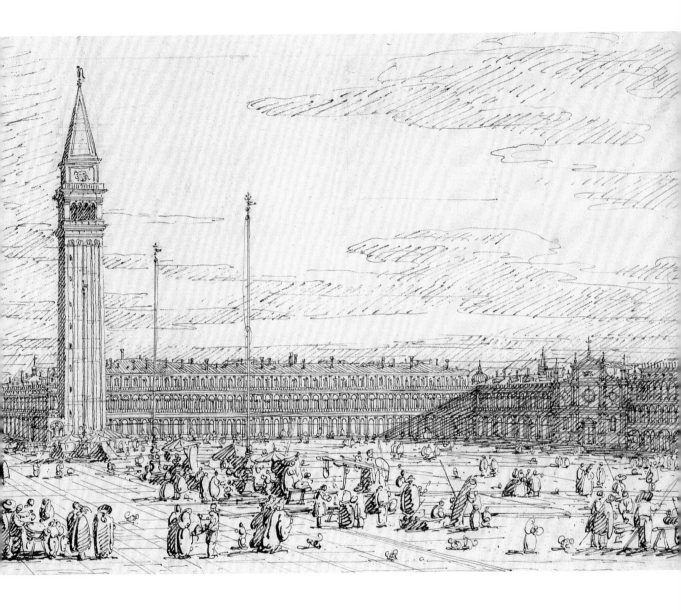

203

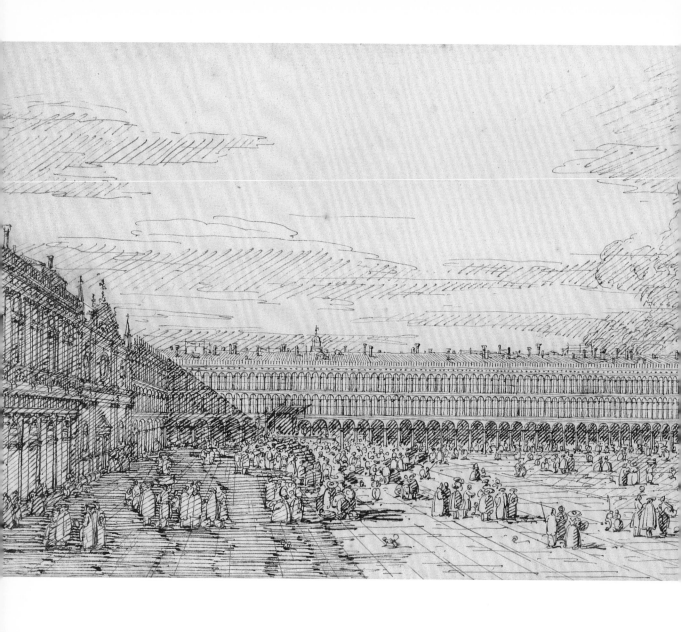

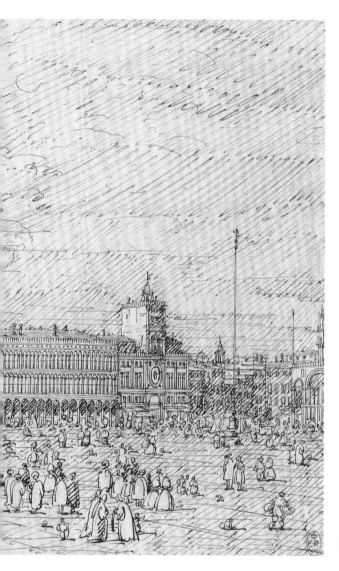

69 The Procuratie Vecchie and Piazza San Marco
*c.*1740

The grid perspective of the paving in the Piazza locates the viewpoint under the arcade six bays from the west end of the Procuratie Nuove. Canaletto's method of constructing the view differs from the two previous drawings in that the north range of the Procuratie Vecchie, with ten bays too many, is not drawn as a simple elevation. While the horizontals remain parallel such that a single-point perspective is maintained, the arches and windows are gradually squeezed together down the east end of the Piazza. This progressive foreshortening is of course observed in reality, but when combined with the uniform height of the building it has the peculiar effect of making the Procuratie seem to curve away from the viewer.

Pen and dark ink, over ruled and a little free pencil and pinpointing, 18.4 × 37.8cm (7¼ × 14⅞")
RL 7424. P.61; C/L 538; Corboz 1985, no. D27

Capricci

Canaletto was fond of taking the churches and other buildings of Venice and placing them in novel and sometimes absurd settings; these are known as *capricci*, from the Italian for the capering of a goat. The *capricci* were a natural extension of Canaletto's free approach to topography in his ostensibly accurate views of Venice, but they emerged as an important category of his art only in the second half of the 1730s, and most of the drawings catalogued here were produced by Canaletto in the late 1730s and early 1740s. This period saw a general slackening of demand for Canaletto's view-paintings, and perhaps he was trying to broaden the appeal of his paintings to those who desired more overt artfulness in their purchases. The period also coincided with the probable presence in his studio of his nephew, Bernardo Bellotto, and some of the *capricci* may have been conceived as drawing exercises, for a number of compositions are found in drawings (and sometimes paintings) by both Canaletto and Bellotto (see no. 80).

The three wide-angle drawings catalogued above (nos. 67–9) were *capricci* of sorts, in that they were faithful to the topography of the area but exaggerated the perspectives to an absurd degree. Several of the following drawings were based on pre-existing views, and in these Canaletto reproduced the motif of a building without alteration, simply inventing a new context for it, seen very clearly in the drawings of the Fontegheto della Farina (nos. 70–73) and of San Marco floating in the lagoon (no. 74). The buildings around Corpus Domini, as drawn at the left of no. 46, were transferred to the lagoon in two finished drawings in the Hermitage and the Morgan Library (C/L 767–8); San Giorgio Maggiore, as drawn in no. 40, acquired a fantastic gothic tower in a drawing in the British Museum (C/L 770); San Pietro

di Castello and San Simeon Piccolo, as seen in nos. 42–3, were later painted by Canaletto with imaginary surroundings (C/L 774, 777).

It was not just the buildings of Venice that Canaletto transplanted. He took ancient buildings – triumphal arches, crumbling ruins, gothic tombs – from other parts of Italy, especially Rome, and placed them incongruously on the shores of the Venetian lagoon (nos. 80–83). The drawings of a further group have been termed *vedute ideate* ('imagined views'), in which Canaletto invented most aspects of the composition (nos. 84–5); many of these are set in the countryside and show picturesquely dilapidated farmhouses or roadside churches against fields and trees. There seems however to have been little, if any, distinction between *capricci* and *vedute ideate* in Canaletto's conception of the invented view, and all are treated here together.

70–73 Two views and two *capricci* of the Fontegheto della Farina
c.1735–40

Nos. 70 to 73 belong to a series of small drawings consisting of pairs of sheets of the same composition, one executed in pen only, the other shaded with grey wash rather than pen hatching (see also nos. 48, 50). The pen style of each is essentially the same, though the flatter handling of the wash version would suggest that in each case it was drawn after the pen-only version. The use of overlays demonstrates that no tracing took place, and that each version was laid out afresh.

The first pair of drawings are not *capricci*, but give a more or less reliable view from the Fondamenta della Farina, west of the Piazzetta and Molo. In the centre is the Fontegheto della Farina, which controlled the supply of wheat and flour in the city. The building became the seat of the Accademia di Pittura e Scultura between 1756 and 1817, when it moved to the converted Scuola Grande della Carità

(see no. 9). It is now the offices of the Capitaneria di Porto. Behind, at a greater distance than the drawing suggests, is Palazzo Valaresso (rebuilt in the nineteenth century as the Albergo Monaco), with Renaissance additions to the rear. This view of the two buildings was recorded rather schematically, and possibly reworked by a later hand, on a page of the Sketchbook (f. 7r), which initially formed the basis for two paintings of the early 1730s (C/L 99–100).

In the foreground is the low broad bridge over the Rio della Luna; to the right, the Granai; to the left, Santa Maria della Salute, the side and the reverse of the façade of San Gregorio, and the tower of Palazzo Venier delle Torreselle, all essentially as in no. 12. The uncertain spatial relationships between the various parts of the composition suggest that Canaletto assembled them from pre-existing studies. There are only small variations of detail between the pen

and wash versions, such as the distant belltower between San Gregorio and Palazzo Venier, with a spire in no. 70 and a dome in no. 71, and the small knot of figures standing before the bridge at lower right, present only in no. 71.

In the second pair of drawings, nos. 72–3, Canaletto placed the central buildings of nos. 70–71 in an imaginary setting. The Fontegheto della Farina is now approached by a sunken courtyard (though the market traders of the Fondamenta have remained), and Palazzo Valaresso has gained an implied two-storey classical façade, the columns of which are visible with an awning on its left side. Beyond, over the wall of the courtyard, is an open arcade, and on the left a neoclassical arch surmounted by the statue of a saint. In the wash version, Canaletto's family arms with the chevron are clearly seen on the near face of the arch.

No. 70: Pen and ink, over a little ruled and free pencil and pinpointing, 18.9 × 27.0cm (7⁷⁄₁₆ × 10⅝″)
RL 7464. P.48; C/L 569; London 1980–81, no. 62; Venice 1982, no. 12; Corboz 1985, no. D58; New York 1989–90, no. 97

No. 71: Pen and ink with grey wash, over ruled and free pencil and pinpointing, 18.8 × 26.9cm (7⅜ × 10⁹⁄₁₆″)
RL 7465. P.49; C/L 570; Toronto etc. 1964–5, no. 35; London 1980–81, no. 63; Venice 1982, no. 13; Miller 1983, no. 17; Corboz 1985, no. D177; New York 1989–90, no. 98

No. 72: Pen and ink, over ruled and free pencil and pinpointing 18.8 × 27.0cm (7¾ × 10⅝″)
RL 7462. P.50; C/L 764; Corboz 1985, no. D29

No. 73: Pen and ink with grey wash, over ruled and free pencil and pinpointing, 18.7 × 26.2cm (7⅜ × 10⁵⁄₁₆″)
RL 7463. P.51; C/L 765; Corboz 1985, no. D30

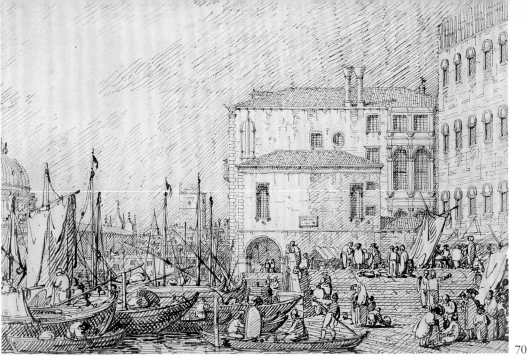

70

71

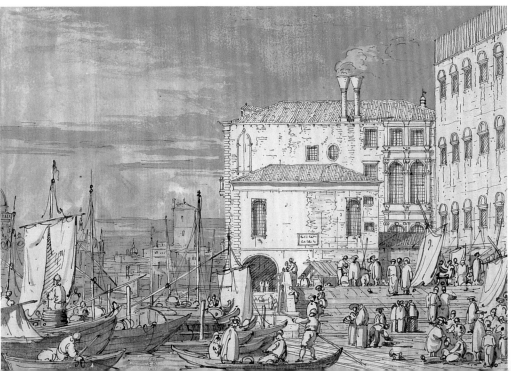

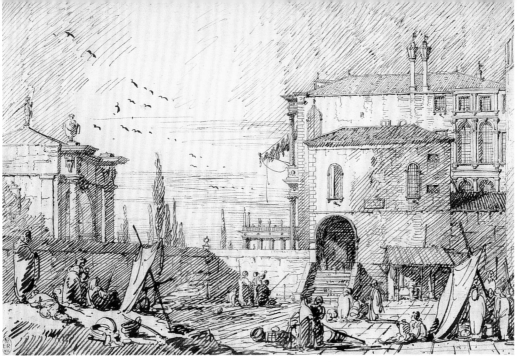

72

73

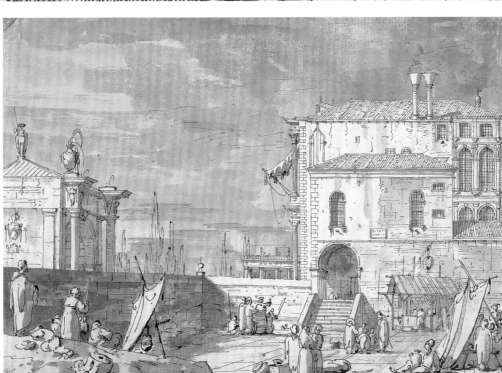

74 A *capriccio* with San Marco in the lagoon

c.1740–45

Canaletto took the north part of the façade of San Marco, as drawn in no. 62, and placed it on a quay approached by wide steps, surrounded by the waters of the lagoon. One of the lions from the Piazzetta dei Leoni (no. 52) has been set among fragments of architecture on a rough shore in the foreground (comparable to the Punta di Sant'Antonio depicted in nos. 55–6); another lion has been placed on the steps of the basilica. In the distance is a city with fanciful towers and a tiered mausoleum.

As in no. 62, the carvings and mosaics within the entrance bays of San Marco were first drawn in some detail with a fine pen, and then overdrawn with heavy parallel hatching, though here Canaletto drew the shadows with the light falling from the left. This suggests either that Canaletto constructed the *capriccio* before he added the heavy shading to no. 62, or that both drawings depend on some outline prototype. It is unlikely that such an efficient artist as Canaletto would have troubled to draw such detail while intending to obliterate it with heavy hatching, and it may be that the outline stage represented a first phase, followed after some time by heavy hatching intended to articulate the drawing.

Pen and ink (two shades), over free and ruled pencil and pinpointing, 27.1 × 37.8cm (10 ¹¹⁄₁₆ × 14⅞")
RL 7432. P.28; C/L 773; Corboz 1985, no. D41

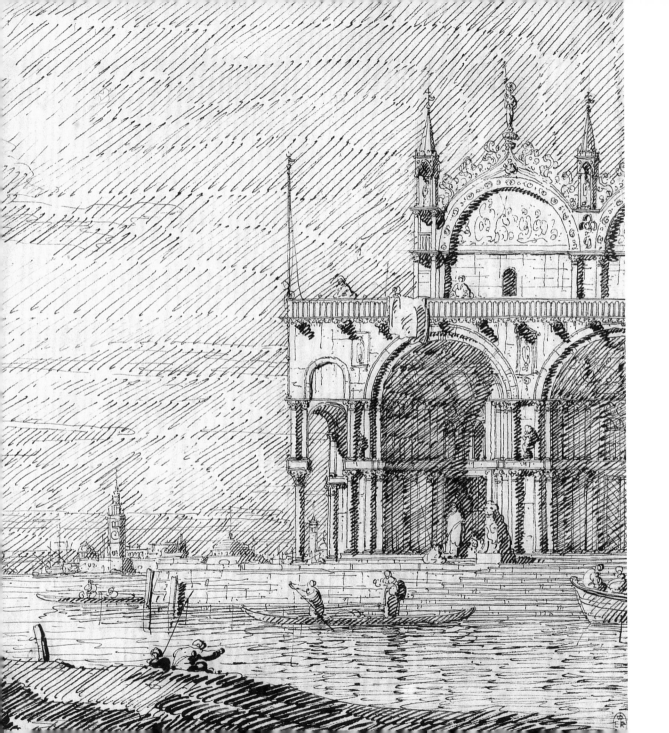

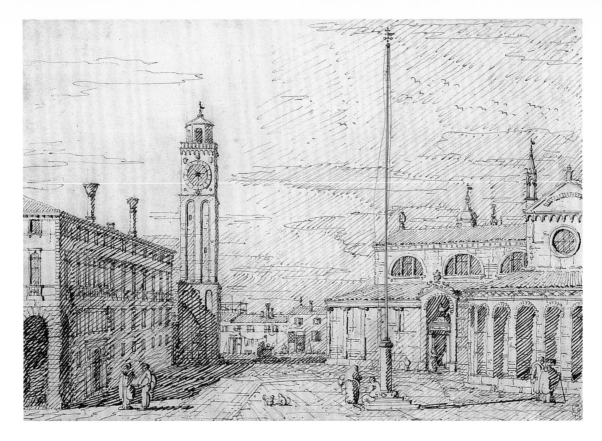

75–6 Two *capricci* with Santi Maria e Donato, Murano

c.1740–45 and *c*.1755–60

The church with its free-standing belltower is based on the church of Santi Maria e Donato on the island of Murano, a kilometre north of Venice. A church dedicated to the Virgin was founded on Murano probably in the seventh century, during the first wave of settlement of the Venetian archipelago. In 1125 the relics of the fourth-century St Donatus, bishop of Euraea in modern-day Albania, were brought to the church from Cephalonia, together with the bones of the dragon he slew (which still hang behind the altar), and the church was rededicated and rebuilt in Romanesque style. The church was heavily restored in the 1970s, retaining its overall form but losing much of its exterior charm.

Canaletto combined two views in no. 75, though neither is wholly reliable. The left side shows the belltower and the flanking *palazzo* (since demolished) from the Ponte di San Donato, looking west; the right side shows the church and flagpole as seen from the southern corner of Campo San Donato, roughly at the corner of the left-hand building, looking north. The effect is to turn the church through 90°

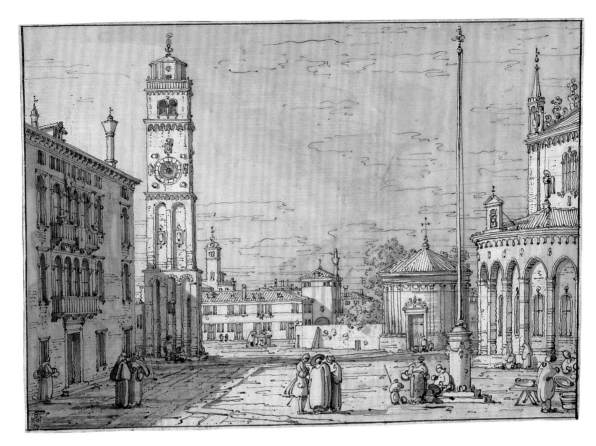

with respect to the belltower. Canaletto maintained the general form of the church, while moving the semicircular arcaded apse to the south transept and altering the windows. He also captured many of the details of the belltower, though not its overall proportions, and in combining the two views he diminished its massive size with respect to the church.

No. 76 is a variant of the composition. Canaletto depicted the belltower of the church more accurately than before, heightening the clock-storey and adding another arcaded storey above. But he completely transformed the church, retaining only the arcaded apse and changing all the details into the language of Venetian gothic, such that without the belltower the church would not be identifiable. A circular *tempietto* now stands in the enlarged space beyond the church. The mannered pen-work indicates that this is a late work, probably executed many years after the original pen drawing.

No. 75: Pen and ink, over free and ruled pencil
19.0 × 27.2cm (7½ × 10¹¹⁄₁₆″)
RL 7492. P.121; C/L 778; Corboz 1985, no. D70

No. 76: Pen and ink with bluish-grey wash, over free and ruled pencil and pinpointing, 19.9 × 28.4cm (7¹⁵⁄₁₆ × 11³⁄₁₆″)
RL 7493. P.122; C/L 779; Corboz 1985, no. D203

77 A *capriccio* with a fountain on the shores of the lagoon
*c.*1740–45

Pen and ink, over traces of free pencil
19.0 × 27.4cm (7½ × 10 ¹³⁄₁₆″)
RL 7537. P.130; C/L 794; Venice 1962, no. 46;
Toronto etc. 1964–5, no. 87; London 1980–81, no. 80;
Miller 1983, no. 34; Corboz 1985, no. D78

In the foreground is a fountain, more like the huge granite bowls familiar in Rome than anything to be seen in Venice, with a small carved lion at its centre. The pedestal bears Canaletto's arms with the chevron. Beyond are trees and a group of fishermen on the shores of the lagoon. The various motifs seem barely connected, and it appears from the minimal pencil underdrawing that Canaletto put the composition together with little deliberation.

78 Trees on the shore of the lagoon
c.1740–45

Pen and ink, over red chalk and traces of pencil
19.9 × 26.8cm (7¹⁵⁄₁₆ × 10⁹⁄₁₆")
RL 7495. P.71; C/L 659; London 1980–81, no. 72;
Miller 1983, no. 26; Corboz 1985, no. D137

The drawing is unusual in Canaletto's oeuvre, both in the detailed depiction of a natural feature and in the extensive use of red chalk. The chalk was not added as shading or simply for colour, but was an extensive initial drawing probably executed in the open air, worked up later with pen and ink. At this later stage Canaletto added the building to the left, the foreground figures and the distant view of the lagoon, not indicated in the red chalk drawing but instead laid out quickly in pencil. The domes and belltowers on the horizon do not seem to be intended as specific Venetian buildings, and attempting to identify a location for the view is probably futile.

79 A pavilion in a walled garden, the lagoon beyond

*c.*1740–45

The location has not been established, and it seems likely that this is an invented view. Garden pavilions, perfect little architectural forms serving as summer houses or for entertaining, were a feature of many of the villas of the Venetian nobility on the mainland, several of which were drawn by Canaletto and Bellotto on their tour of the *terraferma*. In the foreground two figures lean on a garden wall, with architectural fragments, plant pots and so on scattered around. Beyond the rough shore is the lagoon, with a long low building on the horizon, interpreted by Corboz (1985, p. 286) as the hospital of the Lazzaretto Nuovo, on its island to the north-east of Venice. The drawing is a variant of another at Windsor, in pen only (fig. 36).

Pen and ink with bluish-grey wash, over free and ruled pencil and pinpointing, 20.5 × 29.2cm (8¹/₁₆ × 11½")
RL 7543. P.98; C/L 658; London 1980–81, no. 79; Miller 1983, no. 33; Corboz 1985, no. D165

Fig. 36 Canaletto, *A pavilion in a walled garden, the lagoon beyond, c.*1740–45
Pen and ink, 17.6 × 24.3cm (6¹⁵/₁₆ × 9⁹/₁₆")
P.97

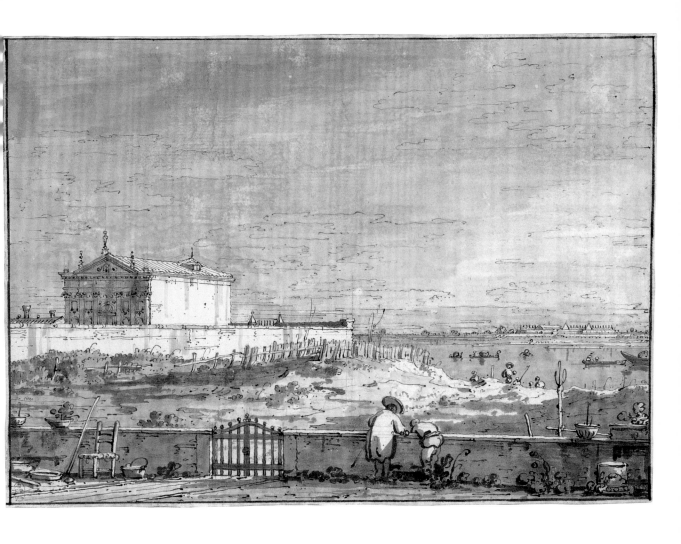

80 A *capriccio* of a ruined arch on the shores of a lagoon

c.1740–45

The arch appears to be entirely imaginary – while its proportions echo Roman arches such as those of Constantine or Septimius Severus, the details are a confection of classical and Renaissance motifs. To the left is a stumpy obelisk; in the centre distance is another arch, and to the right the view opens onto a lagoon, with a domed church on the horizon. Kozakiewicz (K.116; see also Puppi in Gorizia 1988, p. 430) suggested that the composition may have been inspired by Luca Carlevarijs's *Capriccio of a harbour* (fig. 37), then in Smith's collection and presumably well known by Canaletto.

An exact facsimile of the pen drawing (i.e. in outline only) is found among the Bellotto drawings at Darmstadt (K.117). The composition was used in a pair of painted *capricci* by Bellotto in Asolo (K.116, 118), the arch and obelisk in one, the two distant ships in the other. This establishes that Canaletto's most mannered, looping calligraphic style of pen-work, seen in many of the small *capricci*, must have been formulated no later than 1745–6, when Canaletto left Venice for England and he and Bellotto parted for the last time. Other drawn *capricci* by Canaletto at Windsor that are known in outline versions by Bellotto are P.86 = K.110; P.96 = K.49; P.124 = K.122; P.137–8 = K.51.

Pen and ink with bluish-grey wash, over free and ruled pencil and pinpointing, 19.8 × 27.8cm (7 ¹³⁄₁₆ × 10 ¹⁵⁄₁₆″)
RL 7533. P.133; C/L 789; Corboz 1985, no. D206

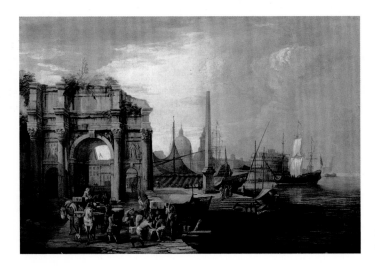

Fig. 37 Luca Carlevarijs, *A capriccio of a harbour*, *c*.1712
Oil on canvas, 98 × 144cm (38½ × 56¾″). Levey 425

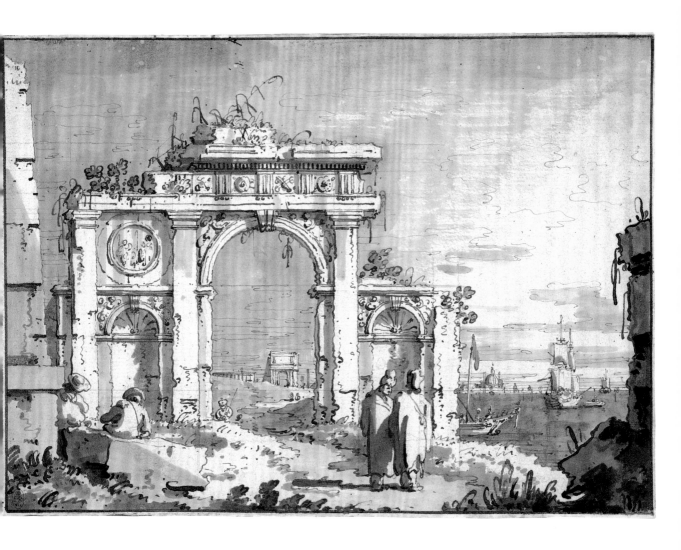

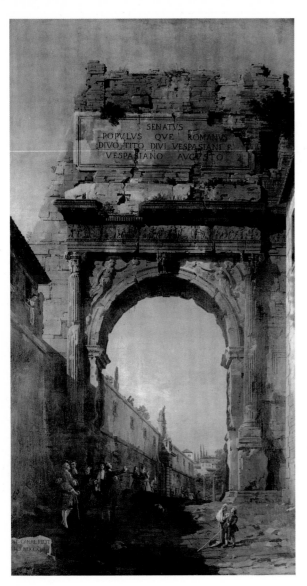

Fig. 38 Canaletto, *The arch of Titus*, 1742
Oil on canvas, 192 × 106cm (75½ × 41¾")
Levey 368

81 A *capriccio* with a Roman arch
c.1742–5

The arch is based (with some licence) on that of Titus in the Forum at Rome, prior to the restorations of 1821 that freed the arch from its later accretions, excavated the pedestal, extended the arch to the left and added a column at each side. Canaletto painted the arch in 1742 (fig. 38), where it is seen with much of its upper storey, here reduced to no more than a few crumbling blocks overgrown with bushes. In the drawing Canaletto added a free-standing column before the engaged column at the left of the arch, and lifted the arch from the Forum to place it on an island on the shores of a lake, reached by a balustraded bridge, with a boatsman in the foreground.

The arch of Titus is not depicted among the twenty-three surviving drawings of Rome executed by Canaletto on his youthful stay in the city (C/L 713; see Venice 2001, nos. 1–13), and it is plausible that both fig. 38 and no. 81 were based on material gathered by Bellotto on a journey to Rome in 1742.

Pen and ink with grey wash, over free and ruled pencil
and pinpointing, 19.9 × 28.4cm (7¹³⁄₁₆ × 11³⁄₁₆")
RL 7523. P.113; C/L 808; Venice 1962, no. 45; Corboz 1985, no. D148

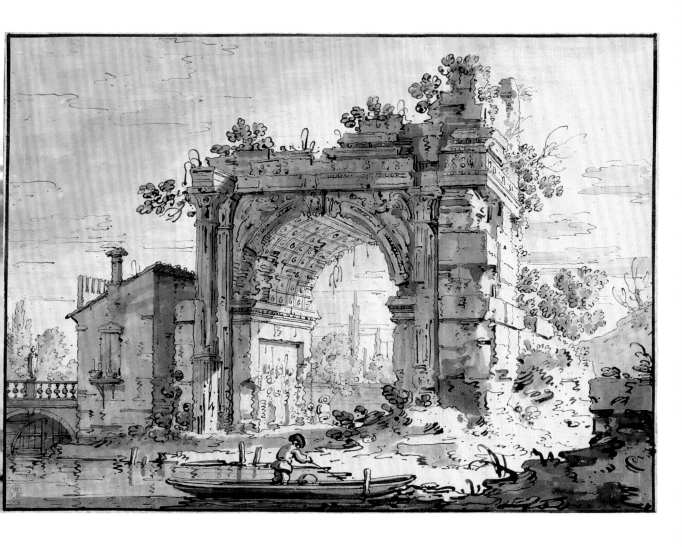

82 A *capriccio* of church ruins on the shores of the lagoon
*c.*1740–45

To the left is the ruined arcade of a Renaissance church, the brick arches still faced with a few marble blocks and pilasters. A sculpture of the Madonna and Child stands to the left; in the foreground a peasant with his dog sits against a sarcophagus beyond which is another with a recumbent effigy. To the right is the canopy of a tomb, and in the distance is the lagoon, with buildings including the stump of a huge clocktower.

In the sky around the canopy can be seen extensive pencil construction lines of unrelated architectural forms. On the reverse of the sheet are more such constructions, difficult to understand and possibly 'ruled doodles' by Canaletto rather than the underdrawing of an abandoned composition.

Pen and ink with bluish-grey wash, over free and ruled pencil and pinpointing, 19.8 × 28.7cm (7¹³⁄₁₆ × 11⁵⁄₁₆")
RL 7528. P.134; C/L 804; Corboz 1985, no. D212

83 A coastal *capriccio*
c.1740–45

Pen and ink with bluish-grey wash, over free and ruled pencil
and pinpointing, 20.3 × 28.7cm (8 × 11⁵⁄₁₆")
RL 7534. P.132; C/L 801; Venice 1962, no. 48; Corboz 1985, no. D210

To the right is a classical ruin, with architectural fragments in the foreground; beyond, fishermen on a short quay, ending in a fanciful pedestal with a coat of arms (unusually, not bearing Canaletto's chevron). In the distance is an imaginary city with mountains rising behind, similar to the Dolomites as seen to the north of Venice on a clear day.

84 A *capriccio* in the courtyard of a villa

c.1740–45

The scene seems to be the courtyard of an imaginary villa on the Venetian *terraferma*. To the right is a Renaissance building of an odd scale, conceived as a triumphal arch closed by a huge wooden screen with a door set in below, entered by a nobleman in a frock-coat. In the tympanum is Canaletto's chevron 'signature'. To the left are the rear of the gate and the domestic buildings, including a loggia, and the statue of a saint standing on the corner of the wall. The scene in the courtyard is unusually anecdotal, with a well-head from which a figure draws water, clothes hanging off the lean-to roof, barrels, benches, pails and other implements laid around.

Although this has been placed by some scholars among Canaletto's late drawings, and is of a non-standard size, it does not seem distinct in style or intent from the series of *capricci* catalogued above.

Pen and ink with wash, over ruled and free pencil and pinpointing
21.5 × 33.8cm (8 ⁷⁄₁₆ × 13 ⁵⁄₁₆")
RL 7544. P.140; C/L 707; Venice 1962, no. 49;
London 1980–81, no. 95; Miller 1983, no. 49;
Corboz 1985, no. D180; Frankfurt etc. 1989–90, no. 44

227

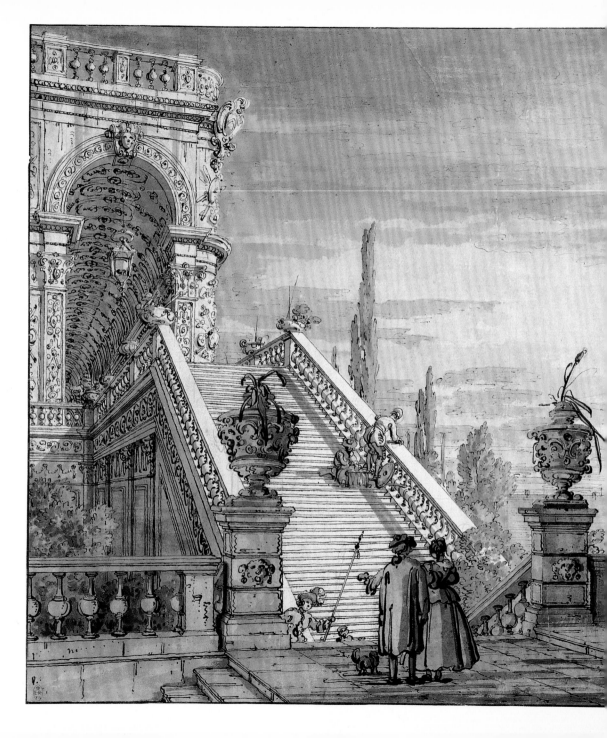

85 A *capriccio* with a monumental staircase
c.1755–60(?)

This is one of the largest and grandest of Canaletto's *capricci*. In the foreground is a shaded terrace, from which a staircase descends to meet – somehow – another rising to a highly decorated loggia, with a shield on its upper corner bearing Canaletto's chevron. The architecture is wholly fictitious: resemblances of the loggia to the Procuratie Nuove, and of the staircase to the Scala dei Giganti in the courtyard of the Palazzo Ducale, are merely generic. To the right is a compressed view of the Dogana and Santa Maria della Salute as seen from the Molo, though the Giudecca beyond has given way to an open horizon.

The drawing is commonly supposed to be late, of around 1760; it displays the strong perspective of, for instance, the drawing that corresponds with Canaletto's reception painting of 1765 for the Accademia (C/L 822), and shares with that sheet such incidental details as the decorated neoclassical vases sprouting a few straggly leaves. It is however richer in effect, with more variation in touch, than the rather monotonous lines of many of Canaletto's certainly late drawings (such as the set of *Feste Ducali*, C/L 630–39); it shares the style and mannerisms of the *capricci* catalogued above, differing only in scale and ambition. While a date after 1755 is probably to be preferred, it may conceivably be a work of the 1740s. This illustrates the stability of Canaletto's style over the last decades of his career, and the consequent difficulty of dating his drawings from this period on style alone.

Pen and ink with wash, over ruled and free pencil and pinpointing
36.3 × 53.1cm (14⁵⁄₁₆ × 20⅞″)
RL 7564. P.141; C/L 821; Venice 1962, no. 50; London 1980–81, no. 96; Venice 1982, no. 63; Miller 1983, no. 50; Corboz 1985, no. D160; New York 1989–90, no. 118

References and further reading

For the standard catalogues cited throughout, see p. 23. Bibliographical and exhibition references prior to Parker's 1948 catalogue of the Windsor drawings are not recorded here. The other references cited are selective.

Belluno 1993: D. Succi, *Marco Ricci e il paesaggio veneto del Settecento*, exh. cat., Palazzo Crepadona

Bomford, D., and G. Finaldi, *Venice through Canaletto's Eyes*, London, 1998

Bonn 2002–3: *Venezia!*, exh. cat., Kunst- und Ausstellungshalle der Bundesrepublik Deutschland

Bromberg, R., *Canaletto's Etchings*, London and New York, 1974

Byam Shaw, J., *The Italian Drawings of the Frits Lugt Collection*, 3 vols, Paris, 1983

Corboz, A., 'Sur le prétendu objectivité de Canaletto', *Arte Veneta*, XXVIII, 1974, pp. 205–18

Corboz, A., *Canaletto. Una Venezia immaginaria*, 2 vols, Milan, 1985

Frankfurt etc. 1989–90: F. Vivian, *The Consul Smith Collection*, exh. cat., Schirn Kunsthalle and elsewhere

Gorizia 1986: D. Succi, *Canaletto e Visentini tra Venezia e Londra*, exh. cat., Castello di Gorizia

Gorizia 1988: *Capricci Veneziani del Settecento*, exh. cat., ed. D. Succi, Castello di Gorizia

Hadeln, D. von, *Drawings of Antonio Canal, called Canaletto*, trans. C. Dodgson, London, 1929

London 1980–81: O. Millar and C. Miller, *Canaletto. Paintings and Drawings*, exh. cat., Queen's Gallery

London 1993: *A King's Purchase. King George III and the Collection of Consul Smith*, Queen's Gallery

London 1994: *The Glory of Venice*, exh. cat., ed. J. Martineau and A. Robison, Royal Academy

Madrid 2001: D. Succi and A. Delneri, *Canaletto. Una Venecia Imaginaria*, exh. cat., Museu Thyssen-Bornemisza

Miller, C., *Fifty Drawings by Canaletto from the Royal Library, Windsor Castle*, London and New York, 1983

Nepi Scirè, G., *Canaletto's Sketchbook*, Venice, 1997

New York 1989–90: K. Baetjer and J.G. Links, *Canaletto*, exh. cat., Metropolitan Museum of Art

Pignatti, T., review of Venice 1962, *Master Drawings*, I(1), 1964, pp. 49–53

Pignatti, T., *Canaletto. Selected Drawings*, trans. S. Rudolph, University Park PA and London, 1970

Potterton, H., 'Canaletto's views of S. Geremia and the entrance to the Cannaregio', *Burlington Magazine*, CXX, 1978, pp. 469–70

Puppi, L., *L'opera completa di Canaletto*, Milan, 1968

Rome 2005: B.A. Kowalczyk, *Canaletto. Il trionfo della veduta*, exh. cat., Palazzo Giustiniani

Toronto etc. 1964–5: W.G. Constable, *Canaletto*, exh. cat., Art Gallery of Ontario and elsewhere

Venice 1962: K.T. Parker and J. Byam Shaw, *Canaletto e Guardi*, exh. cat., Fondazione Giorgio Cini

Venice 1982: A. Bettagno *et al.*, *Canaletto. Disegni, dipinti, incisioni*, exh. cat., Fondazione Giorgio Cini

Venice 1997: A. Bettagno and B.A. Kowalczyk, *Venezia da stato a mito*, exh. cat., Fondazione Giorgio Cini

Venice 2001: A. Bettagno and B.A. Kowalczyk, *Canaletto. Prima Maniera*, exh. cat., Fondazione Giorgio Cini

Index